Stolen, Smuggled, Sold

# Stolen, Smuggled, Sold

## *On the Hunt for Cultural Treasures*

Nancy Moses

ROWMAN & LITTLEFIELD
Lanham • Boulder • New York • London

Published by Rowman & Littlefield
A wholly owned subsidiary of The Rowman & Littlefield Publishing Group, Inc.
4501 Forbes Boulevard, Suite 200, Lanham, Maryland 20706
www.rowman.com

Unit A, Whitacre Mews, 26-34 Stannary Street, London SE11 4AB

British Library Cataloguing in Publication Information Available

**Library of Congress Cataloging-in-Publication Data**

Library of Congress Cataloging-in-Publication Data Available
ISBN 978-0-7591-2192-8 (cloth : alk. paper) -- ISBN 978-0-7591-2194-2 (electronic)

♾ ™ The paper used in this publication meets the minimum requirements of American National Standard for Information Sciences Permanence of Paper for Printed Library Materials, ANSI/NISO Z39.48-1992.

Printed in the United States of America

To my beloved sisters, Ellen Sue Moses and Suzanne Garment

# Contents

# Color Plates

# Preface

In 2006, while searching for the topic for the final chapter of my book, *Lost in the Museum: Hidden Treasures and the Stories They Tell*, I came across a disturbing fact: art museums in the United States and around the world owned thousands of artworks that were likely taken from Jews living in Nazi-occupied Europe. As Jews fled their homes or were dragged to death camps, many had been forced to sell or abandon their paintings, rare books, and other treasures. Since I was writing about museum objects with a secret past, I was very intrigued and decided to check in with some colleagues in art museums.

I soon learned that there are mountains of paintings, sculpture, rare books, ceremonial objects, and other treasures with a provenance that ended around 1933 and picked up again after the end of World War II. Much of it surfaced in Europe around the late 1940s and early 1950s, and dealers lost little time in selling it to major museums around the world. Recently, the museum profession encouraged American museums to post lists of this Holocaust art on their websites, and many have complied. But, although museums had made this gesture towards transparency, they were not interested in discussing the matter. There's reason for this reluctance, since harboring items stolen from helpless Jews on their way to their death is not exactly the type of subject that pushes a museum's positive image.

I thought this matter over and tried to figure out how to convince a museum to allow me access to its Holocaust art. Then I hit on a plan: I would find a museum that had actually returned something to the original Jewish owners or their heirs and tell its story. A museum would certainly welcome the chance to showcase its act of generosity. I imagined being greeted with open arms by one of these courageous museums. I imagined a story in its

local paper celebrating the museum's generosity, its wisdom in righting a terrible wrong from decades past.

That was my plan: to tell the story of a museum that had repatriated an artwork stolen from Jews. I contacted the Association of Art Museum Directors and was directed to a section of its website with a list of about a dozen museums under the heading "Restitution of Claims for Nazi-Era Cultural Assets." I then got busy. I called one museum, and then another, then another. At one, the director was on vacation; at another, the curator was installing an exhibition and was too busy to take my call; at a third, no one called back. I must have made twenty calls, and no one was available for an interview about the artwork a museum had actually returned. Two Ivy League universities were on the list, and I tried them both, naively thinking that academic freedom translated into institutional transparency. After calling seven or eight museums, I finally connected with a sympathetic staff member.

"These museums don't want to be interviewed because they are embarrassed," she told me, after I promised her anonymity. "Even though the museum did the right thing in returning the artwork to the Jewish family, it does call into question how the painting got to it in the first place. In the case of our museum, we're in the process of negotiating the sale of a painting with a problematic provenance. Any publicity would threaten the negotiations."

That was it. I was stonewalled. I quickly found another topic for the final chapter of *Lost in the Museum* and submitted the manuscript to my publisher.

This incident lay festering in the back of my mind for years. As generally happens when something's on my mind, related information appears as if by magic. I began to see newspaper features about Holocaust art, then book reviews, magazine articles, television shows, and movies. There is a very large literature around Holocaust art; it's a well-traveled road. And, as I traveled along it, I started to see how it fit into a larger picture.

I began to think about spoils of war, how through millennia of conflicts the victor claimed the treasures of the vanquished. Much of this war booty ended up filling the display halls of museums, great libraries, and archives, which are collectively known as collecting institutions.

Wars are one vehicle that transports cultural treasures from loser to the winner, but there are others as well. Explorers. Missionaries. Colonialists. Tourists. They see something on their travels and bring it home. These souvenirs can be as grand as the imposing Ishtar Gate of Babylon from the sixth century BCE in Berlin's Pergamon Museum; as astonishing as the intricate bronze plaques that the British stole from the high court of Benin, now at the Art Institute of Chicago; and as memorable as the Parthenon's marble figures, now in the British Museum. While subjugating the natives, Westerners also brought home shrunken heads from the Maori, Kachina figures from Hopi pueblos, and prehistoric pottery from Ban Chiang, Thai-

land, immediately recognizable by its jazzy, swirling patterns. War brings famine and famine brings desperate people to steal their own cultural treasures from archaeological sites and museums, to sell them into the black market. I thought about this as I wandered through museums of art, archaeology, and anthropology. I began asking myself: are these objects better off here, where millions can see them, or should they be back in their home countries, reconnected to their cultures?

An idea for a book began to take shape, something about the removal and return of cultural treasures. Were there instances other than war and colonial expansion? What about true crime stories set in museums? I read about the 1911 heist of the Mona Lisa by three Italian handymen; the 1990 theft of thirteen artworks from the Isabella Stewart Gardner Museum by thieves disguised as Boston policeman; Jack (Murph the Surf) Murphy and his antic crew who, in 1964, entered through an open window and stole twenty-four gems, including the Star of India, from New York's American Museum of Natural History. I watched classic heist movies: *Topkapi, The Thomas Crown Affair, How to Steal a Million.*

Finally, I boned up on theft by insiders. In his book *Priceless*, Robert K. Wittman,[1] founder of the FBI's Art Crime Team, wrote about a case I actually knew, since it took place while I was a museum director in Philadelphia. A trusted janitor at the Historical Society of Pennsylvania spent years smuggling out items in dark, opaque garbage bags, selling them to an electrical contractor. By the time he was caught, the contractor had created his own miniature Historical Society of Pennsylvania in his home.

As my interests expanded from Nazis and war booty to stolen antiquities, and insider theft, so did my research. *The New York Times, Art News*, Great Britain's *The Art Newspaper*, and Douglas McLennan's weekly online compendium, artsbeat@artsjournal.com, report on these matters regularly. There are books about different types of art crimes, thefts of a single object or category of objects, and institutions that may or may not have known they purchased purloined treasures. There are books about art detectives, art and antiquities dealers, and the international art cartel. For my purposes, the most useful of all was Jeanette Greenfield's *The Return of Cultural Treasure*,[2] a comprehensive compendium of legal cases drawn from all over the world. Five years later, I had clipped and read, and read and clipped myself into this book.

On the pages that follow, you will find profiles of objects with institutional pedigrees that were removed in some way, legal or not. All of the objects have some connection to the United States and all made their way back to their original owner. This is not a detailed analysis of any single object; it is neither a legal treatise nor a comprehensive review of the state of cultural heritage. Rather, *Stolen, Smuggled, Sold* is a series of literary snapshots in which a treasure and its story come through in sharp relief.

Objects with problematic provenance are more common than many think: most older collecting institutions own some spoil of war, souvenir from conquered colonial nation, loot from an ancient archaeological site, or other treasure that was stolen, smuggled, and eventually sold by an unscrupulous dealer. Many problematic artifacts came to their institutional home years ago, when acquisition practices were more lenient and source countries less demanding. Happily, the rules governing acquisition now foster greater vigilance, so we should take care when applying current standards to past decisions. While ethics may be universal, their application to collecting institutions and cultural treasure continues to evolve.

One aspect that has certainly evolved has been the legal framework. The seminal document is the United Nations Educational, Scientific, and Cultural Organization (UNESCO) Convention on the Means of Prohibiting and Preventing the Illicit Import, Export and Transfer of Ownership of Cultural Property. Created in 1970 as a response to an increase in trafficking in cultural heritage, the Convention requires its partners to institute such preventive measures as export certificates and imposition of penal sanctions, to initiate restitution provisions to recover and return cultural property imported after this provision, and to strengthen cooperation among countries especially when cultural patrimony is in jeopardy from pillaging. Conventions set standards for countries to follow and are not legally binding. Nevertheless, they do provide moral persuasion and encourage countries to establish their own laws. As of today, 127 nations have accepted or ratified the Convention. UNESCO's Database of National Cultural Heritage Laws contains 1,087 laws, 136 agreements, and 43 amendments covering everything from antiquities to vehicles.

The effect of this Convention was to draw a line in the sand: collecting institutions were obliged to assure the objects they acquired were legally obtained. Anything acquired before November 14, 1970, got a pass. This fact will come to mind as you read the chapters that follow.

The first is about *Portrait of Adele Bloch-Bauer 1*, a gorgeous painting of an Austrian Jewish society matron by the artist Gustav Klimt. Of the hundreds of thousands, perhaps millions, of artworks stolen from Jews during World War II, this one spoke to me. It is the quintessential Holocaust story, featuring a sensational artwork, a dramatic battle by the family to reclaim it, and two museum connections—one in Austria, which was reluctant to relinquish it, the other in the United States, where it resides today. Adele Bloch-Bauer's story has received significant coverage. I include it here because it cuts to the quick of the question: why do so few Jewish treasures ever return to their families of origin?

The second chapter is about another remarkable woman, the exceptionally prolific author Pearl Buck, the recipient of the 1938 Nobel Prize for Literature, the Pulitzer Prize, and many other awards. The typescript for her

best, most important, and most beloved book, *The Good Earth*, went missing for forty years until it turned up at a Philadelphia auction house and was recovered by the Pearl Buck Foundation, beneficiary of the Pearl Buck legacy. Who stole the typescript and why? This is a case where my initial hypothesis was dead wrong. The typescript itself told me its tale.

From Pearl Buck, we turn to the scarred landscape of South Dakota, where, on a frigid December night in 1890, the Seventh U.S. Cavalry gunned down three hundred men, women, and children of the Lakota Sioux nation. This, the massacre at Wounded Knee, came alive as I followed the ceremonial Ghost Dance shirt from the frigid body of a Lakota Sioux warrior, across the ocean to the Kelvingrove Museum in Glasgow, Scotland, and back home again. This is one of the saddest stories in the book, but it is also the most heartwarming because of the unlikely pairing of an unstoppable Sioux woman and an empathetic Scottish museum curator.

The fourth chapter is about the perennial subject of insider crime. Many say insider crime is the most common crime in collecting institutions. When I saw an article about the theft of some 4,800 historical audio discs by a top official at the National Archives, I decided to test this assumption. I expected to encounter some pretty strange characters along the way. What I didn't expect to encounter was my visceral reaction to the criminal, whose motivations are all too familiar to institutional caretakers and private collectors who are drawn to the old and rare.

The next chapter is about an Egyptian mummy, but not your run-of-the-mill mummy, a royal mummy that many experts believe is Ramesses I, the founder of the glorious Nineteenth Dynasty. This is a case where suspicions and serendipity led to a major find. Egyptology attracts colorful characters, and Ramesses I's story includes some especially colorful ones, including a family of grave robbers, a dealer in shrunken heads, and a celebrity archaeologist.

From 3,300 BCE, the book then jumps forward to the 1790s, continues to the Civil War, and moves up to a FBI sting in 2007. This chapter took me to Raleigh, North Carolina, to see its original copy of the Bill of Rights, sent by George Washington himself for ratification. North Carolina was the only colony that refused to ratify the Constitution without a Bill of Rights. That's why they were especially angry when a Union soldier stole their copy. Even though the state was offered it for sale three times, North Carolina turned it down. The reason they did surprised me. Southern honor is real and alive even today.

The next chapter was the most emotionally wrenching to write. It is about an antiquity stolen as a result of the United States invasion of Iraq after the bombing of the World Trade Center on September 11, 2001, and in writing it, I returned to those frightening times. It's a somewhat complicated story, because it weaves together the theft of this ancient treasure in Iraq, its path

across Asia and Europe courtesy of the international antiquities cartel, the bombing of the World Trade Center, and the recovery and eventual return of the antiquity to the Iraqi people. All wars, regardless of their origins, destroy more than people and places. They also threaten the integrity of a culture.

In the final chapter, called "Heroes," I share my reflections, what I've learned over the course of writing this book. When I started it, I envisioned it as a series of mysteries with you, the reader, and me, the author, as the detectives. We would find an object, something memorable, perhaps even something iconic. We would dig deep for its story, its origins. We would follow the object from its source along a long and often convoluted journey back to its original owner. Along the way, we would meet unscrupulous grave robbers, enterprising art dealers, venal Nazis, canny lawyers, acquisitive collectors, unwitting curators—as well as the dedicated government officials whose record of recovery is nothing less than remarkable.

But as I wrote, another, deeper level emerged. *Stolen, Smuggled, Sold* became about law and ethics, a book about who owns—and who should own—the world's cultural treasures. This debate is one of the most enduring, provocative, and problematic of all culture wars, and without a doubt one of the hottest in the museum world today. Every year there are conferences, professional panels, and a slew of new books on the subject. The disposition of cultural property is an issue of professional practice, international protocol, and national law. It's a financial issue: the illicit trade in antiquities and cultural items totals as much as four billion dollars to six billion dollars a year.[3] It is also an issue of justice, of fairness. An ethical issue.

As we sleuths follow the goods, we will confront our own values and views on who *should* own these problematic objects. Here you, the reader, and I, the author, will listen to every point of view. We will keep an open mind. We will ponder, debate, and discuss. You and I might agree about who is the rightful owner of each found treasure, or maybe we won't. Who knows?

What I do know is that the return of cultural treasure is a gigantic and mesmerizing topic that reaches from earliest days of humankind up to the most recent online posting in the international press. Collecting institutions around the world are filled with objects that have breaks in the chain of ownership, suspicious ownership records, or no provenance at all; there's much too much to squeeze into one small book.

Therefore, my hope for *Stolen, Smuggled, Sold* is very modest. I hope that the next time you go to a museum and see something that sparks your interest, you will ask yourself: How did this get here? Who does it belong to? And is that the way it ought to be?

# NOTES

1.  Robert K. Wittman with John Shiffman, *Priceless: How I Went Undercover to Rescue the World's Stolen Treasures* (New York: Broadway Books, 2010).

2.  Jeannette Greenfield, *The Return of Cultural Treasures,* 3rd ed. (Cambridge, England: Cambridge University Press, 2007).

3.  Vernon Silver, "Tomb-Robbing Trials Name Getty, Metropolitan, Princeton Museums," October 21, 2005, Bloomberg.com, http://www.bloomberg.com/apps/news?pid=email_us&refer=&sid=aThsZ_9K56sQ.

# Acknowledgments

Many people generously gave their time and talent during the years I spent writing *Stolen, Smuggled, Sold*. A number are already cited in the text, and I wish to thank each one. In addition I would like to thank V. Chapman-Smith of the National Archives, Brent Glass, former director of the Smithsonian's National Museum of American History, and Stephen R. Phillips, research assistant, Egyptian Section, University of Pennsylvania Museum of Archaeology and Anthropology, who provided many useful insights. I thank Sandra Tatman, executive director, and Jill Lee, circulating librarian, of the Athenaeum of Philadelphia, who gave me a workplace, unlimited encouragement, and a wonderful book collection upon which to draw.

I am grateful to Maureen Ward who shared her insightful opinions, Randi Kamine who checked the facts, and Amy Castleberry who helped assemble the final text. The book benefitted from Bruce Bellingham's sage legal advice and Lynda Barness, Andrea Kramer, and Suzanne Garment's masterful editing. I appreciate the support and dedication of Charles Harmon, executive editor at Rowman & Littlefield Publishing Group, whose faith in my book has meant so much.

Finally, I wish to thank Myron Bloom, my first reader, best friend, and loving supporter throughout forty-one years of marriage.

## Chapter One

# The Lady in the Jeweled Dog Collar

She's a golden goddess, a dazzler in her gold jewels, slim gold gown, and cape, a Mona Lisa smile on her lush, red lips. Millions have fallen in love with this painting of an Austrian socialite by the eccentric artist who may have been her lover. What makes it more remarkable still is its story: the painting was abandoned when its owner fled the Nazis, sold to the Austrian national art museum, won back by its owner's heirs in a battle that went all the way up to the U.S. Supreme Court, and bought for a record price by a billionaire collector.

This is *Portrait of Adele Bloch-Bauer 1* by the Austrian painter Gustav Klimt. It hangs in the Neue Galerie, a jewel box of a museum with a tony address across from the Metropolitan Museum of Art in New York City. The December day I first visited, the Neue was filled with well-dressed patrons in somber greys and blacks, staring at paintings with their audio guides in hand or gossiping over dense coffee and delightful pastries in the museum's lovely Viennese cafe. Nearby was the curving marble staircase that led to the second floor galley dedicated to Austrian artwork.

The painting commands the room. It's about five feet square but seems larger, flanked by a pair of sleek sculptures of male nudes. Klimt painted Adele with dreamy bedroom eyes, flushed cheeks, and an enigmatic smile, with a dense crown of black hair and a jewel-encrusted choker around her long neck. Her head, neck, shoulders, arms, and folded hands appear three-dimensional, surrounded by a dizzying syncopation of gold and silver patterns against a mottled golden wall. The patterns nearly engulf the woman, blurring the lines between figure, garments, and backdrop.

I stared at the painting, then walked around the mauve and grey gallery, past paintings of society women Adele likely knew and places she may have visited; past porcelain clocks and mirrors and a regal robe-like dress by one

of Adele's favorite designers, Emilie Flöge, who was Gustav Klimt's sister-in-law. I then returned to the portrait. The more I looked at Adele, the more Adeles I saw: a glittering Byzantine mosaic Madonna, a hot damsel strangled by her glittering dog collar, a Jewish princess of Vienna's Golden Age, a pathetic relic from the world that the Nazis destroyed. *Portrait of Adele Bloch-Bauer 1* is a stunner on its surface with a darker, more ominous meaning lurking below.

I actually had seen her before, and chances are you have, too, since *Portrait of Adele Bloch-Bauer 1* is one of the most heavily merchandised images in the world. Glamorous Adele has appeared on t-shirts, mugs, key chains, umbrellas, playing cards, and more. A poster bearing her image graced many a college girl's dormitory wall in the 1960s, including mine at Syracuse University. I thought I knew Adele from such frequent encounters, but when I saw the actual portrait, large and extravagant, she morphed into an object of mystery. What was her life like in turn-of-the-century Vienna, I wondered? What inspired Klimt to capture her likeness in such a peculiar portrait? What happened to the painting during World War II, when the Nazis annexed Austria? How did it get from Vienna to Manhattan?

I stopped at the museum's bookstore and purchased a few of the many books about the artist, the painting, and its path through time, including one published by the Neue itself. I went home and began reading: piles of books, scores of websites, as I sunk deeper and deeper into the morbid morass of Holocaust art.

Holocaust art is a genre distinguished not by what is on the canvas but rather by what is missing in its provenance, the chain of ownership records from the artist forward. For Holocaust art, the chain of ownership breaks around the beginning of Hitler's rise to power and picks up again around the end of war. The field of Holocaust art is a sad and eerie place: its books, articles, films, exhibit catalogues, and growing body of case law document the crushingly tragic experiences of millions of human beings and the problematic disposition of their most treasured possessions.

I was shocked to learn that many American art museums own Holocaust art, and that you can actually see it listed on the web. When I heard about this at a museum conference, I immediately went online to the websites of a number of leading art museums. I typed in the word "provenance," and up on my computer screen came photographs of painting after painting, along with descriptions of the museum's Nazi-era provenance research. According to the Association of Art Museum Directors, out of the eighteen million objects in American art museums, approximately twenty-five thousand "require further study into their ownership history during the Nazi era." Between 1998 and July 2006, only twenty-two of the twenty-five thousand works were returned to the heirs of Holocaust victims[1] or, because of settlements reached

with the heirs, remain in the museum. That is hardly a record of which to be proud.

These stolen artworks haunted me and tied me to their dead owners, to the comfortable homes of the Jewish professionals, merchants, and others of means on the cusp of the war. It's impossible to comprehend six million Holocaust victims, but I can imagine a single family living in a flat in Munich or Paris or Vienna, cowering by the windows as their city is invaded, frantically packing up a couple of suitcases, mournfully abandoning their paintings as they close the door on their lives, some getting safely away, others trapped and murdered by the Nazis. I imagine the survivors of the war, learning decades later that the beloved painting that once hung over the fireplace in their flat is now hanging on the walls of an art museum in Memphis or Milwaukee or Melbourne. *Portrait of Adele Bloch-Bauer 1* was one of the lucky few that made it back to its family of origin.

Adele Bauer lived like a princess in Vienna at its most glorious moment, the last years of the Austro-Hungarian Empire. She was born in Vienna in 1881 into a wealthy, well-placed family, her father a distinguished banker and her uncle a titled nobleman and advisor to the Bavarian king. At age eighteen, in Vienna's main synagogue, she married Ferdinand Bloch, a wealthy industrialist and major art collector who was seventeen years her senior. Adele's sister Theresa had wed Ferdinand's brother Gustav a year before. By the time the Bauer girls married, their father and brother had died. Because there was no one to carry on the distinguished Bauer name, both couples decided to use the hyphenated surname of Bloch-Bauer. Adele and Ferdinand had no children, but were very close to Theresa and Gustav's children: Karl, Robert, Leopold, Luisa, and Maria, who show up later in the story. Within a couple of years, Ferdinand had acquired a castle near Prague and a stylish mansion in the center of Vienna: the Palais Bloch-Bauer.

The Austro-Hungarian Empire was Europe's second largest and third most populous nation, with twelve recognized languages. The remarkable sixty-eight-year reign of Emperor Franz Josef I brought it unprecedented political stability and economic prosperity. Vienna was its cultural and commercial core, as brilliant as Paris in the 1930s or Manhattan in the 1960s. Gone were the ancient walls that had long surrounded Vienna's core, replaced by the wide and elegant Ringstrasse, home to major cultural and educational institutions and lavish apartment houses. Just imagine how exhilarating it must have been in Vienna at this moment: to pass Sigmund Freud and his wife strolling along the Ringstrasse, to sit in the audience at the premiere of Richard Strauss' opera *Salome* at the new Opera Hall, to shop for the latest gowns at the Flöge sisters' exclusive salon. You might stop by a fashionable Viennese cafe for a Turkish coffee and piece of strudel and find yourself eavesdropping on a conversation between composers Gustav Mahler and Arnold Schoenberg, writers Franz Kafka and Stefan Zweig, or three

Nobel prize-winning physicians. All these people lived in Ferdinand and Adele Bloch-Bauer's Vienna. Some of these luminaries frequented their salon. Many were Jews.

For, along with being one of the world's most spirited cities, fin-de-siècle Vienna was also among those most welcoming to Jews. During Franz Joseph I's reign, Jews were granted full citizenship rights and thousands flocked to the capital city from the far-flung reaches of the empire. The Jewish population of Vienna, 6,200 in 1860, swelled to 147,000 by the turn of the century.[2] Vienna's Jews created a complete infrastructure: a Jewish newspaper, a Jewish hospital, a Jewish Gymnasium and Pedagogium, splendid synagogues, and the world's first Jewish museum. More than half of Vienna's lawyers and doctors were Jewish, as were sizable percentages of university faculty members, bankers, artists, and businessmen. There were Jewish counts, dukes, and heads of the chamber of commerce.

Not everyone welcomed them. Jews first arrived in Austria in the late twelfth century and from then on had endured at least three cycles of acceptance, threat, and, ultimately, expulsion. Despite their financial gains, fancy titles, and influence, Jews knew they would never really be accepted by mainstream Austrian culture. The mayor of Ferdinand and Adele's Vienna was Karl Lueger, an outspoken anti-Semite whom the Viennese repeatedly re-elected. I was surprised to learn that one of Mayor Lueger's greatest admirers was a thin, sallow young man named Adolph Hitler, who arrived in 1908 with the dream of becoming a great artist but ended up on the streets selling his postcard drawings of Vienna. From this precarious perch, young Hitler watched glittering Vienna and listened to Lueger's powerful anti-Semitic rhetoric. Later, when Hitler was elected Germany's führer, his passion for art became state policy, and his conquering army looted such massive quantities of paintings and other treasures that salt mines, railroad cars, and synagogues were repurposed to store them all.

Photographs of Adele Bloch-Bauer show an intense, stern woman with a crown of dense dark hair, luminous eyes, an aquiline nose, and perfect lips. In fin-de-siècle Vienna, Jewish socialites rarely sought out university education, so Adele became something of a parlor activist and patroness. She advocated for worker's education, social reform,[3] and women's suffrage; supported socialist causes; and, with her husband, collected art, especially by Austrian artists. The salon at Palais Bloch-Bauer drew intellectuals, politicians, collectors, and artists, who came to discuss the affairs of the day and admire the treasures that Ferdinand had acquired: exquisite porcelain from the Imperial Viennese Manufactory, modernist sculpture, Old Master paintings, and early hand-colored engravings of Vienna scenes. The jewels of his collection were the works of Gustav Klimt, Vienna's best-known artist. Ferdinand owned a number of Klimt's sketches and seven of his paintings—two

portraits of Adele, one of another Viennese Jewish woman, and four luminous landscapes.

Adele and Gustav Klimt had met before she was married, and he frequently attended the Bloch-Bauer salon. He had been raised in poverty—his father was a struggling gold engraver—in a suburb of Vienna. At age fourteen, Gustav's drawings so impressed his teachers that they secured a scholarship for him at the new School of Arts and Crafts. There, he and his brother Ernst, equally talented, joined the ranks of students studying to become decorative artists. The Klimt boys were desperately poor, and when a sympathetic teacher recognized their need and talent, he hired them and a fellow student, Franz Matsch, as apprentices. Soon after graduating from the School of Arts and Crafts, the Klimt brothers and Matsch founded their own studio, Künstler Compagnie, and during the next ten years scored a string of commissions painting historical murals, colorful ceilings, and decorative trims on important public buildings along the Ringstrasse. Their rapid ascent from poverty to prosperity was solidified when Ernst Klimt married Helene Flöge, whose sister Emilie owned one of Vienna's most fashionable dress shops and became Gustav's lifelong friend.

A few years later, Gustav's father and his brother Ernst died, leaving the artist as the sole support of his mother, sister, and sister-in-law. No one knows how Gustav felt in his new role as the head of the household—he was not much of a writer—but it seems likely that family responsibility came at personal cost. Gustav never married or traveled much outside Austria, and every evening he returned home to the family table.

The Künstler Compagnie specialized in decorative paintings with a quasi-historical, quasi-literary, or fanciful theme, the kind of paintings that set the mood for the opera crowd. But soon after the death of his father and brother, Klimt's work began to move to a genre, called Symbolism,[4] that was more current and, to many of his patrons, much more confusing. Instead of knights and ladies or portraits of philosophers, he painted towering tangles of naked figures, floating naked women, and viscous voids of stars and fog. He became the leader of the Secessionists, a loose amalgam of artists, architects, potters, goldsmiths, and furniture, book, and fabric designers who were dedicated to moving stodgy Austria into the modern world. His company had accepted a commission to paint three major thematic works for the University of Vienna; he rendered them in his new Symbolist style, causing such a fury of criticism that Klimt kept the works and returned the commission. But while Klimt's Symbolist paintings were too strange for public commissions, they were just the thing for the multidisciplinary Secessionist exhibitions, and soon the cream of Austrian society was flocking to the shows, including Emperor Franz Joseph.

To replace his public work, Klimt moved to private commissions, especially portraits of wealthy women. Women had long been his specialty, and

he lavished attention on the Biblical heroines, Grecian goddesses, medieval virgins, water nymphs, furies, and ancient crones who populated his tableaus and fantasies. Now he turned his attention to living women whose husbands were eager to pay. Klimt was the artist of choice for Jewish millionaires like Ferdinand, who admired his ability to transform portly matrons into buxom beauties and anorexic virgins into fairy princesses.

Gustav Klimt was broad-shouldered and stocky, with a mess of curly hair and hypnotic black eyes. His reputation as a seducer was one of Vienna's most delicious scandals. Visitors to Klimt's studio reported seeing scantily dressed women and whispered that the great artist himself went naked under his signature floor-length artist's smock. Scores of Klimt sketches feature women lolling in bed after sexual intercourse, and the record suggests he indulged. After his death, fourteen alleged lovers and their children made claims on his estate.

Adele's image begins to appear in Klimt's paintings around 1901, recognizable by her regal stance, black hair, striking features, and the jewel-encrusted choker, a gift from Ferdinand, that encircles her neck. She appears as Hygeia, the goddess of medicine, in Klimt's ceiling painting for the University of Vienna, wearing a golden headdress and a golden snake wrapped around her arm. That same year, Klimt used Adele's image in his painting of the Biblical heroine Judith, the beautiful and virtuous widow who first captivated, then decapitated her husband's murderer, the Assyrian commander Holofernes. Adele, as Judith, is shown head to waist, with one breast exposed and her hand entwined in her victim's hair. She is dreamy, post-coital, as if she had just risen from her lover's bed rather than sliced off her enemy's head.

Klimt's third portrayal of Adele is his most famous, *Portrait of Adele Bloch-Bauer 1*, commissioned by her husband. The artist began sketching in 1903, eventually completing one hundred preliminary sketches, and delivered the painting four years later. Generally acknowledged as the pinnacle of Klimt's so-called Gold Period, *Portrait of Adele Bloch-Bauer 1* celebrates his fluency with gold and silver leaf, which came by way of his goldsmith father. Klimt had recently visited Ravenna, Italy, and the painting was likely inspired by the mosaics he saw there, notably the Byzantine mosaic portrait of Empress Theodora in the church of San Vitale.

At the same time Klimt was painting *Portrait of Adele Bloch-Bauer 1*, he also rendered Adele, in *Judith 2*, as an icon of blood lust. Her hair, a black swath across the canvas, frames her perfect profile: the black-lined eyes, the scarlet lips, a seductive beauty spot on her chiseled cheekbone. *Judith 2*'s breasts and torso are naked; her claw-like hands grasp her decapitated victim's hair. *Judith 2* is red-hot. You can almost hear her panting from the excitement of the slaughter.

In all of these paintings, Klimt sexualizes this wealthy Jewish matron, which has led many to wonder whether he and Adele were lovers. While there is no actual proof, it seems possible, given her unconventional views and devotion to the artist and his reputation as a seducer. Except for his lifelong friend, Emilie Flöge, Adele Bloch-Bauer is the only woman who appears multiple times in his work. But, whether or not the affair existed in the real world, it lived in the world of Klimt's imagination. *Judith 1*, *Judith 2*, and *Adele Bloch-Bauer 1* portray a woman whose passion calls out to the painter beyond the picture frame.

Five years after Klimt delivered Adele's first portrait, Ferdinand commissioned a second. *Portrait of Adele Bloch-Bauer 2* is a staid society lady with a body as stiff as a dressmaker's mannequin. The first portrait's glittering backdrop of gold and silver leaf became blocks of chalky blue, green, and mauve, with faint flowers and hints of Asian horsemen. Something is missing in this second painting. The heat is gone.

Gustav Klimt died six years after completing Adele's second portrait. In 1918, he suffered a major stroke that paralyzed his right side and made painting impossible, contracted influenza, and was gone.[5] By that time, Austria had lost World War I, the Hapsburg Empire was ending, and life in Vienna had become precarious. Younger painters with a darker palette and deeper emotions had come on the scene, rendering Klimt's exuberant Symbolism passé. Klimt was never really part of any particular school or movement. He never changed with the times or gained disciples. His style was uniquely his own.

Adele Bloch-Bauer died of encephalitis in 1925 at the age of forty-three, leaving her grieving husband as her sole heir. In her will, written two years earlier, she had requested that Ferdinand leave the two portraits and four landscapes by Klimt to the Austrian National Museum, called the Belvedere because of its location in Vienna's Belvedere Castle. Adele's request made sense,[6] because Ferdinand had contributed funds to the Belvedere for the purchase of a Klimt mural and loaned *Adele Bloch-Bauer 1*, *Adele Bloch-Bauer 2*, and four Klimt landscapes to the museum for about a year while the Palais Bloch-Bauer was being renovated. Her husband ignored Adele's wishes, choosing instead to hang her portraits and the other Klimts in a sort of shrine at Palais Bloch-Bauer dedicated to his beloved dead wife.

Ferdinand's world shattered on March 12, 1938, when the German army entered Austria. Nazis called this the Anschluss, which in German means "connection" or "link-up." No fighting took place; not a shot was fired. Instead, two hundred thousand cheering, flag-waving Viennese greeted the triumphant Hitler as he drove through the city. At the time, 10 percent of Vienna residents were Jews or people with one Jewish parent. Within days, the Nazis instituted anti-Semitic laws, barring Jews from positions of public trust, demanding they wear distinguishing yellow stars on their clothing, and

requiring them to register all of their property and pay exorbitant taxes. Artwork that the Nazis determined to be of national interest was confiscated. By the end of the summer of 1938, the Nazis had opened a concentration camp near Linz, the first of more than sixty throughout Austria. November saw the Kristallnacht pogroms, in which most of Vienna's synagogues and many Jewish-owned businesses were burned and vandalized as the fire fighters and public looked on.

Ferdinand fled Austria on the eve of the Anschluss. Within six weeks, the Nazis filed criminal tax evasion charges against him. By the summer of 1939, hundreds of Jewish-owned factories and thousands of businesses had been closed or confiscated by the government, including the Bloch-Bauer empire, which became the property of a powerful German industrialist.

It is easy to understand why Ferdinand left in March of 1938. The question is why he stayed until then. Why did Ferdinand remain in Vienna until the eve of the German invasion? What compelled him and so many others to stay as Hitler captured power just across the German border and began to fulfill his pledge to destroy the Jewish race? From my comfortable vantage some eighty years later, I can only speculate on why Jews—especially people of means, like Ferdinand—remained in Austria. Anti-Semitism was nothing new in Vienna: perhaps Ferdinand thought the Nazis were little more than a splinter faction that would soon dissipate. Maybe he was counting on his wealth and prominence to protect him. Maybe he could not imagine any circumstance in which his life would no longer be within his control and his fate would lie in others' hands. Whatever the reason, Ferdinand remained in Palais Bloch-Bauer until the very last possible moment—and then abandoned everything.

He wasn't alone in his decision to stay. Thirty percent of Vienna's Jews remained in place. They were soon deported to concentration camps in Austria or to Dachau or Buchenwald, or sent to labor camps in Russia, or murdered. By the end of World War II, only five thousand Jews remained in all of Austria.

When Ferdinand Bloch-Bauer fled the Nazis, all his treasure remained behind: the priceless Austrian porcelain collection, the Old Master paintings and prints, and all of the paintings by Klimt, including *Portrait of Adele Bloch-Bauer 1* and *2*. He escaped to his castle in Czechoslovakia, but was soon forced to flee in advance of Hitler's invasion of that country. He eventually settled in Switzerland. Nazi policy was to Aryanize the property of Jews, first by paying them a small fraction of its value, later by taking it outright. Ferdinand's homes became government property: the offices of the German Railroad moved into Palais Bloch-Bauer in central Vienna and a succession of Nazi officers occupied the castle. Ferdinand died in Zurich in November of 1945 at age eighty-one, bitter and broken. His will left his Bloch-Bauer nephews and nieces with a problematic legacy: a vast conglomerate, a castle,

a palace, and prized porcelains, books, and paintings including *Portrait of Adele Bloch-Bauer 1*, all in Nazi hands. Ferdinand's Jewish friends and neighbors suffered similar losses: their businesses stolen and their treasures looted, forced to pay exorbitant sums for exit visas or sent to death camps. In her meticulously researched book, *Was Einmal War*, art historian Sophie Lillie tracks the sad path of the Bloch-Bauer's and 147 other exemplary art collections owned by the Jews of Vienna.

The fate of Ferdinand's heirs speaks to those turbulent times. His three nephews, Karl, Robert, and Leopold, fled to Canada in 1938, where they changed their names. Leopold and his brother-in-law started a furniture and paneling veneer company that quickly grew into Canada's leading forest-product company. Robert, who changed his last name to Bentley, joined the British army. Their sister Louise fled to Zagreb with her husband, who was later murdered by Communist partisans. She eventually remarried and joined her family in Canada. The experience of the final heir, Marie Bloch-Bauer Altman, was the most harrowing. Her husband was arrested in Austria soon after the Nazis arrived in 1938 and was held hostage at the Dachau concentration camp until the family agreed to transfer the Bloch-Bauer holdings to the Germans. Marie and her husband then fled for their lives, leaving all their possessions behind, eventually settling in California in 1942. She became a U.S. citizen three years later.

Once in control of Austria, the Nazis determined the fate of the Bloch-Bauer treasures. Three nineteenth-century Austrian paintings became trophies in Hitler's private collection, and others were placed in storage for the grand Führermuseum in Linz that Hitler envisioned as a showcase for his artistic vision and might. Other items from the Bloch-Bauer collection were claimed by high-ranking officers or given to museums. Some of Ferdinand's valuable Austrian porcelain was sent to a number of institutions and the rest was sold. Hitler found Klimt's work degenerate, so *Portrait of Adele Bloch-Bauer 1* and *2* and the other Klimt paintings were assigned to Erich Fuhrer, a prominent Nazi attorney and rabid anti-Semite with an apt name and an especially low moral threshold. Fuhrer sold *Adele 1* and four other Klimt paintings to the Belvedere. The fact that the German government, not Fuhrer, owned the paintings was evidently not an issue to him or the museum. *Adele 1* next appeared in a retrospective exhibition of Klimt's work in 1943, under the name "portrait of a lady against gold background" to hide Adele's Jewish origins.

As the war in Europe concluded, the Allies realized that the Nazis had plundered hundreds of thousands of paintings, sculpture, rare books, and other works of art from countries they had occupied. No one knows how much was looted. Estimates run as high as 650,000 artworks came from Jews, worth billions of dollars. In the chaos, the safety of these works became a matter of international concern. With the blessing of General Eisen-

hower and President Roosevelt, the U.S. military assembled a corps of some 350 art historians, professors, and museum curators, called the Monument Men, and charged them with securing and returning the treasures to their original owners. In Austria alone, the Monument Men uncovered more than 6,500 art works, including masterpieces by Michelangelo, Vermeer, and Jan van Eyck, slated for the Führermuseum. The Nazis had stored them in a complex of salt mines in Altaussee, Austria, and the miners had saved the paintings by ignoring the German military's orders to bomb the mine.

Erich Fuhrer fled Vienna when Soviet and American forces entered Austria in the spring of 1945, abandoning the fourteen paintings owned by Ferdinand Bloch-Bauer that Fuhrer had hung in his apartment.[7] Fuhrer was captured and put on trial. He testified that he was holding the paintings for Bloch-Bauer, but the courts didn't believe him, so he was sentenced to three years in prison.

Immediately after the war, Ferdinand Bloch-Bauer's nephew, Robert Bentley, returned to Austria as a British officer, hired an attorney, and began what was to become a thirty-year battle to reclaim his family's possessions. He could not secure the family's companies or castle in Czechoslovakia because both were located in the Russian zone, outside of Austrian control. He could not reclaim the Palais Bloch-Bauer because its occupant, the Austrian railroad, refused to give it up. Bentley's attempt to reclaim *Adele Bloch-Bauer 1* and the rest of Ferdinand's beloved treasures were also thwarted by Austrian red tape. By this time, Austria had passed a law that declared all transactions motivated by Nazi ideology to be null and void, but the law failed to compel the government to take action. Another law prohibited export of any artwork deemed important to the Austrian cultural heritage, as defined by the Federal Monuments Agency. Works by Klimt were considered vital to Austrian cultural heritage, so the Bloch-Bauer heirs could not obtain exit visas for *Adele Bloch-Bauer 1* or any of the other Klimt paintings. When Bentley's attorney approached the director of the Belvedere, he was informed that the museum owned the Klimts, since Adele, in her will, had bequeathed them to the Belvedere.

When Bentley and his siblings realized the impossibility of obtaining export visas for their precious Klimts, they took the route employed by so many of their Jewish countrymen whose property had fallen into Nazi hands. They agreed to accept their losses and use the paintings as leverage to extract other family property. In 1948, the family reluctantly acceded to Austria's claim so *Adele Bloch-Bauer 1* and the other Klimts remained the property of the Austrian state. Bentley then quickly petitioned the Monuments Office for export licenses for all of the rest of the Bloch-Bauer property that remained in Austria. The petition was summarily denied. The family was left with nothing.

For years, Austria stonewalled Jewish families' attempts to reclaim their possessions. Although thousands of artworks found by U.S. forces were transferred to the Austrian government in 1952, it made no effort to find the owners. In 1969, public pressure finally forced the Austrian government to publish a list of more than 8,400 objects owned by the Federal Office of Monuments. Fewer than 550 were ever claimed and returned. The rest were stored in a monastery in Mauerbach, Austria, and largely forgotten.

As this story unfolded in Austria, thousands of paintings, sculptures, antiquities, and other treasures with no provenance records began appearing in auction houses and dealers' showrooms in Europe and around the world. Art museum and private collectors were eager to purchase them at bargain prices. Although these transactions took place decades ago, directors of art museums still do not want to talk on the record about this. But as one of them recently told me off the record, "Dealers would say the paintings had been owned by an important British family which had discovered them in the basement of their manor home, but there seemed to be too many making that claim."

In 1984, *Art News*, a leading American art magazine, published a story titled "A Legacy of Shame," which documented, for the first time, Austria's culpability in refusing the claims of Jewish families to their stolen art treasures. Within a few years, an embarrassed Austrian government had returned another three hundred objects to heirs, auctioned off those artworks remaining, and assigned the proceeds of the sale to the Jewish community of Austria and other Holocaust victims.

It was another fourteen years before Austria made its records available. In 1998, in response to substantial public pressure, the government passed the Art Restitution Act, which opened the government's archives for the first time. Immediately, Hubertus Czernin, an Austrian investigative newspaper reporter, applied for access to the Belvedere's archives. There he discovered irrefutable proof of the director's collusion with the Nazis. Moreover, *Portrait of Adele Bloch-Bauer 1* had not been donated in 1936, as claimed in the Belvedere's literature. Instead, the museum had purchased it and the other Klimts owned by Ferdinand Bloch-Bauer from Erich Fuhrer during the war. Moreover, the records revealed that Adele had never bequeathed the paintings to the Belvedere, as the museum had always alleged. In fact, she had never even owned them. Her 1923 will, the one cited by the museum as proof of its ownership rights, was not binding because her husband, Ferdinand, legally owned the paintings. The Belvedere's director had known this all along and had covered it up.

By the time Hubertus Czernin's articles appeared in the press, only one of the Bloch-Bauer heirs remained: Maria Altmann, age eighty-three. She had been nine years old when her aunt died in 1925 and had always believed that her aunt had bequeathed *Portrait of Adele Bloch-Bauer 1* and the other Klimts to the Belvedere. When Altmann learned the truth, she committed

herself to reclaiming the portrait and the family's other property, and soon retained the attorney Randol Schoenberg, whose Austrian grandparents had been family friends.

"I was a young associate at a large law firm," Schoenberg recently told me, "and one of the name partners was a German-Jewish immigrant, so he was sympathetic to the cause and gave me a bit of coaching. But no one really knew what to do with a case like Marie Altmann's or how to do it. There were no road maps for this case, so I had to rely on gut feeling."

From a legal standpoint, the Bloch-Bauer case was a long shot. No heir of a Holocaust victim had ever managed to repatriate any possessions from any European museum. Moreover, in civil matters, international law provided few grounds on which citizens of one country could bring suit against another country. The standards set by the 1976 Foreign Sovereign Immunities Act overwhelmingly supported government immunity. The case also carried great financial risk for Altmann and her attorney. According to Austrian law, plaintiffs must deposit with the court the estimated value of the recovery sought, and the court establishes the sum. If Altmann lost the case, under Austrian law she would be responsible for the full payment of her opponent's legal costs—and Randol Schoenberg, who was taking the case on contingency, would lose years of legal fees.

Despite these obstacles, Marie Altmann and her attorney were determined to stop Austria from benefitting from the possessions of Austrian Jews whose lives had been destroyed. Even if Altman lost the case, the world would know about the family's situation. That was of critical importance to her.

Schoenberg soon formulated his legal strategy. First, he needed to locate a relevant case, a precedent, an attorney's strongest weapon. Second, he needed to carve a loophole in the international law that would permit Maria Altman to sue the Austrian government. Finally, he needed to circumvent the requirement for a cash advance, set by the court at $1.8 million, a sum well in excess of his client's financial capacity.

These were daunting challenges, but Schoenberg was resourceful. He was deeply knowledgeable about the Holocaust and passionate about restitution. He knew, from working for celebrity clients like Michael Jackson, that publicity could influence the outcome of a case. "The Bloch-Bauer case made for a good story," Schoenberg told me, "so I made sure the press would tell it. Remember, the suit was against the government, not individuals, not corporations. What do politicians care about? It's votes. The more negative publicity we could stir up, the better our chances."

Schoenberg's final asset was his name, a name that carried a lot of clout in Austria: "My grandfather, the composer Arthur Schoenberg, was arguably the most well-known Austrian Jewish refugee. Because of who my grandfather was, I receive a level of recognition in Austria that I don't get here. When I go to Vienna, they have to take me seriously."

In other words, when the grandson of Austria's most famous Jewish refugee brings suit to claim one of Austria's most beloved paintings, that's news.

Schoenberg brought the case before the Austrian Advisory Board, which reviewed the claims of Holocaust victims. When the board ruled against Altmann, he filed a case with the U.S. District Court for the Central District of California seeking legal standing to sue the Austrian government for *Portrait of Adele Bloch-Bauer 1* and five other paintings by Gustav Klimt.

By this time, he had found a small exception to the 1976 Foreign Sovereign Immunities Act. A foreign government—or an agency of a foreign government—cannot claim immunity if two conditions apply. First, the issue must involve property taken in violation of international law. Second, the government or its agency must be engaged in a commercial activity in the United States. Moreover, Schoenberg discovered a Ninth Circuit case that met both conditions. A Jewish family had been able to retrieve a hotel taken from them by the government of Argentina because the hotel had advertised in the United States. That was the precedent he needed.

The Austrian National Museum, also known as the Belvedere, was an agency of the Austrian government. The letter from Erich Fuhrer in the Belvedere's own archives proved that the paintings had been stolen, satisfying one condition for the exception to the Foreign Sovereign Immunities Act. The second condition was that the Belvedere had engaged in commercial activity in the United States, and it had: it had sold the rights to *Portrait of Adele Bloch-Bauer 1* for t-shirts, mugs, key chains, umbrellas, playing cards, and posters, like the one that hung in my freshman dorm room. The Belvedere's active merchandising of Adele's image—the Adele kitsch—helped saved the day.

Schoenberg appeared before the U.S. Supreme Court in October of 2003 representing Marie Altmann in her suit against the Austrian government. Eight months later, the Justices ruled, six to three, in favor of Altman in the Court's first ruling about any Nazi-era claims.

Although Altmann won the case, she did not automatically win back her possessions, for the ruling merely allowed her to sue the Austrian government in Austrian federal court. She was almost ninety years old; she had been fighting for more than seven years. In spring of 2005, she and the Austrian government agreed to go to binding arbitration before a panel of three Austrian arbitrators chosen by both parties—an option that her attorney had offered long before. In January, 2006, the three-judge arbitration panel unanimously ruled in favor[8] of returning *Portrait of Adele Bloch-Bauer 1* and four other Klimts to the Bloch-Bauer heirs. That year, the Bloch-Bauer heirs also recovered $21.9 million in compensation for their company and their Vienna palace.

After almost sixty years as one of Austria's most beloved paintings, *Portrait of Adele Bloch-Bauer 1* was returning to its owner. Vienna gave her a royal send-off, posting oversized images of Adele with the words "Ciao Adele" on bus shelters throughout the city. Austria was not left bereft of Klimt paintings, however. One of Gustav Klimt's sons, Gustav Ucicky, had acquired numerous Klimt works from the Nazi-looted collections of Jewish families and had bequeathed many to the Belvedere upon his death in 1961.

Ronald S. Lauder had been watching the story unfold. An heir to the vast Estee Lauder cosmetic fortune and one of the world's wealthiest men, Lauder had long been active in Jewish causes, philanthropy, and art, and had served briefly as U.S. ambassador to Austria. Lauder had begun collecting twentieth century German and Austrian art in his teenage years, and in 2001 he and Serge Sabarsky, a specialist in the genre, opened the Neue Galerie to display the collection.

Lauder had met Marie Altmann, and she had visited the Neue Gallery when it opened. According to a story in *The New York Times*, Altmann said she was especially receptive to Lauder because he constantly kept in touch with her during the long years the family spent trying to reclaim its artwork. "He was incredibly generous and constantly supportive," she said.

In April 2005, *Portrait of Adele Bloch-Bauer 1* and the other Klimts were displayed in public again, first at the Los Angeles County Museum of Art and later at Lauder's Neue Galerie. In June 2006, Lauder purchased the painting through Christy's for $135 million, the highest sum ever paid for a painting at that time.

"This is our *Mona Lisa*,"[9] the proud Lauder announced. "This is the great picture of our time . . . there is no better painting."

Gustav Klimt as significant as Leonardo Di Vinci? *Adele Bloch-Bauer 1* as important as the iconic *Mona Lisa*? I don't think so. If *Adele* is a Mona Lisa, she's a Mona Lisa in bondage.

Regardless of personal views, though, it is clear that the worth of the painting well exceeds its dollar value. *Adele* gave the families of Holocaust victims hope that they could claim their possessions from recalcitrant governments. Its importance as a symbol, an artwork, and a cultural treasure put the world on notice. But all of this was a byproduct, not Schoenberg's primary intent. "We realized the case would be emblematic, but I didn't try this case for everyone," he said. "Each painting has its own story; each case has to be tried one at a time. Some argued at the time that there would be a flood of cases of heirs trying to claim their artworks, but these cases are very rare."

I wondered why the Bloch-Bauer heirs would spend years reclaiming a painting only to promptly sell it. Schoenberg had a ready answer.

"Well, think about it. There were a number of heirs, and all of them had agreed what to do. It scared them to think about having a fifty-million-dollar

or one-hundred-million-dollar painting hanging on the wall: the insurance alone would be astronomical.

People often ask, why didn't they donate the paintings?" he continued. "It seems strange to me that anyone would even raise this question. This was their inheritance, their possession. Why should they give away something so valuable? They did want to make sure that the gold painting was sold to a public museum, which they accomplished. The others are now in private collections, which makes sense, since they always were in private hands."

"Why don't more families try to get their possessions back?" I asked.

"Most of the big items stolen from Jews were dealt with in the immediate post-war period," he answered. "Much of the rest has not appreciated in value. And these artworks are hard to connect to their owners because there is no record of ownership, as there was in the case of the Klimt paintings. There are only a very small number of very valuable, important paintings."

"How about paintings in museums?" I asked.

"Museum-quality paintings?" Schoenberg responded. "Now we're talking about only the upper one percent of all of the art. You must remember that museums are institutions, and, as you know, there are hundreds of paintings in storage for every one on display. If a museum loses a painting here or there, who cares? Of course," he added, "that's not how museums see it."

Litigation to reclaim a piece of art is not for those with a faint heart or limited income. Bringing a court case is expensive, time-consuming, and frustrating. Heirs do it, though, for emotional reasons: because they promised their family members, because they cannot stand to see anyone else own it or to let the Nazis win, or because objects connect people with their past in a way nothing else can. A painting holds memories: you remember the wall where it hung in your parents' home, or the art exhibition where you first saw it, or the vacation when you purchased it. The Nazis stole more than artworks from Jewish families; they stole the sweet memories these works stirred.

Today, seven decades after the end of World War II, one would think that the issues surrounding Holocaust art would be settled; if anything, they have become more heated. Wesley Fisher, director of research for the Conference on Jewish Material Claims Against Germany, deals with these on a daily basis.

"Guidelines from the American Alliance of Museums apply to work that changed hands in Europe between 1933 and 1945," he told me. "These are the works posted on the websites of art museums. But how do you prove whether a painting or other piece of art was looted from Jewish families and belongs to their heirs?"

Recently, experts have begun to link works of art with families by studying the original records of Nazi looting, and the Nazis kept very detailed records. But proving that the artwork in the records belongs to the heirs of the

murdered Jews is a whole other thing, because many families did not have records on their artwork or, if they did, the records were lost in the war.

I thought about my family's modest collection of paintings, none of them documented. If we had lived in Vienna in 1938, my family would have been forced to abandon it all, and if we had survived the war, there would have been no way to prove it was ours.

Fisher believes that the Klimts were very important. They set the precedent of bringing a suit against a foreign government under the exception to the Foreign Immunities Act that has been used by Jewish heirs to gain restitution of their family's artworks. Today, European museums have changed their policies towards restitution, and Austria is leading the way. Austrian museums conduct provenance research and have all sorts of mechanisms to return Holocaust art to the families that owned it.

Here in America, we are lagging behind. It is a sad irony that the association representing the largest number of U.S. museums is working to close the loophole in the Foreign Immunities Act in order to discourage suits. Often, when a museum is faced with a claim from an heir, it brings a lawsuit to "quiet the table" by forcing the heir into a costly court battle. Wesley Fisher thinks the only way to change this behavior is by training the next generation of museum curators to believe that there are more important things than holding onto a collection at all costs.

Maria Altmann died at the age of 94 in February 2011. The day after she died, a brief interview of her, talking about *Portrait of Adele Bloch-Bauer 1*, appeared on YouTube.[10]

"The picture does itself have its own story—of where it lived in luxury in a private home, and then how it was robbed from that house, and then it was hidden, and then it lived in the museum. And now it travels to another country to be seen by other people, more people, and that's very beautiful for me."

Gustav Klimt is long gone, though not forgotten. In 2013, Vienna celebrated his 150th birthday with an original musical production and an exhibit at the Belvedere, which owns a number of paintings by Gustav Klimt: one from the collection of Ferdinand Bloch-Bauer, others from collections of Jewish families who died during the Holocaust.

Today, E. Randol Schoenberg is of counsel to the law firm he founded, Burris, Schoenberg & Walden, LLP, where he made a career specializing in cases involving plundered art and the recovery of property stolen by the Nazi authorities. He received enough in the settlement of the Bloch-Bauer claim to help fund a Holocaust museum in Los Angeles.

*Portrait of Adele Bloch-Bauer 1* is back where she started, supported by a wealthy Jewish industrialist, ensconced in a lavish mansion, and surrounded by the style she loved and the women she knew. She is in good company,

since the Neue Galerie now owns more Klimt paintings and drawings than any other museum in the nation.

The Neue also controls the rights to the painting and continues Austria's tradition of licensing Adele kitsch. So, if you, like so many others, fall in love with *Portrait of Adele Bloch-Bauer 1*, you can visit the painting, read a book or two, or buy any of the t-shirts, mugs, key chains, and other items that bear her image.

## NOTES

1. Association of Art Museum Directors, "Art Museums and the Identification and Restitution of Works Stolen By the Nazis," (May 2007).

2. Rebecca Weiner, "The Virtual Jewish History Tour," *Jewish Virtual Library*.

3. Sophie Lillie and Georg Gaugusch, *Portrait of Adele Bloch-Bauer* (New York: Neue Galerie New York, 2007), 38.

4. Nina Kränsel, *Gustav Klimt* (Munich: Prestel, 2007), 31.

5. Ibid., 103.

6. Lillie and Gaugusch, *Portrait*, 62–63.

7. Ibid., 76.

8. "E. Randol Schoenberg," http://www.bslaw.net/schoenberg.html.

9. Carol Vogel, "Lauder Pays $135 Million, a Record, for a Klimt Portrait," *The New York Times*, June 19, 2006.

10. "Ms. Maria Altmann Talking About The Gold Portrait by Gustav Klimt," February 8, 2011, https://www.youtube.com/watch?v=DsSnR0IygJ8.

*Chapter Two*

# The Case of the Missing Masterpiece

Donna Carcaci Rhodes never expected to receive *this* phone call, especially during her first weeks in the job. "My name is David Bloom," the voice said, "and I work in the manuscript department of Freeman's auction house in Philadelphia. I have in my possession the original typescript for *The Good Earth*. Would you be interested in buying it for the Pearl Buck House?"

"My first thought was that it was my brother playing a joke," Donna told me. "*The Good Earth* had gone missing forty years before." To Rhodes, curator of the Pearl Buck House, the whereabouts of this manuscript was one of the greatest mysteries of the twentieth century.

While I couldn't agree that it was one of the *greatest* mysteries of the twentieth century, I was definitely intrigued by the mysterious disappearance of the original typescript of *The Good Earth* when I read about it in a June 2007 story in the *Philadelphia Inquirer*. I knew the book from my high school reading list and from seeing it on the family bookshelf along with other books by Pearl Buck. She was my mother's favorite author; her strong voice and well-wrought characters spoke to women like my mother, educated women living in solid homes in post–World War II suburbs. Pearl Buck, I knew, was one of the most celebrated authors of the twentieth century, the first American woman to receive both the Pulitzer Prize and the Nobel Prize.

Reading the *Philadelphia Inquirer* story more closely, I realized that no one had been prosecuted or convicted for the removal of this iconic and irreplaceable document, valued by the FBI at one hundred thousand dollars.

*Who took it?* I wondered. *Why weren't they prosecuted? How did this valuable document get to Freeman's auction house, a couple of blocks from my home in Philadelphia?*

These questions started me on the hunt for Pearl Buck and the mysterious person who absconded with her typescript. The trail led from her birth to her

death, from America to China and back multiple times, from poverty to worldwide acclaim, though two marriages, eight children, many philanthropic enterprises, and piles of publications. I became immersed in her life, seduced by her powerful presence, and bowled over by the audacity of this rabble-rouser in proper frocks and pearls. Along the way, I searched for clues to her missing typescript.

I started by purchasing a paperback copy of *The Good Earth*, opening its pages with some trepidation, since books admired in youth can lose their transformational power. Not *The Good Earth*. This reading was just as enchanting as the first, catching me up from the first page, sweeping me into the lives of farmer Wang Lung, his stalwart, big-footed wife, O-lan, his cranky old father, elegant concubine, children, wastrel uncle, and the many others who populate this captivating novel. The book has a strong narrative line, a cast of memorable characters, and a Biblical cadence that nudges these ordinary lives nearer the mythic, as if Northern China were populated by saints and prophets instead of farmers and fancy girls. Pearl Buck always insisted she only wrote about what she saw, the authentic lives of those 99 percent of the Chinese. But there is something about Wang Lung's pull-yourself-up-by-the-bootstraps sensibility that seems more American entrepreneur than Chinese peasant farmer.

"The key to Pearl Buck was her unique existence in two separate cultures and her difficulties in coping with either of them," Peter Conn told me. "She was not *in* two worlds; she was *between* two worlds, never comfortable in either of them."

Conn and I were meeting in his office at the University of Pennsylvania, where he is an emeritus professor of English. He became interested in Pearl Buck when he and his wife adopted an Amerasian child from Welcome House, an adoption service that Pearl Buck established. Conn's book, *Pearl Buck: A Literary Biography*, is the best of the many biographies of her.

"She lived a spectacular life," Conn said. "She invested millions of dollars, hours of time to the causes she cared about most. She was a speaker on behalf of women, minorities, children, and the disabled. Tens of millions of copies of her books were sold. Her perspective on China was unique; it cannot and will not be duplicated."

Pearl Buck did live a spectacular life—in fact, she lived two spectacular lives, each with more than enough events to fill any single life. Her first forty years were spent in China as a missionary's daughter, an academic's wife, and as a missionary and teacher herself. The second forty were spent in the United States as an exceptionally prolific writer, outspoken social critic, and generous champion of worthy causes. The pivotal point between the two lives occurred in March of 1931, when *The Good Earth* was published.

She was born Pearl Comfort Sydenstricker in 1892, when her parents were on home leave in the United States. Her father, Absalom, and mother,

Caroline, called Carie, met in 1880 and married shortly thereafter; he because missionaries need wives and she because she wanted to experience the world beyond her small West Virginia town. The couple had seven children, only three of whom survived to adulthood: Pearl, her older brother Edgar, and her younger sister Grace.

Absalom was a fire-and-brimstones minister who was called to China, he said, to convert the millions of heathens to the ways of Christ. He spent fifty-one years following his calling whenever and wherever it took him, sometime over the objection of the Presbyterian hierarchy, often at the expense of his family, and always at the cost of their creature comforts. He poured so much of his meager salary into his translation of the Bible into vernacular Chinese that the family lived on the edge of poverty.

By the time Absalom and Carie arrived in China, it had been conquered, carved, and colonized by the British, Portuguese, Germans, and Americans. The Sydenstrikers were part of the "well over a hundred different types of the Protestant Christian religion alone"[1] that claimed their own spheres of influence in what Pearl Buck later called "spiritual imperialism." The sorry truth was that very few Chinese conversions resulted from so much Western proselytizing.

The Sydenstrikers never fit into the lifestyle of the Western compound whose residents sought to recreate their worlds back home rather than consort with the Chinese. Not Absalom and Carie, who relished their Chinese neighbors. Pearl Buck's first playmates were Chinese, and from early childhood she was fluent in English and Chinese. She describes living in a "double world, the small white, clean Presbyterian American world of my parents and the big living merry not-too-clean Chinese world, and there was no communications between them. When I was in the Chinese world I was Chinese, I spoke Chinese and behaved as a Chinese and ate as the Chinese did, and I shared their thoughts and feelings. When I was in the American world, I shut the door between."[2] Her childhood was filled with stories: folk tales of her Chinese nanny and playmates, folk theater performed on city streets, episodic Chinese vernacular novels and the cream of English literature that she found in her family's library.[3] By age ten, Pearl had decided to become a novelist.[4] There's a family photograph of little Pearl Sydenstriker from around that time with Alice-in-Wonderland hair and a stiff white frock.

In Pearl Buck's China, being born female either killed you—literally—or made you strong. The birth of a girl child was cause for mourning, and many who lived were crippled for life, their feet bound and broken from age three so that bone and flesh could be molded into the tiny "golden lilies" that future husbands expected. Later, the author filled her books with the Chinese women she knew: noble ladies and farm wives; courtesans and prostitutes; newborn girls strangled by their mothers; traditional women struggling to keep up with their educated, modern husbands; young wives driven to sui-

cide by their mothers-in-law. These vivid portraits, and Pearl's strong voice, are what drew so many women to her fiction.

Pearl Buck spent her Chinese years channeling through cycles of prosperity, poverty, floods, and famines. Her stories from these wild times stretch the bounds of credulity: her mother facing down a band of bandits by politely inviting them in for tea; her father bound to a stake and forced to watch the torture and murder of a Chinese convert; lepers, their flesh eaten away from their bones; and dead children abandoned on hillsides with wild dogs gnawing their bodies. The family fled China not once but many times, each time returning to rebuild their lives under increasingly perilous circumstances.

In 1910, when Pearl was eighteen years old, the family traveled to America to enroll her in Randolph Macon Women's College, the first women's college in the South. It was here that she experienced her first successes: election as senior class president and an impressive academic record that led to job offers. Her plan was to remain in the United States after graduation, but her beloved mother was gravely ill, so she returned to China and assumed Carie's missionary duties: managing the household, teaching Bible classes, leading a teacher training class, and operating a clinic for Chinese women. You might imagine that a young woman who had tasted sweet freedom would resent returning to the tradition-bound world of colonial China, but that's not how Pearl Buck remembered it. "It was a wonderful time to be in China," she remembered, "and I was at the right age for it."[5]

Soon after her return, she fell for John Lossing Buck, a tall, strong, and handsome Cornell-trained agriculturalist whose mission and passion was to revolutionize farming in China. Seduced by his confidence, pragmatism, and lack of religiosity, the enamored young woman ignored her parents' warning that Lossing might not be a sympathetic partner. There's a photograph from 1917 of the wedding party in Carie's lovely garden, the couple dressed in white, surrounded by family, colleagues, and three little girls carrying flower baskets.

With all of the exuberance of secular missionaries, the newlyweds set off to transform Chinese agriculture. The first stop was Nanzuxhou, a remote village on the arid plains of Northern China where farmers relied on cultivation practices dating back millennia. The area was regularly subjected to droughts, floods, high winds, locusts, and famine. Pearl Buck happily came along as Lossing traveled the countryside, translating his questions to the farmers and their answers back to him, and later transcribing her husband's meticulous observations. She also roamed on her own, befriending Chinese women, learning their hardships and joys, absorbing their lives; for many she was the first white woman they had ever seen. By the time the couple left Nanzuxhou two and a half years later, Lossing had acquired the data for his two landmark studies of Chinese cultivation practices, and Pearl Buck had

absorbed the sights, smells, tastes, and sounds that would suffuse her most famous book, *The Good Earth.*

Pearl was elated when she discovered that she was pregnant, around the time Lossing accepted a position at the newly established college of Agriculture and Forestry at the University of Nanjing. The couple settled into faculty housing, a lively social life, and teaching positions. Their daughter, Carol Grace Buck, was born in March 1920. A few weeks later, Pearl's doctor found a tumor in her womb, so the young family traveled to the United States for Pearl's medical care. As the surgeon cut out the tumor, he also removed her uterus, a loss Pearl mourned for the rest of her life. When the Buck family returned to China, Pearl Buck found her mother very ill, and when Carie died in October 1921, her daughter poured her grief into a memoir of her mother, which she put away for fifteen years before it was published as *The Exile.*

Carie's death freed something in her daughter: "I remember quite clearly one August afternoon," Pearl wrote, "that I said suddenly, 'this very day I am going to begin to write.'"[6] She began with an essay about the forces of modernization sweeping across the world, titled "In China Too," which was published in *The Atlantic* in January 1924. That led to a commission by the editor of *Forum* and that led to the essay "Beauty in China."

A couple of years later, the Bucks traveled to the United States to attend Cornell University. By this time, they knew that their daughter Carol had failed to develop properly, though none of the doctors could tell them why. It was later learned that she suffered from phenylketonuria, an inherited metabolic disease, which, if not treated, could lead to profound and permanent mental retardation. As if to compensate for the loss of their dreams for Carol, the couple adopted a pale, abandoned infant whom they named Janice Buck. Soon after that, something happened that permanently broke the bond between husband and wife. Their marriage began to unravel; Pearl decided to take full responsibility for her disabled child.

Early in the marriage, Pearl Buck had devoted herself to helping Lossing with his scholarship. She evidenced little interest in pursuing a writing career. That now changed permanently. Pearl Buck needed money for a private facility in the United States, or Carol would spend the rest of her life in a public institution. Writing was the only way she knew to earn money, so Pearl began to write. Out of despair she became dogged, unstoppable, and mercenary. For the rest of her life, Pearl Buck used her writing and the sums it generated to do exactly what she wanted.

When the family returned to China in 1925, Pearl Buck remained with her daughter Janice in Shanghai, because the family home in Nanjing was under siege. She then set about securing the accoutrements of a writer: a preowned portable Royal typewriter and a literary agent, David Lloyd of the Paget Agency, whose advertisement she found in a directory in a Shanghai book-

store.[7] Pearl Buck began to mail him short stories, essays, and the manuscript for a book that was eventually titled *East Wind: West Wind*. Lloyd secured commissions for the articles and shopped the book to publishers. After more than two dozen rejections, he secured a contract from a small, new publishing house: John Day and Company, owned by Richard Walsh.

Four years later, the Bucks were back in the United States, and Pearl spent her time finding a permanent home for Carol, eventually selecting Vineland Training School in New Jersey for its humane treatment of its mentally disabled residents. The fee was one thousand dollars a year, well beyond the resources of an academic family. She borrowed two thousand dollars from a member of the Mission Board in New York to cover Carol's first two years, with no prospects of repayment.

After a wrenching departure from Carol, the family returned to Nanjing and Pearl Buck began to write. Every morning after Janice left for nursery school, Pearl Buck climbed the stairs to her office, pulled her Chinese rosewood chair up to her Chinese rosewood desk, and began typing on her portable Royal typewriter. Three months later, the typescript for *The Good Earth* was done.

"It was all on the tips of my fingers," she recalled, "what I had to say, and it went very fast . . . in spite of the fact that I was in an environment that did not and could not take novel-writing or novels very seriously and even I myself came to consider it a secret indulgence."[8]

She typed two copies, only one of which has ever been located. She carefully packed up its pages and mailed it to her literary agent, who took it to Richard Walsh, the publisher, at John Day and Company. She named the book *Wang Lung* after its main character, and the only major change Walsh requested was a change of title, writing that it needed "a good deal of sweep and romance, something like the Good Earth." The name stuck.

From her perch in Nanjing, some ten thousand miles away from her publisher, Pearl Buck waited for news. In early 1931, an ecstatic and somewhat perplexing letter arrived: *The Good Earth* had become a Book-of-the-Month-Club selection. Living so far away, she had never heard of the wildly popular Book-of-the-Month Club or its power to transform an obscure author into an overnight sensation. More good news followed: all the leading newspapers in the United States had alerted their readers to publication of *The Good Earth*, and it had garnered glowing reviews. Sales were so strong that John Day Publishing Company could not keep up with demand.

"It is a curious feeling writing to you at so great a distance about these matters," wrote Richard Walsh in one of his many letters to Pearl. "We sit here in a genuine whirl of excitement about the book which you have written and you the author are completely detached from it."[9] The author's own excitement was tempered by her naiveté and fear that someone would learn

about her mentally disabled daughter. She constantly worried about keeping Carol a secret and having enough money to support her.

In September of 1931, Pearl Buck received a cable announcing that *The Good Earth* had won the Pulitzer Prize. Film rights had been sold to Metro-Goldwyn-Meyer for fifty thousand dollars, the highest sum ever. Richard Walsh was arranging a major launch, so the Bucks left for North America.

I picture this overweight academic wife in a dated dress, arriving from far-off China and finding herself flooded with interview requests. I see fear in her eyes as she entered the Jade Room of New York City's famed Waldorf Astoria Hotel, where two hundred handpicked guests—the fashionable intelligentsia—awaited. What did it feel like to be showered with praise and riches—with no notion of how to handle them properly? What did a missionary's daughter and a missionary's wife know about motion picture deals, reporters, or investments? First from necessity and soon by preference, Pearl Buck came to rely on her publisher, Richard Walsh. She even placed the original typescript of *The Good Earth* in his hands. His letter of acceptance said, in part, "But I do wish to say to you that I do not believe that valuable manuscripts should remain in the possession of any individual, or that they should be sold for profit at any time. Therefore, I shall want to provide by some sort of documents, including my will, that the collection should at some proper time in the future be turned over to a library."[10]

*The Good Earth* was an instant hit, read by everyone from scholar and statesman to seamstress to society girl. Within the first eighteen months of publication, its author earned well over $100,000—$1.4 million in today's dollars. It was the bestselling book of both 1931 and 1932, and the second-most popular book of the twentieth century, after *Gone with the Wind*.

What accounts for this blockbuster popularity? There's never a single reason. One has to be the narrative: Pearl Buck was a masterful storyteller who understood pace, characterization, and drama. Another is the Biblical cadence of her prose, transforming ordinary people into universal symbols. She was also blessed with good timing: the book came out in the 1930s, when powerful storms drove American farmers from their lands, much like their Chinese counterparts. It is no coincidence that *The Good Earth* was published around the same time as *The Grapes of Wrath* and *Gone with the Wind*, all sweeping novels about man and the land.

Beyond all this, Richard Walsh's masterful marketing acumen did much to drive sales. He made sure that buzz was out prior to publication. He negotiated *The Good Earth*'s selection by the Book-of-the-Month Club and its purchase by Warner Brothers Films. He also secured a publishing deal with the new Pocket Books, a British company that produced paperbacks at an especially affordable price. *The Good Earth* was Pocket Book's first buy in the United States, and its low price point opened up sales to thousands of readers.

*The Good Earth* is an important book as well as a wonderful read. It is simply unique and will remain so. This was the first novel that revealed the lives of ordinary Chinese. Real people fill the story, not the caricatures or stereotypes that filled Western popular culture of the time. No one—no Chinese writer, no Western writer—had ever done this before. Today, when China is no farther away than the click of a computer key, it's easy to forget how distant, exotic, and mysterious it appeared in 1930. Today, we might find it odd, even racist, to have the roles of Chinese peasants played by American movie stars, but it seemed normal in the 1937 film version of *The Good Earth*. American actress Luise Rainer even won an Academy Award for her portrayal of O-Lan, a reflection of a time when studio moguls thought it took star power to make China good box office. Twenty-four publishers turned down *The Good Earth* because they thought no one was interested in China. Twenty-four publishers were wrong.

*The Good Earth* not only transformed American's view of China, it also transformed the lives of those closest to it. It catapulted this missionary daughter, wife, and worker from obscurity to celebrity and gave her riches beyond even her fertile imagination. It brought author and publisher together—first as business associates, then as lovers. Pearl Buck finally had the resources to create a life of her own design. She even had the power to trade up from an unsupportive husband with whom she had little in common to Walsh, an erudite, romantic prince whose principal wish was to serve her. She could build the family of her dreams in the place of her dreams, advance causes about which she cared deeply, and speak out on the issues of the day. She was free. She was powerful. She was determined to speak her mind.

She fired her first major salvo in front of two thousand guests at a fund-raiser for the Presbyterian Church. By now, Pearl Buck was an international celebrity, and the missionaries embraced her as one of their own. When asked to comment on her four decades as child, wife, and teacher, she denounced the entire missionary movement.

> I have seen the missionary narrow, uncharitable, unappreciative, ignorant. I have seen missionaries . . . so lacking in sympathy for the people they were supposed to be saving, so scornful of any civilization but their own, so harsh in their judgments upon one another, so coarse and insensitive among a sensitive and cultivated people, that my heart has fairly bled with shame. I can never have done with my apologies to the Chinese people that in the name of a gentle Christ we have sent such people to them. [11]

"How did she have the courage to publically criticize her world?" I asked Peter Conn.

"She was very brave," he replied. "She picked her fights and waded in: religion, women, and abandoned children. She was isolated from the ques-

tions, the brickbats. She didn't read American newspapers, never had American friends. Richard Walsh kept her safe."

As it turned out, this speech was the beginning of four decades of pronouncements. It was also the beginning of a love affair. Within a few years, she had left Lossing and traveled back to the United States with her daughter Janice. In 1935, in Reno, Nevada, Pearl and Lossing Buck divorced, on the same day as Richard and Ruby Walsh. The next day Pearl and Richard married. Pearl Sydenstriker Buck Walsh never saw China again.

Once she was committed to a new life in the United States, it was time to get things organized. Pearl's first project was her husband: although he was charming and connected, finances were not Walsh's strong suit, and John Day Publishing faced bankruptcy. Pearl sat down at the typewriter and wrote a novel, titled *The Mother*, which garnered thirty-five thousand dollars from serialization in *Cosmopolitan* and sold eighty thousand copies within three months of publication. She then moved into the John Day Publishing House and became its principal literary advisor, using her celebrity to attract other top-selling authors. From the piles of invitations for speaking engagements and writing assignments, she cherry-picked the most lucrative ones, determined to earn as much as quickly as she could. Some of her fees were used to purchase Green Hills Farm in rural Bucks County, selected because of its relative proximity to Manhattan, Philadelphia, and Carol's home in southern New Jersey.

During these years, Pearl Buck turned out work, as one critic put it, "on an industrial scale."[12] She wrote very quickly—she seldom went back to rewrite—and her output was exceptionally eclectic: bestselling novels, mysteries, serials, poetry, speeches, juvenile books, history books, and books about international relations. She authored newspaper commentaries, speeches, radio shows, and television scripts. She wrote to entertain, to educate, to convince, and, most important, to earn the dollars that bought independence. Walsh served as editor and publisher, opening the right doors, making the best connections, promoting her, and sharing her passions. Their talents meshed perfectly. By the time of her death at age eighty, she had produced a remarkable 1,300 works, including seventy novels. Not all are of equal merit. After *The Good Earth*, her two best books are the memoirs of her parents: *Fighting Angel*, about Absalom, and *The Exile*, about Carie.

Pearl Buck learned she had been awarded the 1938 Nobel Prize in Literature from an NBC radio broadcast. Her first words were Chinese, translated as: "I don't believe it." Her second were in English: "That's ridiculous. It should have gone to (American novelist Theodore) Dreiser." Many critics shared her opinion.

"The Nobel Prize just killed her," said Peter Conn, shaking his head. "Until the prize, Pearl was treated with respect, even by *The New York Times*. Then the New York establishment woke up to the Nobel Prize. 'Really?

You're kidding me,' were their reaction. The implication of the Nobel Prize is that you're the best writer in the world. Pearl was seen as a new, an average, a productive writer, but not the best writer in the world."

But, while her Nobel Prize may not have made sense as a literary choice, it did make sense as a political gesture. In 1938, the Swedish-based Nobel Committee looked out over an increasingly bleak Europe: the Fascists were winning in Spain, and Germany was invading Czechoslovakia. Many interpreted Pearl Buck's Nobel Prize as a celebration of democracy over fascism, although few imagined a world war was so near.

Perhaps part of her agreed with her critics, for soon after Pearl picked up the prize in Sweden, she moved more aggressively beyond the writer's desk to the world outside. She became a sort of secular missionary, fearlessly championing the causes she cared most about: humane treatment of the mentally retarded, equal rights for African-Americans, the plight of children abandoned by their American soldier fathers and Asian mothers, pay equity for women. She shared the stage with birth control advocate Margaret Sanger and first lady Eleanor Roosevelt. When she spoke, a surprising number of people listened, especially to her opinions about China. Pearl's familiarity with all classes of Chinese and her fluency in many vernaculars gave her an insider's view of the values that underlay the rhetoric on all sides of a conflict.

In 1940, she and Walsh announced the formation of the China Emergency Relief Committee, which soon led to an invitation to serve as chair of the United China Relief, an umbrella organization for the Chinese Emergency Fund and six other charities. Its success, in turn, led Walsh and Pearl Buck to establish the East and West Association, an organization that promoted cross-cultural understanding. By the middle of World War II, this secular missionary was serving as guest writer and editor of a newly revamped *Asia* magazine, leading three charities, and speaking out on behalf of China throughout the nongovernmental sector. Pearl's many crusades and social engagements left little time for a home life: while she and Walsh adopted or fostered seven children, they later recalled spending very little private time with their celebrity mother.

After World War II, the humanitarian work continued with the founding of Welcome House, the first international, interracial adoption agency. Pearl also continued to express her views on social issues: British resistance to India's independence, the peacetime draft, the expansion of the military. Over time, as the Cold War began, she grew increasingly out of step, and her popularity and royalties declined.

In 1953, Richard Walsh suffered a massive stroke. While he survived as an invalid for another seven years, the stroke ended his and Pearl's remarkable partnership. His death in 1960 was anticlimactic; by that time, she had moved on.

Walsh's stroke left Pearl without her protector. From then on, she made all her decisions herself. Not all of them were good. In 1963, she met a man who would trigger the most controversial years of her often-controversial life.

It began innocently enough, when Pearl called the local Arthur Murray dance studio to secure a teacher for her daughters. The charming young man whom the studio sent to the house, Theodore Harris, essentially never left. He was forty years her junior. She made Harris her coauthor, director of her foundation, and constant companion. He also became her greatest liability.

Harris entered the picture just when Pearl was launching yet another charity, the Pearl S. Buck Foundation, to provide scholarships for Amerasian children in their home countries. She had assembled a blue-ribbon board that included Dwight D. Eisenhower, Joan Crawford, Princess Grace of Monaco, Sophie Tucker, Robert F. Kennedy, and two neighbors: David Burpee, founder of the Burpee Seed Company, and real estate developer Herbert Barness. Ted Harris, she decided, was just the person to serve as president of the new Pearl S. Buck Foundation, despite his lack of a college degree or experience in philanthropy. She rented a large townhouse for the organization in Philadelphia's elegant Delancey Place, filled it with antiques, and installed Ted Harris. Soon his staff included a cook, a houseboy, and Harris's long-time companion—all financed by Pearl.

With Harris' encouragement, Pearl resigned from many public commitments, updated her wardrobe and makeup, and joined him on a twenty-city tour to raise funds for the new foundation at Pearl S. Buck gala balls. People began to express concern over Pearl's infatuation, Harris' obsequiousness, and the Pearl S. Buck Foundation's predilection for spending more on Harris and his entourage and less on scholarships for Amerasian children. When David Burpee realized that "Arthur Murray people" were dominating the foundation, his letter of resignation urged that Pearl proceed with caution. She answered it vigorously: "David, please don't worry about me. I have always done what people said was impossible. . . . Publishers and literary agents once told me that I could never make a success at writing about Chinese people. I thought of that the day I stood before the King of Sweden to receive the Nobel Prize!"[13]

In 1966, she and Ted Harris coauthored *For Spacious Skies*, generally considered one of her weakest books. That is where we first learn that the only extant copy of the typescript for *The Good Earth* has vanished. "The devil has it," Pearl writes. "I simply cannot find it."[14] A year later, on the eve of her seventy-fifth birthday, Pearl updated her will to bequeath her entire estate, estimated at some seven million dollars, including Green Hills Farm, to the Pearl S. Buck Foundation, and left with Harris on an extended tour of Asia.

In 1969, the gossip swirling around Pearl Buck and Harris went public when *Philadelphia Magazine* published "The Dancing Master:" "Famed novelist Pearl S. Buck has been waltzing into a heartbreaking story," it began. The extensive, damning expose detailed Harris' flamboyant lifestyle and his unorthodox management of the Pearl Buck Foundation. Soon after the story appeared, Pearl, Harris, and their retinue moved to Vermont, where she died in 1973 at the age of eighty.

All of this led me to wonder: could there be a connection between the appearance of Ted Harris in Pearl's life and the disappearance of the typescript for *The Good Earth*? The two incidents seemed to have happened around the same time. Perhaps there were some clues at Pearl Buck's home. So, on a raw January morning, I drove the hour from Philadelphia to rural Bucks County. I traveled down long serpentine roads flanked with fields, forests, old farmhouses, and new housing developments to a Pennsylvania Commonwealth historic marker dedicated to Pearl Buck, and a blue and white road sign that reads, "Pearl S. Buck International, Opening Doors to the World, Gift Shop." I turned into Green Hills Farm and followed the road past her gravesite, marked by an odalisque inscribed only with her birth name, "Pearl Sydenstriker," as if she had shed her first and second husbands for all eternity. The road ended in a parking lot flanked by the three buildings. Pearl Buck has morphed into a nonprofit conglomerate called Pearl S. Buck International, an umbrella organization for three charities: the Pearl Buck House National Historic Landmark, Welcome House, and Opportunity House, which provides sponsorships for mixed Asian-Caucasian children in their home countries. The Pearl S. Buck Foundation, the charity Ted Harris ran as president, is gone.

Curator Donna Carcaci Rhodes met me in the spacious lobby of the Welcome Center and led me past the gift shop and into to the Pearl S. Buck Trophy Room, packed with awards, honors, photographs, and memorabilia. In case you've never seen one, the Nobel Prize is a gold medal approximately three inches in diameter with a silhouette of Arthur Nobel in relief, and the Pulitzer Prize is a framed certificate issued by the Trustees of Columbia University. Nearby, a glass case held Absalom Sydenstriker's sermon book from 1888—small enough to fit into his coat pocket—and a photograph of him as an old, gaunt man standing on the steps of the Buck's house in Nanjing, where he lived after his wife died.

I followed Rhodes out of the Welcome Center and down a path to the nineteenth-century fieldstone farmhouse that Pearl transformed into a large and rambling family home and offices. "This is now a house museum, and it's set in the 1935–1938 period when Green Hills Farm was most active," Rhodes explained as we entered. We walked through the original front door into a living room with worn, wide plank floors covered with blue Chinese rugs, sturdy furniture, and walls enlivened by paintings and prints. "Mr. and

Mrs. Walsh were early collectors of illustrations," said Rhodes, pointing to two dramatic Chinese scenes painted by famed illustrator Charles Edwards Chambers. Over the fireplace hung a portrait of Pearl as a demure missionary wife with cornflower blue eyes and soft brown curls. "Ms. Buck never liked the portrait," said Rhodes.

We walked over to the old Royal typewriter that Pearl Buck used to type *The Good Earth*. It was sitting on her carved Chinese rosewood desk in front of the Chinese rosewood chair that Pearl had imported from Nanjing. "This is where *The Good Earth* typescript was displayed in 2009 after it was recovered," said Rhodes. "Then Edgar Walsh, Ms. Buck and Richard Walsh's adopted son, took it back. He's the executor of his parents' estate, so controls the typescript. He lives in Connecticut and keeps the typescript in a secure vault."

We sat for a moment while Rhodes reconstructed the recovery of the typescript. She had received the call from David Bloom from Freeman's auction house asking whether the Pearl Buck House was interested in purchasing *The Good Earth* typescript. Rhodes knew she had to work carefully and quickly or this precious treasure might disappear.

"I need to check with my supervisor," Rhodes told Bloom. "Do you think you can send me visual proof?"

Fifteen minutes later, an email arrived from Freeman's. Attached to it was a jpeg of a single page. "I printed out the document, walked from my office into this house, went to this desk, and put on my white cotton curator's gloves. I then carefully inserted a sheet of paper in this, Pearl's Royal typewriter, and typed the first sentence of the jpeg."

With a jeweler's loupe close to her eye, she compared the two pages. They were virtually identical. After forty years, Rhodes was holding proof of the long-missing document in her hand.

Rhodes shared the good news with her bosses at Pearl Buck International and they called the FBI. Soon she was on the phone with Robert Wittman, senior investigator with the FBI's Art Crime Team, telling him about the typescript and the call from David Bloom. Wittman called Bloom, who immediately referred him to Susan Shaddinger Dempster, the woman who had appeared in his office with the typescript. Wittman then called Dempster, who was shocked to hear from the FBI: she thought the typescript and other documents in the hatbox actually belonged to her mother, Helen Shaddinger, Pearl Buck's secretary. Within a matter of days, *The Good Earth* typescript was with the FBI.

"The typescript was yellowed with age. It was wrapped in paper and put inside a red and white box. Then, the box was wrapped and placed in a woven leather suitcase from the 1950s," remembered Rhodes. The box also contained a manila file, labeled "Famous People," with about a hundred letters to Pearl Buck from President Harry Truman, First Lady Eleanor

Roosevelt, and other major figures of Buck's day. There were also a number of letters from 1933 between Pearl and Richard Walsh, her then-publisher and later husband, including the correspondence from the 1930s when she assigned him ownership of *The Good Earth* typescript, and he wrote back an acceptance letter.

All evidence pointed to Pearl Buck's secretary. I wondered why she was never prosecuted for the theft.

"Call Bob Wittman," Rhodes suggested. "He'll fill you in on the details."

"No one was arrested or prosecuted for the theft of *The Good Earth* typescript. Can you tell me why?" I asked Wittman when I reached him a few days later. He had retired from the FBI and written a book about his exploits and was happy to provide a tutorial in criminal law.

"Pearl S. Buck's former secretary, Helen Shaddinger, is the person we think had the typescript," Wittman said. "The problem was that she had passed away, so we couldn't interview her—or Pearl Buck, who was also dead. When Susan, Helen's daughter, found *The Good Earth* typescript in the basement, she thought it might be a copy. That's why she took it to David Bloom at Freeman's. No one can prove any criminal intent."

No criminal intent means there's no crime. One part of the case of the missing typescript has been solved. We know who took it: Pearl's long-time secretary. But, why? What led her to remove these documents from Pearl Buck's home and hide them away?

"What is your opinion?" I asked Donna Carcaci Rhodes on my next visit. "Why did Helen Shaddinger take the typescript?"

"I believe the motivation was protection, not thievery," she replied, "Pearl Buck and Ted Harris had a relationship for ten years. That was enough time for someone to remove things if he or she felt it was important to remove things to protect them."

That made sense. Helen Shaddinger took and hid *The Good Earth* typescript and other documents to keep them safe from Ted Harris. At the time the manuscript disappeared, Pearl was ready to sell it to finance the Pearl S. Buck Foundation.

"Pearl Buck was making a conscious effort to say, 'what's going to help these Amerasian children with their need?' She was asking herself, 'why do we have these manuscripts lying around when they could help people?'" said Rhodes. "She was not going to let anything of value remain as a 'dust collector.' Ted Harris was saying, 'let's establish your house and your foundation.' She was handing things over to him as a business matter; she saw him as a business partner. Until she died, she defended Ted Harris as helping her and helping children."

I thought this over for a while and realized the story of the document actually posed an ethical question that went something like this: What is more ethical, allowing an owner to sell property that has significant and

irreplaceable social value, or taking the property from the owner to protect it for posterity? Removing a possession without the owner's approval is against the law. In the case of this iconic document, the question is: do ethics trump the law?

Let me complicate things a bit more. What if you believe the owner of this iconic document cannot think straight because she is under the sway of someone else? Does this make taking her property more ethical? Or, here's another question. What if your perceptions are wrong and the owner is not under anyone's sway, but rather acting independently, though imprudently? Does that affect the ethics of this situation?

You can see how complicated this can get.

So, in the interest of clarity, here's my ending to the case of the missing typescript. First, while I don't buy the view that Pearl Buck saw Ted Harris as just a "business partner," I also don't believe she was an addled old lady, swept away by a charming and conniving swindler. I think she had control of her faculties. I think she was aware of Harris' antics, but chose to ignore them because they didn't matter to her. She wanted to enjoy life and assure that her final gift to the world, the Pearl S. Buck Foundation, would survive. Pearl Buck always used her royalties to live exactly as she wished, including supporting Harris and his staff in a luxurious townhouse. The proceeds from the sale of *The Good Earth* typescript would save Amerasian babies, send them to school, and assure them a better life. If the world failed to understand her . . . well, it never really understood. The damning article in *Philadelphia Magazine* was just another example.

After forty years' absence, the precious typescript of *The Good Earth* had finally been found—and hidden again. It is in a vault, safe but unavailable. No one can visit it; no one can study it without Edgar S. Walsh's permission. Legally, he can do anything he wants with it. He can sell it to the highest bidder, and if that bidder is a private individual, he or she can move it from Walsh's vault to his or her own. Or, the buyer can sell or donate it to the Pearl S. Buck House or any of the other six institutions located in the United States, China, and Korea that connect to Pearl's past or carry her legacy.

That would be a fitting tribute, a fitting result. Edgar's father, Richard, didn't want such a "valuable manuscript . . . sold for a profit." He wanted it "turned over to a collecting institution." That's what Richard wrote to Pearl when she placed the document in his hands.

After being discounted for decades, Buck is now being rediscovered. *The Good Earth* is a perennial favorite, translated into at least sixty-five languages, and has held a permanent spot on many high school reading lists. In 2004, it was selected for the Oprah Winfrey Book Club—a twenty-first-century version of the-Book-of-the-Month Club; the selection sent it back to the bestseller lists. Peter Conn receives a steady stream of young Chinese scholars interested in working with him, as well as invitations to scholarly

conferences about Pearl Buck's work and influences in Nanjing, where she and Lossing taught.

"Chinese scholars are taking great interest in Pearl," he told me. "Her books are uniquely valuable: they're the only record of life of the peasant."

Pearl Buck spent the first half of her life in the Presbyterian missionary world in China and the second half as a secular missionary in the United States. Her perspective on China was unique; it can never be duplicated. But she was always an outsider.

I remembered what Peter Conn had told me the day I visited his office: "The key to Pearl is her unique existence in two separate cultures and her difficulties in coping with either of them. She was not *in* two worlds, she was *between* two worlds, never comfortable in either of them."

Pearl Buck never quite understood American society, and it never understood her. And, at the end, many saw her as a pathetic old woman caught in a predator's web, when all she wanted was to go out dancing in the arms of a charming young man.

## NOTES

1. Pearl S. Buck, *My Several Worlds: A Personal Record* (New York: The John Day Company, 1954), 71.

2. Ibid., 8.

3. Ibid., 75.

4. Ibid., 76.

5. Hilary Spurling, *Pearl Buck in China: Journey to the Good Earth* (New York: Simon and Shuster, 2010), 81.

6. Ibid., 127.

7. Peter Conn, *Pearl S. Buck, A Cultural Biography* (Cambridge: Cambridge University Press, 1996), 101.

8. Spurling, *Pearl Buck in China*, 187.

9. Conn, *Pearl S. Buck*, 123.

10. Andrew Maykuth, "FBI Says Secretary Took Buck Typescript," *Philadelphia Inquirer*, June 28, 2007.

11. Conn, *Pearl S. Buck*, 148.

12. Dwight Garner "The Meteoric Rise, and Decline, of a Talented Young Writer," *The New York Times*, June 8, 2010.

13. Conn, *Pearl S. Buck*, 357.

14. Patrick Lester, "Missing Pearl S. Buck Writings Turn Up Four Decades Later," *The Morning Call*, June 28, 2008, http://articles.mcall.com/2007-06-28/news/3723754_1_manuscript-bucks-county-buck-s-son.

## Chapter Three

# Ghost Dancing at Wounded Knee

He lay dying in the snow in a small, desolate valley next to a creek called Wounded Knee.[1] Along with other Lakota braves, women, and children, he had followed his chief, Big Foot, 220 miles south from his home on the Cheyenne River Reservation to this lonely spot in South Dakota. After years of resistance, years of hunger bordering on starvation then going beyond, Big Foot and his followers had agreed to accept their fate and move onto the nearby reservation at Pine Ridge. Surrounded by the enemy, they knew they had one last layer of protection from the soldiers' bullets: the Ghost Dance, which they had danced for days on end, and the ceremonial Ghost Dance Shirts they wore.

The Ghost Dance Shirt still covered the brave. But its magic power had failed to stop the two bullets that ripped through the sacred muslin and penetrated his now-dying body.

Two days of blizzards sealed the brave's fate. On the third, a soldier or officer or Indian scout carefully pulled the garment off of him before throwing his frozen corpse into a wooden wagon, lugging it up a small hill, and dumping the naked body, together with those of some two hundred other men, women, and children, into a shallow grave.

Everything about Wounded Knee, this bloody massacre of the Lakota Sioux by the Seventh Cavalry of the U.S. Army, will break your heart. It broke the Lakotas' spirit and drove them to a life of degradation on the reservation. It is one of our nation's most searing, if little known, tragedies.

I didn't know all this when I flew to South Dakota to see the Ghost Dance Shirt. I had found the story of the shirt[2] in Jeannette Greenberg's *The Return of Cultural Treasures*. The garment had traveled from Wounded Knee to Europe, then to Scotland before returning more than one hundred years later

to the South Dakota Cultural Heritage Center in Pierre, the capitol of South Dakota. I didn't realize it symbolized a wound too deep to ever fully heal.

A Ghost Dance Shirt? What was "ghostly" about it, and how did the dance fit in? Why did it travel to Wounded Knee, Scotland, and back? And what was the story behind Wounded Knee? I remembered it as the place that was occupied by members of the radical American Indian Movement in 1973, but had a much fuzzier notion of the original significance that made them choose this spot. I decided to go to South Dakota and see the Ghost Dance Shirt for myself.

The South Dakota Cultural Heritage Center, with its museum and archival wings, is a sleek modern building carved into a hillside, both a tribute to the pioneer sod houses and a cost-efficient measure to achieve the consistent temperature and humidity that archival and museum collections need. A larger-than-life size sculpture of a pioneer woman stands at the entrance. On the day I visited, its bronze body was burning to the touch in the blazing July sun. It was ninety-six degrees, and South Dakota was in the middle of a wicked drought.

Dan Brosz, the museum's curator of collections, met me in the center's sun-filled lobby. He is a fit and friendly native South Dakotan who loves his state's endless horizons and even its frigid winters, when the temperature routinely drops to twenty degrees below zero. Brosz first came to Pierre as a college intern at the South Dakota State Museum and later returned as its curator after securing a graduate degree.

"People from other places say people in South Dakota are so friendly," he explained. "Friendliness is ingrained in us; we are so isolated that when you see someone, you spend the whole day talking. South Dakota is just one big town that happens to be seventy-five thousand square miles big." Brosz and I had corresponded before my trip, and he had sent me his paper on the Ghost Dance Shirt.[3] "It's my favorite artifact," he wrote. He had prepared for my visit by assembling a pile of file folders fat with newspaper clippings, photographs, documents, and reports. I had prepared by reading the book he recommended, James Mooney's *The Ghost Dance Religion and Wounded Knee*,[4] a detailed account by a Smithsonian Institution ethnographer of his travels through South Dakota and other parts of the West in 1890 and 1891. For the next couple of days, Dan Brosz and James Mooney served as my guides.

I followed Brosz into the museum's exhibit hall, where we stopped to admire the carved wooden horse in flight, red wounds on its side, which stands as the Center's logo. We walked past dioramas of buffalo hunting and cattle rustling, a loaded gold mining car, a 1927 Dodge Coupe, displays of Native American artifacts, farm equipment—the flotsam and jetsam of South Dakota life—to a small, dimly lit gallery at the end. It was dedicated to the massacre at Wounded Knee, and the Ghost Dance Shirt from Scotland hung

alone in an unlit glass case near the entrance. Across the room was another glass case housing another Ghost Dance Shirt, this one with the label "Picked up by Eisenberg, a private, confiscated by an officer," along with a pair of beaded moccasins, a Winchester Model 1876 rifle, and a shell from a Hotch-kiss rifled cannon that looks like a bullet shell on steroids. All of these had been taken from the killing field at Wounded Knee, and between the two cases were text and illustrations that told the story. "We keep the gallery dark to allow the public to reflect on the situation the Indians dealt with," said Brosz. "It's a contemplative space."

We stood in front of the unlit case. I looked at Brosz. I looked at the Ghost Dance Shirt. It was big enough to fit a six-foot frame, made of muslin or unbleached cotton with a red-painted V-neck and long sleeves. Short red fringe surrounded the V-neck, top of the biceps, inside seam of the arms, cuffs, and straight-cut bottom. An eagle feather rested in the center of the V-neck, and another was attached to the inseam of the elbow area. There were two small round bullet holes in the shirt, one on a sleeve and the other on the back.

"The bullet that pierced the back of the shirt would have entered the brave's body and could have killed him,"[5] he said, pointing to the hole. "But the brave might have been hit over the head by one of the soldiers of the Seventh Cavalry, or lanced and left to die. Artifacts can help us answer many questions, but also to ask so many more."

I tried to imagine life in South Dakota in 1890s. It must have been precar-ious, very hard. I wondered why anyone would take the time to save such a simple, unadorned garment made of the cheapest possible material.

Brosz looked at me quizzically, a South Dakotan's polite way of saying you're asking the obvious. "Indian materials were very desirable, even in the 1890s. Shopkeepers would trade goods for them. Also there is a lot of lore around the Ghost Dance."

It was 1890, and the great Lakota were in trouble. For one hundred years or more, they had been one of the largest and fiercest Native American tribes of them all, the vast buffalo herds supplying them with food, shelter, and clothing. The Lakota, called Sioux by the white men, are members of one of two main tribes: the Santee, made up of Yankton-Yanktonai and Teton, and the Dakota, both Nakota and Lakota. The most famous Lakota was Sitting Bull, the great spiritual and political leader who was widely credited as the architect of the Battle of Little Big Horn in 1876, when his tribe defeated the U.S. Seventh Cavalry and killed General George Custer. But even this deci-sive victory could not halt the press of the white man's progress. By 1890, most Lakota were virtual prisoners on reservations where the barren land could not support crops, the cattle died of disease, and the women and chil-

dren starved and froze in the harsh Dakota winters. A small remnant remained outside the reservations, those too proud to surrender.

These were wretched times not only for the Lakota but also for all Native people, who had been moved and removed again from their ancient lands to make way for the white man. Out of these times emerged a spiritual leader named Wovoka, a Paiute Indian, who announced a revelation. During an eclipse of the sun, Wovoka fell into a fever and found himself transported to another world, where he saw God, the Great Spirit, and all of the people who had died long ago, engaged in their old-time sports, happy and forever young. God, in this revelation, told Wokova that if the Indians worked hard, lived morally, and kept peace with the white man, they would attain eternal happiness. God also gave Wovoka a dance to bring back to his people, saying that if the Indians performed this "ghost dance," they would awaken the dead, and the white men would disappear forever.

"The times were ripe for a messianic movement," explained Dan Brosz. "People were poor and desperate, and desperation makes you open to ideas that might alleviate it." Indians are spiritual people, so they imagined a spiritual salvation to their problems. The Ghost Dance religion was so compelling that almost thirty tribes became believers, making it the first-ever Pan-Indian religious movement.

*How could anyone believe such a bizarre myth?* I wondered. Then I remembered my own tribe, the Jewish people, also a spiritual people with a history 5,800 years long, much of it filled with great suffering. When life became nearly unbearable, a Jewish prophet would appear as if out of nowhere with the promise of salvation.

When the Lakota heard about Wovoka and his prophesy, they, like many other tribes, sent representatives to investigate. Short Bull and Kicking Bear met Wovoka and became his strongest Lakota prophets, carrying the Ghost Dance back to their people and teaching the ceremony.

James Mooney's book[6] brings us a white woman's eyewitness account of the Ghost Dance. She described three hundred tents arranged in a circle with a large pine tree in the center covered with strips of cloth, eagle feathers, stuffed birds, claws—offerings to the Great Spirit. As the ceremony began, a high priest or master of ceremonies called out instructions. Three hundred to four hundred dancers formed a circle around the tree, each with a hand on the shoulder of the person next in line. As they circled the tree, the dancers cried out the names of their dead and called to the Great Spirit to allow them to see and hear their departed family and friends. Many danced to exhaustion in order to experience visions of the dead and of a Promised Land filled with game. For the ceremony, dancers replaced their usual, often Western clothing with special garments, Ghost Dance Shirts, made of buckskin or muslin, decorated with sacred emblems and hand-sewn by women.

All the tribes wore Ghost Dance clothing for the ceremony, but for the Lakota the garments took on special powers. The Lakota believed they made their wearers invincible, protecting them against the white man's bullets and other weapons.

As the Ghost Dance movement swept through Indian country, white settlers trembled in fear and sought help from Washington. Soon the largest deployment of soldiers since the Civil War—almost half of the entire U.S. Army—moved west, charged with ending the ceremonies and moving the Indians onto reservations. The Seventh Cavalry was assigned to the Lakota Sioux, Sitting Bull's tribe, the same tribe that had defeated them fourteen years earlier at Little Big Horn.

On December 5, 1890, Indian scouts hired by the U.S. Cavalry assassinated Chief Sitting Bull at his home in the Dakota Territory. Following the murder, there was a brief skirmish in the Black Hills close by, and ultimately Chief Big Foot of Cheyenne River agreed to bring his people to the Pine Ridge reservation to find safe haven with the other Sioux who were settled there. They packed their things, traveled to Wounded Knee Creek, and settled in the valley before making the final sixteen-mile trek to Pine Ridge. Many were women, children, and the elderly; all were starving. The Seventh Cavalry took up positions on the hills that surrounded the valley: 470 armed soldiers and officers and four Hotchkiss cannons.

Shortly after 8 o'clock on the morning of December 28, 1890, the soldiers ordered the braves to come out from the tipis and deliver their arms, which meant the end of hunting for the game their families so desperately needed. When the braves resisted, the soldiers were ordered to search the tipis; they overturned beds, smashed furniture, and drove out the protesting women and children. In this melee, Yellow Bird, a medicine man, walked through the campsite urging the warriors to fight back and reminding them they were wearing the magic Ghost Dance Shirts that would render the soldiers powerless, their bullets useless. Suddenly Yellow Bird threw a handful of dust into the air, and a young Indian named Black Fox drew his rifle and fired. The soldiers instantly replied with a volley of bullets that killed nearly half of the braves. At the first volley, the Hotchkiss guns opened fire, mowing down everything alive. Within a few minutes, some three hundred Indian men, women, and children lay dead, along with thirty soldiers killed by their own.

I imagine the valley strewn with bodies, the trashed tipis, the overturned cooking pots, the tiny dead infants still wearing their delicate embroidered slippers, the women racing into the empty creek bed and up the tree-lined hillsides as the soldiers hunted them down like dogs. The bodies lay where they fell for two days while fierce winds whipped snow across the plains, so much snow that no one could reach them. When the soldiers and their scouts finally returned, they gathered up the dead Indians, lifted the stiff, frozen corpses into a wagon, dragged the wagons up the tallest hill, and threw the

bodies into a long, shallow mass grave. Many of the Indians were naked, stripped by their murderers of their ceremonial Ghost Dance Shirts—the garments they believed had magic protective powers.

"This would have happened after rigor mortis set in—and, as you can see, this shirt wasn't even cut," said Dan Brosz pointing to the Ghost Dance Shirt. "It must have been removed from a frozen body carefully, without cutting the garment."

At least two photographs survive from that day. In one, a horse-drawn cart is filled with frozen corpses, their legs and arms askew. The other shows two men standing in a shallow ditch stacking bodies of Indian men, women, and children as a phalanx of white men looks on.

So, the story of the Ghost Dance Shirt was unfolding. A Lakota woman from the Cheyenne River Reservation made it for a brave, and he wore it as he danced his final Ghost Dance and later on the day he died at Wounded Knee. Now, I wondered, how did it get to the Kelvingrove Museum in Scotland?

I found the answer in one of the files Brosz pulled for me, in a brochure from the Kelvingrove Art Gallery and Museum, Scotland's largest museum, which is owned by the city of Glasgow. The brochure featured a group photograph taken on the Pine Ridge reservation two weeks after the massacre with a couple of Lakota, the internationally renowned showman William "Buffalo Bill" Cody, and George C. Crager, a white man who often served as an Indian interpreter. Cody had come to Wounded Knee to recruit authentic Indians for his Wild West show. Crager had come as the special correspondent for *The New York World*—the massacre was big news. While there, Crager acquired the Ghost Dance Shirt and a number of other items. He also secured a position as the interpreter for Short Bull, Kicking Bear, and other Lakota who joined Buffalo Bill's Wild West show.

That struck me as odd. Why would Indians whose friends and families had been massacred by the white man want to sign up for a job in a white man's show?

"The government gave the Lakota a choice: join the show or go to jail," Brosz said. "Buffalo Bill needed real Indians to chase the stagecoaches, so he got the government to help him out." *How ironic*, I thought. The braves who brought the Ghost Dance to their people and survived the final resistance ended up performing in a Western-themed extravaganza.

In the summer of 1891, Buffalo Bill's Wild West Show toured Europe, then settled into winter quarters in Glasgow, Scotland. That December, George Crager wrote a letter to the curator of the Kelvingrove Museum:

> Dear Sirs, Hearing that you are empowered to purchase relics for your museum I would respectfully inform you that I have a collection of Indian Relics (North American) which I will dispose of before we set sail for America.

Should You wish any of these after Inspection I would be pleased to have you call at my room at the East End Exhibition Building.

Under his signature Crager wrote: "in charge of the Indians." The following month, Crager turned over twenty-four objects to the museum,[7] four of which he said he had secured at Wounded Knee, including the Ghost Dance Shirt. The accession register records the donation as:

"*Ghost Shirt*" of cotton cloth with feather ornament, blessed by "Short Bull" the High Priest to the Messiah, and supposed to render the wearer invulnerable. Taken from a Sioux Warrior killed at the battle (sic) of Wounded Knee, 30th December (sic), 1890.

We can never know whether Crager's shirt was actually removed from the body of a brave at Wounded Knee. Crager was known to stretch the truth, and there was an active trade in fake Ghost Dance Shirts. The marking, manufacture, and materials of the garment verify its Lakota origins, but beyond that we must go on faith.

"So Dan, we've followed the Ghost Dance Shirt from Cheyenne River, South Dakota territory to Wounded Knee, then around Europe and to Scotland, where it landed at Glasgow's Kelvingrove Museum. Now, how did it get back to South Dakota?"

"Well, it's quite a story, he replied. "I suggest you ask Marcella LeBeau. She lives on the Cheyenne River reservation; I think she was the key."

The next day, I drove the ninety minutes from Pierre to Cheyenne River to visit Marcella LeBeau. As I passed oversized flatbed trucks carrying rolls of hay, the road shimmered with puddles of water mirages. A partridge skittered across the highway in front of my car. The outside thermometer read one hundred degrees.

Marcella LeBeau lives in a rose-colored stucco house on a quiet street with cows grazing across the way. Knowing she was over ninety years old, I expected to find an infirm old woman but instead was met by a small, elegant lady with bright eyes and silver hair caught up in a chignon topped by a silvered flower. She asked me to wait while she took a long-distance conference call about some piece of tribal business and sat me at the dining room table, which she had stacked with files documenting the repatriation of the Ghost Dance Shirt. When she was finished with the call, she began plowing through the files, handing me duplicates of some of the news clippings.

LeBeau had arranged for us to talk at the reservation's community health center, so we drove there via a quick tour of Eagle Butte. She told me about her life, how she was raised on the reservation, trained as a nurse, and traveled to Europe during World War II, a stint that won her the French Legion of Honor Medal. After the war, LeBeau returned to Cheyenne River reservation, married a local boy, and raised a family of eight children and

thirty grandchildren. She continued her nursing career, eventually retiring as head of the nursing department of the local hospital. But retirement is not really what LeBeau is all about. She's at the center of a multitude of causes—education, public health, smoking cessation, cultural preservation—the quintessential tribal elder with too much to do to find time to die.

"A young lawyer, John Earl, a Cherokee from Georgia, was touring Europe and saw the Ghost Dance Shirt in an exhibition in Glasgow,"[8] she began. According to newspaper clippings in her files, Earl saw the shirt in a 1992 exhibit entitled *Home of the Brave* at the McLellan Galleries in Glasgow. Although he had never seen a Ghost Dance Shirt before, he recognized it immediately and knew its spiritual importance to the Lakota people. When Earl returned home, he contacted Marie Not Help Him, president of the Wounded Knee Survivors Association, and she, in turn, enlisted the help of Mario Gonzalez, one of America's most prominent Indian rights lawyers and a descendent of a warrior who died at Wounded Knee. At the time, there were two branches of the Wounded Knee Survivors Association, one at Pine Ridge, the other at Cheyenne River. Gonzalez petitioned the Kelvingrove to repatriate this spiritual object and arranged for delegations from both branches to travel to Scotland. Marcella LeBeau was secretary of the Cheyenne River branch, though not a descendent of Wounded Knee, and since the branch president could not go, she agreed to serve as its representative.

"I knew descendants of Wounded Knee who lived in Cheyenne River," LeBeau told me. "I know the sadness they hold in their hearts. I just felt compelled that an effort should be made to repatriate the Ghost Dance Shirt. Our youth need to know their history and not forget. And, if I could play a small part in that, I wanted to do it."

In April 1995, the Wounded Knee Survivors Association representatives arrived in Glasgow, garnering considerable curiosity from the local press. "Sioux on the warpath," read one headline; "Sioux pow-wow for return of Ghost Shirt," read another. "Silly, negative things," said LeBeau. "They clearly didn't understand us." The delegation met with the City Council, which has responsibility for overseeing the Kelvingrove, and carefully explained the significance of the massacre at Wounded Knee and the spiritual meaning of the Ghost Dance Shirt.

The Kelvingrove had prepared for the hearings by inviting museum visitors to comment on the repatriation request and by consulting curators from national and international museums. Museum visitors generally endorsed the return, but many of the professionals did not. They worried about precedent, arguing that if the Kelvingrove returned the Ghost Dance Shirt when it was under no legal obligation to do so, then every indigenous people from any place in the globe could come forward to make a claim for other artifacts. The Kelvingrove's director, Lucian Spaulding, shared the professionals' point of view and did what he could to derail the reparation process. But he

didn't really have to, for the Indians derailed it themselves. Spaulding had received a letter from the Standing Rock tribe disputing the Survivors Association's claim and requesting reparation of the Ghost Dance Shirt on the grounds that they, the Standing Rock tribe, were Sitting Bull's tribe and would display it in their tribal museum. This gave the Kelvingrove reason to deny all claims.

The museum's curator of history, Mark O'Neill, told a local reporter, "We are sympathetic. I wouldn't close the door on its repatriation." He said the decision would be made on ethical, not legal, grounds, balancing the Lakota's rights to have these objects against the museum's responsibility to educate the public about the history of the world.

LeBeau and Mario left Glasgow despondent but not defeated. Their quest to reclaim their heritage had engendered substantial public sympathy and attracted a group of local supporters determined to keep the Indians' claim alive.

By 1998, it was time to try again. The Indians had settled the alternative claim, and there had been considerable movement in Glasgow. The City Council had received so many requests from indigenous people for the return of their material heritage that they had developed a claims and repatriation policy, and were eager to test it on an actual claim. The Lakota's friends had organized a petition drive, and the newspapers and City Council had invited Glaswegians to express their opinion. "[O]ur whole class voted that the shirt should be returned to its rightful owner," wrote students of the St. Gerardines Primary School. Another man wrote: "The fact that it [the Ghost Dance Shirt] was taken from the body of a dead Lakota at Wounded Knee and that it has a sacred significance gives the Lakota a unique and irrefutable case for its return." The Lakota had reason to believe they might succeed.

Again, the Wounded Knee Survivors Association asked LeBeau to join Mario Gonzalez as its representative. A week before they were scheduled to depart, Gonzalez called to say he was unable to go. So, LeBeau went alone, as the entire delegation, accompanied by her son Richard.

"Before we left for Scotland, we searched our genealogy and discovered that my children, on their father's side, were descendants of a woman named Burnt Thigh, whose name appears on the list of those massacred at Wounded Knee. This made Richard a descendant," Marcella LeBeau said.

On November 13, 1998, the Glasgow City Council's Arts and Culture Committee held a public hearing about the repatriation of the Wounded Knee Ghost Dance Shirt. The room was packed—in fact, so many wanted to attend that the City Council held a public lottery for the seats. Mark O'Neil, the curator of the Kelvingrove, framed the discussion, describing the final disposition of the Ghost Dance Shirt as a moral question that spoke to the role of museums in society:

The choice of whether or not to return the Wounded Knee artifacts[9] is a central issue, not because it creates a precedent for other returns, but because it reflects exactly what museums are all about. It forces us to ask whether museums can possess objects such as these and still provide places for exploring our values, for discussing what is right or wrong, what relationship we wish for between ourselves and other peoples, what our obligations toward the past, present, and future are, and where museums fit on the spectrum from the sacred and the spiritual to the secular and the materialistic.

This time LeBeau was prepared. She had spent hours at the kitchen table handwriting a detailed brief. She also brought along a replica of the Ghost Dance Shirt to leave in place of the original. She and her daughter had sewn the garment themselves out of "treaty cloth," using another Ghost Dance Shirt as a model. As it turned out, her community, Cheyenne River, owns a number of Ghost Dance Shirts and other artifacts from Wounded Knee. When LeBeau spoke, she gave the replica Ghost Dance Shirt to one of the councilwomen, who formally accepted it for the museum. Her son, Richard LeBeau, shared his concern about Indian youth. The audience was clearly moved.

"As we spoke, people said there was sobbing in the audience," remembered LeBeau. "Even a reporter later wrote there was a tear in his own eye."

A few days later, the Glasgow City Council voted to repatriate the Ghost Dance Shirt to the Wounded Knee Survivors Association, but with some conditions. The Association had to agree not to bury the shirt, which often happens with funerary objects. Instead, it had to be displayed in a museum where the conditions were environmentally controlled, to assure that it would be preserved for posterity. That's when the South Dakota State Historical Society stepped in.

In summer of 1999, the Ghost Dance Shirt traveled, along with a delegation from Glasgow, back to the United States, and hit a final roadblock. U.S. Customs refused to allow it to enter the country because it had an eagle feather, and eagles are an endangered species. The lawyers soon solved that problem, and the shirt was on its way back to South Dakota. The garment was welcomed at LeBeau's Cheyenne River community before it traveled to Wounded Knee, where the Oglala Sioux tribe staged an event. As the crowd was walking up the hillside from the killing field to the cemetery, someone saw a spotted eagle flying overhead, a very special moment. This was followed by a reception at the South Dakota Cultural Heritage Center, where the Ghost Dance Shirt remains today.

Marcella LeBeau is pleased that the Ghost Dance Shirt is displayed in a secluded area with other materials from Wounded Knee. "I think people need to see it," she said. "It helps with the healing."

"Healing?" I asked.

She stopped for a moment, and then took a breath. "My grandfather Joseph For Bear was forced to give up his ways of life as a Lakota and live their ways, the white man's ways. At age ten, my mother died and my father didn't have the wherewithal to care for me. I was sent to a boarding school where I could not speak my language and the teachers said that Indians were dirty, we couldn't be anything. That does something to you as a child.

"The federal government called Wounded Knee a battle. They gave twenty soldiers the Congressional Medal of Honor for Wounded Knee. There hasn't been any closure. They won't revoke the honors. They buried our people naked. What society would do something so disrespectful, burying the dead naked?" She shook her head.

The Curatorial Agreement[10] between the South Dakota State Historical Society and the Wounded Knee Survivors Association called for the society's "holding the shirt at the Cultural Heritage Center until such time as the Association completes construction of a suitable museum at Wounded Knee or on the Cheyenne River Indian Reservation."

"What would it take to build a museum here?" I asked.

"That's a goal," LeBeau replied. "We have a preservation office here and I understand they want to build a museum, but they've chosen a noisy spot, near the airport. A cultural center was built here, but it ran out of funds before it was all completed, as I understand it, so they didn't build the museum wing. I feel a museum is very important for youth—to learn about their ancestors, how noble they were. Today our reservation still carries the trauma. We're learning that traumas are generational; they last for generations and generations. We have our Lakota group, we have our young people joining, but it's slow. If we could go back to our values and traditions it would be healing."

"'Stolen,' now that's an interesting word to use,"[11] said James Nason when we met at the Burke Museum of Natural History and Culture at the University of Washington in Seattle. "Was the Ghost Dance Shirt stolen? The person who wore it was dead, so maybe not. From the perspective of the Lakota, the shirt was stolen. But from the perspective of the army, probably not. In the 1890s, objects taken from battlefields were considered 'war loot.' In ancient times—and even recently—that's how you paid your troops. This was hardly new behavior, in the United States. Cavalry troops not only looted objects but also human remains," Nason continued. "The War Department requested bodies and skulls; these eventually went to the Smithsonian Institution."

*That's pretty grisly,* I thought, remembering the day about a decade ago when I saw a wall of storage drawers filled with human bones in the Smithsonian's Natural History Museum.

After my trip to South Dakota, I had sent James Nason an e-mail requesting an interview, thinking he might have some views on the Ghost Dance Shirt. I was right. Nason, a member of the Comanche tribe, has been in on almost everything connected to Native American material culture: he helped craft the Native American Graves Protection and Repatriation Act of 1990 (NAGPRA) and served as a consultant to the National Native American Museum in Washington, DC. Nason introduced me to Megon Noble who coordinates the museum's NAGPRA repatriation process.

NAGPRA was a revolutionary piece of legislation that permanently changed the power relationship between Native Americans and museums. It compels any institution that receives federal funds to inventory, document, and, if requested, repatriate objects that are covered under the act: funerary and sacred objects and objects of cultural patrimony. If a tribe can prove the item is covered under NAGPRA, the museum is obliged to return it. Since most natural history, anthropology/archaeology, and local history museums in the United States store Native American artifacts, there's been a lot of repatriation in recent years. One of Nason's greatest achievements has been in helping Native people learn how to care properly for the treasures they get back and create tribal museums for them.

According to James Nason, the reparation debate over the Ghost Dance Shirt garnered so much public attention because of the British Museum's refusal to return cherished treasures taken during the period of British colonization in Africa, Greece, and other counties. People in Glasgow wanted to show that the Scots were fair and just; that is, different from the English. This was a period during which Scots were agitating for political autonomy.

"When the Kelvingrove's director, Julian Spaulding, came out strongly against repatriation," Nason said, "he used the same arguments that the American Association of Museums used against NAGPRA: the Ghost Dance Shirt was in the public domain where it belonged; there are many Ghost Dance Shirts in the United States, this is the only known one in Europe; this was a good faith acquisition by the museum. You know, Spaulding was terminated over this matter."

If the Kelvingrove Museum were in the United States today, it would have to return the Ghost Dance Shirt because the shirt is considered a funerary object, buried with the dead, and thus covered by NAGPRA. No comparable law existed in Britain (indeed, no comparable law exists there today), so the Kelvingrove was under no obligation to give it back. At the time when the Lakota were trying to repatriate the Ghost Dance Shirt, there were five other requests for repatriation, including a request from Australia for human remains and a request from Benin for bronzes. The City Council hired a consultant to prepare a strategic plan to address all of these requests, and the Lakota request became the test case. Some of the criteria were the same as those that would be applied in NAGPRA: Was the community requesting

repatriation an authentic one? Was there clear continuity in the community? Did the object in question have clear-cut cultural or religious importance? Other criteria were different. The City Council was particularly concerned that the Ghost Dance Shirt not be buried, as is the case with many similar funerary items, but preserved for posterity and displayed in a public museum. And the agreement that was finally reached included a hope of future links between the Lakota and Glasgow.

There are more than two hundred tribal museums in the United States; many, though not all, are pretty basic. The Comanche Nation recently purchased an existing museum building next to Fort Sill in Lawton, Oklahoma. The Agua Caliente Tribe, which owns all of the land in Palm Springs, California, is investing ten million dollars in its museum. These have many of the traits of other museums, except for two: they will not display objects that are sacred to the tribe, and their primary educational mission is directed to their community.

"Ownership is also an issue," said Nason. "Does the piece belong to an individual? To a group like the Wounded Knee descendants? To the tribe? Disputes around ownership can go on for decades. Whether the Lakota will create a museum depends on the priorities of the tribal council, how much money they have, and whether there are hidden agendas."

"Here's my final question," I said. "There is a big National Park Service site at Little Big Horn. Why isn't Wounded Knee a National Park Service site?"

Nason shot me a quizzical look. "At Little Big Horn, there were major figures; it was really a big deal involving many Native peoples, and a star-caliber general, General Custer. It was the same Seventh Cavalry. It would be interesting to know who fired the first shot, why the Seventh Cavalry plowed down innocent women and children. Regimental history is a big deal, you know.

"Wounded Knee had no impact on the public psyche of the time. A small number of Indians were killed. The Indians lost. Happened many times.

"Lots of Indian battles grounds are not memorialized. Some are now casinos."

On my final day in South Dakota, Dan Brosz and I drove three hours from Pierre to Wounded Knee. White clouds rimmed the horizon; it was another hot, dry day. In the car, we talked about the American Indian Movement activists who occupied the area for seventy-one days in 1973. They selected Wounded Knee for its symbolic importance and went there to protest a tribal election and the U.S. government's failure to fulfill treaty obligations. Because there is only one road to the site, it was relatively easy for the FBI and U.S. marshals to cordon off the area. One marshal and two activists died, and another activist disappeared and was never heard from again. I remembered

the television coverage—it was big news. Nothing much happened as a result, though.

Wounded Knee was designated a U.S National Historic Landmark in 1965, but that was not obvious on my visit. There is no pristine National Park Service building or bathrooms or interpretative markers, only a dusty parking lot and a couple of lean-tos shading women selling jewelry. A sign marks the area: "The Wounded Knee battlefield is the site of the last armed conflict between and Sioux Indians and the United States Army." The text comes directly from *Bury My Heart at Wounded Knee* by Dee Brown, a white man whose research is now largely discredited. The word "battle" is covered by a piece of wood with the word "massacre" written on it.

A road cuts through the killing field, separating the small round valley where the Lakota were encamped, though it's hardly a valley, more like a soft dip in the landscape, near the Wounded Knee creek bed that's hardly a creek, just a small indentation in the land, not even as deep as a small person is high. The valley is surrounded on three sides by hills, and on the highest one are a church and cemetery marking the place where the Cavalry stood, pointing their Hotchkiss guns directly down on the tipis. "Hotchkiss guns fire shells rapidly with great range and lots of power. They had them in a fish bowl," Brosz told me as we climbed the dusty hill to gain the soldiers' perspective. To our left were the tree-covered hills where soldiers on horses hunted down fleeing women and children.

We walked to the cemetery, its entrance framed by a decorative metal arch spanning red and white brick pillars. I leaned over the wire fence and read the inscription on one of the graves that packed the cemetery. "Lost Bird, born May 1890, died February 1919."

"Lost Bird died of pox, smallpox, at age twenty-nine," a young Lakota man said, moving up next to me. He was hanging out, ready to tell stories to the tourists for tips. "When they found out she was a descendant of the massacre, they brought an eagle feather to her grave and prayed, and then carried the feather here and buried it in this grave."

Some graves were decorated with careful arrangements of plastic flowers—pink, lilac, yellow, blue, and white. Others featured twigs of sage, ribbons, and other small gifts. "Emerald Gibbons, 8-7-1925 to 5-1-1927; Baby Girl Gibbons, 7-9-1929 to 11-11-1929; Elsie Long Cat Gibbons, 8-16-1914 to 9-25-1997." People continued to bury their dead here long after the Wounded Knee massacre.

In the center of the cemetery is a trench four feet wide and seventy-eight feet long, the mass grave where the victims of Wounded Knee were buried three days after the massacre ended. Surrounding it is a wire fence hung with red cloth prayer bundles, socks, bags of sage, and scarves. At one end is a monument with a plaque that reads: "This Monument is erected by surviving relatives and other Ogallala and Cheyenne River Sioux Indians in memory of

the Chief Big Foot Massacre, December 29, 1890, Col. Forsythe in command of U.S. Troops."

Who was to blame for the deaths at Wounded Knee: the Lakota or the Seventh Cavalry? This was the question that brought James Mooney, Smithsonian ethnographer, to this desolate, ghost-filled landscape, the question he attempted to answer with exhaustive research in official and unofficial documents, in interviews with survivors and participants, and in carefully walking the battlefield accompanied by a scout. Here is, in part, what he found:

> [T]he author arrives at the conclusion that when the sun rose on Wounded Knee on the fateful morning of December 29, 1890, no trouble was anticipated or premeditated by either Indians or troops; that the Indians in good faith desired to surrender and be at peace, and that the officers in the same good faith had made preparations to receive their surrender and escort them quietly to the reservation . . . that the first shot was fired by an Indian, and that the Indians were responsible for the engagement; that the answering volley and attack by the troops was right and justified, but that the wholesale slaughter of women and children was unnecessary and inexcusable. [12]

Standing on the hillside overlooking the small valley, I thought about the emotional resonance of the Ghost Dance Shirt. Where does it come from? Is it because, as Nason said, "Wounded Knee was a clear cut massacre, a blatant case at a very late date?" Is it because the shirt was a burial garment that now stands as witness? Or does its power also derive from something else? Does the return of the Ghost Dance Shirt also represent an act of grace from one people to another, which allows, as Marcella LeBeau said, the healing to begin?

Today, the Ghost Dance Shirt from Wounded Knee hangs in its unlit case in a dim gallery in the museum built into a prairie hillside, awaiting its final resting place. In Great Britain, the Kelvingrove's willingness to repatriate it to the Lakota has become a shining example of how museums sometimes do the right thing by native people.

Every couple of years, someone promotes a new plan for an official commemoration of the massacre. One recent plan that became a piece of federal legislation would have established the Wounded Knee massacre site and its cemetery as a National Tribal Memorial Park. The National Park Service would provide funding for restoration of the site and its perpetual upkeep, though its ownership would remain with the Oglala Sioux tribe. The tribe would operate the site, creating jobs for administrators, maintenance workers, and rangers. The park would not only commemorate that historic tragedy and honor the victims of the massacre, but also bring visitors to the reservation and revenue to the local economy.

The Wounded Knee Survivors Association is now called the Heartbeat at Wounded Knee 1890. It and others put a stop to the legislation. Their reason,

I was told, is that they did not want anyone exploiting their honored dead by making money from the sacred site.

If I hadn't been at Wounded Knee, I would not have understood why. Now I do. These are the proud Lakota.

Someday, the Lakota Ghost Dance Shirt will return home, but that might take a while. When it comes to the return of tribal treasures, it's best to take the longer view.

## NOTES

1. For an overview of the repatriation of the sacred Ghost Dance Shirt see: Daniel Brosz, "Mending the Hoop: The Repatriation of the Sacred Ghost Dance Shirt" (The University of Nebraska-Lincoln, 2002).

2. Jeanette Greenfield, *The Return of Cultural Treasures*, 3rd ed. (New York: Cambridge University Press, 2007), 312.

3. Dan Brosz, "Lakota Ghost Dance Clothing: History, Meaning and Manufacture" (The University of Nebraska- Lincoln, 2002).

4. James Mooney, *The Ghost-Dance Religion and Wounded Knee* (New York: Dover Publications, Inc., 1973).

5. Interview with Daniel Brosz (Curator, North Dakota Cultural Heritage Center) in discussion with the author, July 24, 2012.

6. James Mooney, *The Ghost-Dance Religion and Wounded Knee* (New York: Dover Publications, Inc., 1973), 796.

7. Sam Maddra, "Glasgow's Ghost Shirt," booklet published by Glasgow Museums, 1999.

8. Interview with Marcella LeBeau (Cheyenne River reservation), in discussion with the author, July 25, 2012.

9. Mark O'Neill, "Glasgow City Council's Arts and Culture Committee Report," November 13, 1998.

10. "Curation Agreement," South Dakota Department of Tourism and State Development, January 2005.

11. Interview with James Nason and Megon Noble (Burke Museum of Natural History and Culture at the University of Washington in Seattle), in discussion with the author, August 1, 2012.

12. James Mooney, *The Ghost-Dance Religion*, 870.

## Chapter Four

# Babe Ruth on a Quail Hunt

On October 26, 2010, Leslie Waffen, the recently retired director of the Motion Picture, Sound and Video Branch of the National Archives, opened the door of his house in Rockville, Maryland, to find five government agents with a warrant to search the premises. In the basement, they found boxes of audio discs stolen from the Archives.[1] A year later, on October 4, 2011, Waffen pleaded guilty to one count of embezzlement of government property with a value greater than one thousand dollars. As part of the plea agreement, he surrendered 955 sound recordings owned by his former employer and agreed to pay full restitution. He was eventually sentenced to eighteen months in federal prison, fined $10,000, and ordered to pay $99,864.44 to the National Archives and the victims who had inadvertently purchased the purloined sound recordings. He also lost his pension. "Our hope as you go forward is that you will abandon that parallel universe of crime," said federal judge Peter Messitte. [2]

The news of Waffen's sentencing in the *Washington Post* brought me back to my days as executive director of Philadelphia's history museum, the Atwater Kent. The responsibility for the one hundred thousand objects in the museum's collections weighed heavily on me. I worried about them all the time—their condition, their safety. My sleep was haunted by a recurring nightmare: I would open the door of my house to find men in black looking for stolen artifacts that I couldn't remember if I had stolen. Angst notwithstanding, I loved the job, especially the topsy-turvy valuations of artifacts, where the most valuable items were actually the most ordinary ones, because ordinary items are the least often saved. I came to share the curatorial staff's deep devotion to the 1840s school desk carved with the initials of long-dead children, the display signs from long-defunct department stores, the two-hundred-year-old wooden pipe that carried water from river to households,

the scruffy taxidermied dog named Philly who had protected our brave boys in the foxholes of World War I France. While the Atwater Kent was no National Archives, I felt a punch in the gut when I read about Leslie Waffen's crime.

Waffen, it turned out, had spent forty years climbing the bureaucracy to a senior position in what is arguably the country's most important archive. *How was he caught?* I wondered. *Why did it take ten years to detect the thefts and figure out that it was Waffen who committed them?* I knew that collecting institutions tended to keep insider crimes like Waffen's under wraps, but was this possible in a public institution like the National Archives? Why would someone of his stature risk his reputation to steal the very items for which he was responsible?

Les Waffen's story is a cautionary tale about those curators, registrars, archivists, and librarians, those collections professionals who stray over the line. On the surface, he seemed an unlikely thief. His colleagues called him a "committed scholar" who was "very conscientious and upstanding" and "pretty easygoing."[3] Even the man who discovered the crime admired Waffen as one of the nation's top audio archivists. No one suspected he was pilfering piles of audio recordings.

Since neither the felon nor his wife would grant an interview, I turned to the documents to get the facts of the case. A generous attorney, Bruce Bellingham, prepared a Freedom of Information Act request for the Office of Inspector General, National Archives and Records Office, and the Department of Justice. A few months later, a letter arrived from the Assistant General Counsel of the Office of Inspector General. Attached to it was the report for Investigative Number 11-0002-I, "Theft of Historical Audio Recordings." Large swaths of the investigation report were redacted, and some of the court documents were secret, but between the parts of the report that were legible, the available documents from the trial transcript, and a couple of newspaper articles, I was able to piece together the sequence of events.

In 1976, David Goldin, an avid radio collector, donated thousands of original sixteen-inch and twelve-inch acetate aluminum, pressed vinyl, and glass base disc recordings to the National Archives and Records Administration. Each disc carried old radio broadcasts that Goldin had acquired over the years. On September 27, 2010, Goldin notified the Archives' Office of General Counsel that someone with the handle "hi-fi_gal" was offering one of these discs for sale on eBay. That notification led to the raid on Waffen's home by U.S. marshals and special agents from the Archives' Office of Inspector General. They arrived with a long list of missing discs and a moving truck, went down into the basement, found boxes of audio recording discs, identified them as owned by the National Archives, and loaded them into the truck. According to the agents, Waffen appeared surprised and his

wife upset as they sat together on the couch while all this was going on. The raid lasted about forty-five minutes.

The agents seized 6,153 individual sound recordings, 955 of which were confirmed as National Archives holdings. Eventually, the court ordered Waffen to surrender a total of 4,806 discs.[4] Attached to the Report of Investigation on the Waffen theft were fifty-three pages of titles of radio broadcasts that he had stolen from the Archives. They included the first World Series Game of 1948, a rare recording of the 1937 Hindenburg disaster, episodes of three radio series—"Counterspy," "Suspense," and "Gunsmoke"—news shows, game shows, the Boston Symphony, the Ziegfeld Follies of 1936, and an address by Madam Chiang Kai-Shek to Congress, one of a series titled, "NBC Historic War Speeches." Disc number RG200G was the one that led the agents to Waffen. It was titled, "Babe Ruth Quail Hunt at Forked River, New Jersey," recorded on December 10, 1937, by WOR radio.

Babe Ruth on a quail hunt? I knew Ruth was a baseball powerhouse who played both pitcher and outfielder positions. He retired in 1934—three years before the quail hunt broadcast—with 714 lifetime career home runs, a baseball record until Hank Aaron broke it in 1974. But even if Ruth were the greatest baseball player of all time, I couldn't figure out why a radio show about him quail hunting was significant enough to end up at the National Archives. In fact, I wondered why any of these stolen sound recordings belonged in the National Archives, as its mission is to preserve federal government records, and these recordings seemed to be a hodgepodge of everything except government records. So, I decided to visit the man who had made the original donation and discovered the theft.

J. David Goldin, who goes by Dave, is a burly guy with a twinkle in his eye and a Santa Claus rosebud of a mouth under a thick white mustache.[5] He and his wife, Joyce, live in a corner of Connecticut that looks like a suburb plopped down in the middle of the woods. When I contacted him for an interview, he was happy to oblige. I drove up a long dirt road to a wooden house set high on a woody hillside and knocked on the door. When Joyce opened it, the first thing I saw was a stack of boxes of recording tapes four feet high sitting in the front hall. She led me into a wood-paneled room. I looked around in awe. The entire room was banked with shelves lined with radios of all shapes and sizes. There was a radio shaped like a violin, another shaped like a piano, a radio featuring pictures of the Dionne Quintuplets, another of famed ventriloquist dummy Charlie McCarthy, and a line of colorful transistor radios that had a Jersey shore vibe, circa 1950.

Over the shelves hung a frieze of record album covers from old radio shows: the "Fred Allen Show" with Fred in a bowler hat and handlebar mustache; "The Wizard of Oz" with Dorothy, the Tin Man, the Cowardly Lion, and the Scarecrow on the cover; "Little Orphan Annie"; "The Shadow"; and "Tokyo Rose," the famed World War II Japanese propagandist, this

last one with a photo of Lotus Long, the elegantly dressed Japanese lady who played Rose in the movies. It was like sitting inside the head of a particularly avid radio aficionado.

And there, seated in a chair on a raised platform at the far end of the room, surrounded by computers, printers, and other paraphenalia, was Dave Goldin. Although he owns about one thousand radios, one hundred and fifty thousand radio broadcasts, and many television sets, microphones, recorders, and other communications gadgets, you can't really classify him as simply a collector because he's so much more: a radio authority, archivist, historian, entrepreneur, producer, and engineer. He is also a philanthropist who has made major donations of audio discs to not only the National Archives, but also the Library of Congress and the University of Missouri, Kansas City. Some call him "the man who saved radio" because he has rescued so many radio shows that would otherwise have been lost. He calls himself a radio historian, curator, and archaeologist.

"I was one of those kids who was passionate about radio," he told me. By age sixteen, there was no question what he wanted to do with his career. Radio was his life. In 1963, Goldin left college for a year to follow his dream to Alaska for a short stint as a disc jockey, then returned to school in New York, graduated, and secured "a whole bunch of FCC licenses." He worked as a radio operations engineer at NBC and the Mutual Radio Networks before landing a job at CBS.

Collecting old radio shows has been a major part of Goldin's life since he recorded the December 1957 broadcast of the CBS show, "A Year in Review." Some recordings he purchased; others he salvaged from radio stations that were cleaning house. He had a knack for turning radio station trash into marketable treasure. In 1969, he produced his first record, "Themes like Old Times," for the Viva label. It landed the number twenty-three spot on *Variety*'s weekly list of best-selling LPs and led to a contract with Columbia Records to produce "WC Fields on Radio," which was nominated for a Grammy for the Best Comedy Album of the Year. In 1971, Goldin left his job at CBS and started his own label, Radiola, selling, via mail order, tapes of old recordings. In 1978, he entered the video market, selling Betamax and VHS videotapes of films in the public domain. Twenty years later, he retired and sold his business. Along the way, Goldin's productions garnered one Grammy award and five additional Grammy nominations.

"Take a look at this," Goldin said, holding up a sixteen-inch electronic transcription disc. "This is what Les Waffen stole." The discs, originally made of metal, then manufactured of glass during World War II, cut on a lathe one at a time, were used exclusively by radio stations to record broadcasts.

"There are more in the basement," Goldin said, in what turned out to be a major understatement. The basement, like the first floor study, was lined with

shelves holding radios of every shape you could imagine. There were several radios shaped like horses, with and without cowboys atop them, an elegant Art Deco radio loudspeaker with dancing nymphs, a whisky bottle-shaped "Magic-Tone" radio bearing the inscription "The Radio that Soothes Your Spirits," and a sleek black-and-cream-colored radio with a stylized eagle standing on a wreath surrounding a Nazi swastika. The basement was also home to the "vault," a museum-quality, climate-controlled storage facility for original recordings that Goldin preserved after cleaning up the sound and transferring them from disc to tape. Each tape carried an average of five radio broadcasts; the tapes were neatly housed in boxes with catalog numbers. All the recordings were entered into Goldin's own Radiogoldindex Master Catalog so that he could locate anything at any time. It was as professional an archival set-up as I've ever seen, inside or outside an archive.

In 2010, Goldin was trolling on eBay for more radio shows to add to his collection when he noticed something odd: there, for sale, was a sixteen-inch disc with an electronic transcript of a fifteen-minute interview of baseball great Babe Ruth hunting quail in New Jersey in 1937. "That's funny, I thought," he told me. "I had the exact one, and there's only one in existence. I acquired it in 1967 when WOR's news director was cleaning out a closet and gave it to me, along with a pile of other recordings."

Babe Ruth on a quail hunt was among the ten thousand recording discs that Goldin had donated to the National Archives. He figured if the National Archives were selling the discs he had donated, he wanted them back. So, he wrote to the archivist of the United States and the legal department of the National Archives, alerting them to the fact that the tape was being offered for sale on eBay and, if the Archives were de-accessioning it, asking to have it back. About ten days later, he received a call from the investigative archivist in the Office of the Inspector General, who asked Goldin how he knew it was the same disc. Goldin was well prepared to substantiate his claim with a copy of the Babe Ruth recording taken from the disc he had donated, a tax return from 1976 with an itemized inventory of the donation, and the receipt he received upon the delivery of the Babe Ruth disc to the Archives, signed by a young archivist named Leslie Waffen.

The next call came from a federal marshal, asking Goldin if he knew who hi-fi_gal was. Goldin said he didn't, but he offered to find out. He then went onto eBay and purchased a disc from hi-fi_ gal. A couple of days later, a package arrived with a return address in Rockville, Maryland. Goldin looked it up in a reverse directory and was shocked to discover that hi-fi_gal shared an address with Leslie Waffen.

"I had a good relationship with Les Waffen," Goldin sighed. "But I don't really know him personally. He had invited me to the Archives, and I'd spoken to him on the phone a couple of times. He seemed like a nice guy and

very knowledgeable, small and mousy, your typical archivist type. I saw him at his sentencing and he said he didn't blame me for turning him in."

Goldin pressed a couple of keys on one of his computers, and out came a printout of nineteen listings for Babe Ruth in the Radiogoldindex Master Catalogue. Number 15377 was titled, "Quail Hunt at Forked River, New Jersey. December 10, 1937," with the following description:

> Using short wave equipment, this is a radio quail and pheasant hunt with Babe Ruth, among others. Many birds are shot out of the air. This is O.K. if you're out in the woods, but lousy radio. Babe Ruth. Fifteen minutes. Audio Condition: Excellent. Complete.

"Why would a radio station save such a strange item?" I asked.

"There are any number of reasons," Goldin said. "Maybe because it was a delayed broadcast, perhaps for a legal reason like protecting it from a possible suit by Babe Ruth. Maybe advertisers wanted to listen to the program to hear how their ads sounded."

And, while you and I might be more interested in the radio show than the disc it's recorded on, to Goldin, these metal recording discs are actually important artifacts.

"Why is an original of a painting more valuable than a copy?" he asked rhetorically. "You can see a picture of the Sistine Chapel on your computer, but that's not the same as seeing the real one. I'm interested in the original bone, not the plaster cast. Who's to judge what's important, anyway? As a historian, I'm like a vacuum cleaner, trying to collect everything connected to radio."

"Les Waffen didn't need the money," Goldin continued, shaking his head. "He had a pension, he had a beautiful house in Maryland. He sold the Babe Ruth disc for only thirty-eight dollars on eBay. I think he had a compulsion. As far as I'm concerned, it's forgive and forget. I didn't feel like a hero. I actually felt like a whistle-blower because I was ratting someone out."

My next stop was the National Archives, to find out how someone could walk out the door of a federal government facility with four thousand discs over a ten-year period without getting caught. I secured an interview with the archivist of the United States, David Ferriero, booked a train ticket, and boned up on the Archives.

The National Archives and Records Administration, known by its initials NARA, was established in 1934 to deal with a serious problem: the records of the federal government were at risk. At the time, every federal agency was responsible for maintaining its own records, with mixed results. Some documents were stolen, some were lost, some misfiled, and others ruined by water, fire, sunlight, and bugs. When the National Archives assumed responsibility for federal recordkeeping and the first archivist of the United States

was appointed, there wasn't even an accounting of how many government records actually existed and how much space would be needed to house them. The archivist had to guess—he guessed 374,000 square feet of storage—but he was way off. Almost as soon as the building based on the architect's original design was completed, records began to fill the building's interior courtyard, doubling storage space to more than 757,000 square feet. Over time, the federal government grew, first with the New Deal, then World War II. Within twenty-six years, the headquarters building was full.

From one building on Pennsylvania Avenue, the National Archives has now grown to more than forty facilities nationwide, including regional archives, federal records centers, presidential libraries, the Federal Register, and the National Historical and Publication Commission. What we think of as "government records" has also expanded, now including not only pieces of paper but reels of film, maps, photographs, technical drawings, artifacts, video, audio recording discs, audio tapes, and billions of machine-readable data sets.[6] The Archives is responsible for a mind-blowing twelve billion items, and our current complement of 275 government agencies continues to churn out more every minute.

It was steamy and overcast on the August day when I took a train to Washington for my meeting with David Ferriero.[7] On the way down, I read the "Victim Impact Statement" that he had submitted to the court at Leslie Waffen's sentencing, a litany of damages resulting from Waffen's theft of many "unique and irreplaceable materials with a cultural, research, and educational value far outweighs their monetary value, materials lost not only to this generation of researchers, but to scholarship long into the future." By stealing so many discs, he had compromised the integrity of the Special Media collections "that Mr. Waffen claims to have worked so hard to build and preserve." In addition, Waffen had damaged the reputation of the National Archives and he had betrayed and upset his colleagues. Ferriero asked for a stiff prison term, because of the crime's impact on the National Archives and as a message to others about the serious nature of the offense.

David Ferriero, with his square jaw and salt-and-pepper hair, reminded me of a president of a good liberal arts college. He greeted me in the archivist of the United States' spacious and patriotically decorated office with its gorgeous view of downtown Washington, and we began talking about insider crime.

"Studies by the FBI claim that 75 percent of thefts in research institutions and libraries are insider thefts," he told me. "The fact that some of the material stuff isn't processed is the reason why some can walk out the door. There are no records."

Ferriero told me that archives are especially susceptible to theft because so much of their collection is so easy to hide. Think, for a moment, about how easy it would be to hide a sheet of paper. The other problem is the sheer

volume of material. When documents are accepted—accessioned—by the National Archives, they are placed in an area to be processed, which means they are inventoried and coded so that researchers can locate and use them. But the staff can't keep up with the all of the processing that all of the new material requires, so some items must wait. According to Ferriero, the National Archives has control over groups of records, but not over individual items, because there are simply too many of them.

I asked whether Leslie Waffen's theft was an unusual occurrence at the National Archives.

"I hope so," said Ferriero. "This is a man who was on the staff for forty years. He was the senior person in the Motion Picture, Sound and Video Branch. He was responsible for gifts, so he knew what items were coming into the collection. The staff used to joke, 'That's Les taking his work home with him.' I've worked in a number of other libraries. When I came to the National Archives, I found that it was the first place where my bags were not inspected when I left the building. Now, all bags are checked. Even mine."

I asked what a recording disc of Babe Ruth on a quail shoot was doing in the collection of the National Archives and learned it was a part of Goldin's gift that had never actually been processed, so no one noticed that it was missing. But Waffen "took all kinds of things," said the archivist. "These are unique materials, in many cases one of a kind, in many cases irreplaceable, so it's depriving future generations of documentation that demonstrates how decisions were made, our history, firsthand accounts of our history. The Archives was established so that the American people would be able to hold the government accountable for its actions, to learn how decisions were made, to learn from the past. Any material taken deprives the government of being able to do that."

Although the National Archives is often approached about donations, it seldom takes them. It's only responsible for the records of the federal government, and if someone has a government record they're trying to sell, it likely should not be in their hands. "We try to encourage them to give it back to us before we take legal action," said Ferriero.

Since Waffen's crime was discovered, the National Archives has buttoned up its security. It has sponsored a public meeting on security, established a holding protection team to evaluate security and train staff, and an archival recovery team that looks for stolen materials. "We're being very public about these things, to shift perceptions. These security problems are nothing new: I've been dealing with them my entire career," he sighed.

"What do you think Waffen's mind-set was? Why did he do it?" I asked.

"Waffen's mind-set?" Ferriero repeated. "That one is real troubling, because he wasn't making a lot of money. He was charging ridiculously low sums for what he was selling. He and his wife set up a business, and she handled the business side of the operation. I don't understand the incentive."

Insider crimes leave their mark. National Archives staffers are proud to care for the national records and believe strongly in preserving the integrity of their profession. When a crime by one of their own is discovered, they wonder how to make sense of it.

Ferriero continued, shaking his head. "Waffen had colleagues here for forty years; they feel guilt, a sense of betrayal. People here have a passion for the mission, to make sure the holdings are here forever. There is a huge wake of survivor guilt when these things happen. It's very sad."

After our interview, the archivist of the United States escorted me down long hallways to the entrance to the National Archives' Great Rotunda, a majestic granite and marble shrine. I joined a line of quietly chatting tourists in jeans and backpacks and followed along as they climbed three steps to stand before the iconic Charters of Freedom. We stopped reverentially before the Declaration of Independence, the U.S. Constitution, and the Bill of Rights. I imagined these treasures as the epicenter of vast highways of government documents extending from this building on Pennsylvania Avenue to forty others across the nation.

"Our founders conceived of America as a constant dialogue between leaders and citizens," wrote presidential historian Michael Beschloss in the seventy-fifth anniversary publication of the National Archives. "What better symbol is there of this principle than the National Archives?"[8] Documentary filmmaker Ken Burns called it "the great gift of our accumulated memory— our good words as well as our terrible deeds."[9] Cokie Roberts, the political analyst, said, "Our history isn't always pretty but it's often provocative. And only with records can we know it accurately."[10]

Back home from Washington, I reassembled the pieces of the story. Waffen was able to steal 4,800 audio discs because they had never been processed. Because he was the person who had accessioned them, he knew where to find them; because no one was checking bags, he could take them without being detected. His role as a supervisor was an advantage: it gave him the clout to accession items and determine their relevance to the mission of the Archives, to decide which ones were important to process first and which would never make the cut. I kept thinking of those billions of documents under the stewardship of David Ferriero and how easy it would be for a researcher or a staffer or even a supervisor to steal some of them.

Leslie Waffen's theft of 4,800 original historical audio discs was a big deal. But exactly how common is insider theft? The FBI has said it represents 75 percent of all theft in research libraries and special collections, but where were the facts? Archivists and librarians tend to be gentle people, unwilling to believe one of their own could be a predator; so, no one really knew for sure—until a team of three librarians from Texas A&M University decided to find out.[11]

The team began its work by defining an "insider" as someone with "an intimate knowledge of the physical layout of the facility where materials are stored and a position of formalized trust within the institution, either as an employee or recurring visitor known to regular staff and with access to areas where collection materials are housed."[12] They then collected publicized incidents of theft for the years 1987 to 2010 and coded them in their Library Theft Database. For about 180 of the 340 cases they collected, there was sufficient information to draw conclusions about the nature of the theft and identity of the perpetrator. Then they analyzed the data.

Their research revealed that insiders perpetrated 33 percent of known library thefts.[13] More surprising, only 10 percent of the insider thefts were by staff professionals. Most of the rest were by nonprofessional, temporary, or informal members of the staff. One hundred and eighty cases over twenty-three years is a tiny sample, to be sure. And, as an official at the National Archives pointed out, college libraries and federal archives follow different security procedures. Still, the Texas A&M study does suggest that Les Waffen, as a director of a major division of the nation's most important archive, was not your usual suspect. No wonder so many were stunned by his crime.

At this point, most of my questions about Les Waffen had been answered. I knew what he stole, how he stole it, and how he was caught. One question remained. Why did he do it? There's a sizable body of literature about why employees steal from companies: some do it to make up for low wages, others to get even with companies and managers who treat them coldly. In some places, stealing is part of the workplace culture. Others steal for the thrill of beating the system. Most thieves are interested in making extra money they may or may not need. None of these seemed quite right for Les Waffen. He didn't seem to be the kind of person who was angry with management, since he was held in high regard by his colleagues and promoted to the top of his field by the National Archives. Money didn't seem to be a motive, since he sold discs for significantly below market value. Theft as part of corporate culture certainly didn't fit, since stealing is the antithesis of the culture of a collecting institution. Waffen didn't seem fit the mold of an insider criminal in business. Could it be something else?

I turned for clues to Les Waffen's own words, from the "Open Letter to ARSC Colleagues" that he published in the Association for Recorded Sound Discussion List. Waffen had served as president of this professional society and been instrumental in crafting archival standards and practices. Now, he was writing a mea culpa to his colleagues.[14]

"As reported on this discussion and in the media the last few weeks," he wrote, "I was accused of stealing sound recordings from the National Archives. I have now accepted a plea agreement and pled guilty to the theft and conversion of government property." He apologized to his professional colleagues, accepted responsibility for his actions, said he was cooperating

with authorities, and went on to explain, "[T]he sound recordings found in my possession after I retired or the ones I sold were not (in my opinion) unique or of significant historical value to [the National Archives and Records Administration]. Most were copies, or even copies of copies, of discs that were appraised by me and others on the staff and considered to be duplicative, excess, or rejected because the content did not meet criteria and guidelines for inclusion in the holdings. In other words, they did not document significant federal government agencies' activities or functions and were not worthy of permanent retention or preservation." He concluded by admitting he had lost "archival perspective and judgment," but was nevertheless proud of his accomplishments as an audiovisual archivist over his "career of forty-one years."[15]

I then consulted an authority. Beulah Trey is an industrial psychologist whose practice focuses on ethical behavior in the workplace. I was sure she would be able to find the crux of Waffen's motivations.

"Hmmm," she said after I had read her Les Waffen's mea culpa. "There's something about Waffen's story that sounds like a slippery slope."

Many criminals, she went on, begin by committing a small crime, then another, then another. They find themselves able to justify the crime to themselves as something that does no harm. Over time, the criminal's defenses dull and their crime becomes routine. They take a first step into crime and slide down a slippery slope.

"We can't know what happened, but we can imagine," she told me. "Les Waffen took the ethics of his profession seriously. He said in his open letter that he wouldn't dream of taking materials that were important to the National Archives. But he believed the discs he took were not important: they were duplicates, or duplicates of duplicates. He might have thought, the Archives is going to get rid of these discs, so why don't I take them? He loved listening to them; they gave him joy.

"Les Waffen's note is powerful," she continued. "There are not a lot of spots where he is justifying his actions. The Waffen that everyone knew is still there. That man is relieved that it's over."

This made a lot of sense. Waffen was someone without a clear moral compass. I imagined him as a young archivist in 1976 when Dave Goldin pulled a truck up to the National Archives and unloaded thousands of audio discs. Later, Waffen and a couple of his fellow archivists must have looked over the list of recordings. A number fit the National Archive's mission, but many didn't. The archivists might have added these candidates for deaccessioning to the growing backlog of material that needed to be processed. None of them was inventoried, none assigned numbers, and, because there was nothing that documented the location of these recording discs, they could easily walk out the door.

Of course, Les Waffen knew this. He knew there were many alluring radio broadcasts among the rejects on Goldin's list, since Waffen himself signed for them. About thirty-five years later, in 2001, he might have remembered them. Because he loved old radio shows, he must have decided to take one of the discs home, just to listen to it. He smuggled it out of the Archives in something large enough to hold a sixteen-inch record, nodding to the guards just as he always did. Perhaps he planned to return it, and maybe he did. Soon he took another, then another.

Over time the discs must have piled up, and it might have become much too risky to smuggle them back into the Archives. Soon, big boxes filled with recording discs might have cluttered the family's basement. Maybe Waffen and his wife needed some money, maybe they didn't; but in either case, these piles of recording discs had become a big problem. Maybe the Waffens decided that the best way to rid themselves of the problem was by selling the discs on eBay. But that presented another problem: how to avoid getting caught? If the discs were sold at full value, they could attract attention; so Waffen and his wife might have set the prices low in order to remain under the radar. I can imagine Waffen having these private conversations with himself; maybe he became a little obsessed. I can imagine he felt some relief when his crime was discovered.

I spent a long time mulling over Les Waffen's predicament. Something continued to trouble me: the jolt of recognition I felt when I read his story in the newspaper. What was it that drew me in?

And then I knew: I knew how Les Waffen felt because I had felt that way, too.

I think Les Waffen was motivated by the feeling that sits at the heart of every archivist, librarian, registrar, and curator in every country in the world. All of them love the material. They are passionate about things that are old and rare. And so am I.

There is something magical about these treasures—how they feel to the touch, their texture, their smell. With only the smallest of imaginative leaps, you find yourself transported to another time and place. You sense the spirit of those who made or wrote them, who handled them, who owned them. The very act of touching something old and rare connects you to a mesmerizing alternative reality.

Archivists and curators are some of the most contented people I know, because they can indulge their craving for the old and rare every day. But it's a thin line between love and obsession. While a passion for collections is an occupational requirement, it can also become an occupational hazard. That is why the profession frowns on those who amass private collections of the same material they oversee at their institutions. According to the official report on Waffen, there were over 6,000 sound recordings in his basement, only 4,800 of which were owned by the National Archives. This suggests

that he had acquired 1,200 recordings on his own. By the time Waffen was caught, he had moved from curator to collector.

Collections caretakers are not alone in their peculiar predilection for the stuff; private collectors also feel its allure. While some acquire art, antiquities, documents, and specimens as an investment, most collectors are motivated more by passion than by profit. They love to admire the beauty of these items, sense their faint aroma of times long past, fondle them, show them off. The difference between collections professionals and private collectors is that the latter can indulge their appetites to the extent of their resources without the strictures of mission or ethics that constrain their institutional counterparts. David Goldin is the quintessential collector: he and his wife actually live inside his collection. The one thousand radios, one hundred fifty thousand audio recordings, and many other communications artifacts are his passion, and while he tends them with the loving care of the most conscientious of curators, he is free to sell, buy, or even destroy items whenever he wants.

So, what do we make of poor Leslie Waffen? As a leader within the archival profession, he was uniquely positioned to know the rules; as a division head in the National Archives, he was uniquely positioned to break them. His story shows us what can happen to those who find themselves sliding down a slope where one ethical lapse leads to another and another. His crime did not come into play when he stole the 4,800th disc or even the 400th. It happened when he took the first one.

While Waffen may be an anomaly among insider criminals, many within and outside of collecting institutions share the passion that drove him to his crime. But while every private collector has a bit of David Goldin in him, very few professional archivists have a bit of Les Waffen.

## NOTES

1. Elahe Izadi,"Leslie Waffen: ex-National Archives Director's Home Raided," *TBD* October 28, 2010, accessed February 2014.http://www.tbd.com/articles/2010/10/leslie-waffen-ex-national-archives-directors-home-raided-profile—26689.html.

2. Eric W. Morris, "Leslie Waffen, Ex-Archives Worker Sentenced for Stealing Recordings," *Washington Post*, May 3, 2012, accessed February, 2014. http://www.washingtonpost.com/local/crime/leslie-waffen-ex-archives-worker-sentenced-for-stealing-selling-recordings/2012/05/03/gIQAX0f7zT_story.html.

3. Izadi, "Leslie Waffen."

4. National Archives and Records Administration, *Theft of Historical Audio Recordings Investigation Number 11-00021* (2013), 20.

5. Interview with David Goldin (David Goldin's home), in discussion with the author, July 5, 2013.

6. Anne-Catherine Fallen and Kevin Osborn, *Records of Our National Life: American History and The National Archives* (London: GILES, 2009), 22.

7. Interview with David Ferriero (Archivist of the United States, National Archives and Records Administration), in discussion with the author, August 19, 2013.

8. Fallen and Osborn, *Records*, 12.

9. Ibid., 14.

10. Ibid., 18.

11. Todd Samuelson, Laura Sare, and Catherine Coker, "Unusual Suspects: The Case of Insider Theft in Research Libraries and Special Collections," *College & Research Libraries* 73, no. 6 (2012), 556–68.

12. Samuelson et al., 8.

13. Ibid., 8.

14. Association for Recorded Sound Discussion List, Sunday, 16 October 2011 17:26:50, Leslie Waffen, Listerve.LOC.GOV.

15. Ibid.

**Portrait of Adele Bloch-Bauer 1 (Courtesy of Bridgeman Art Library)**

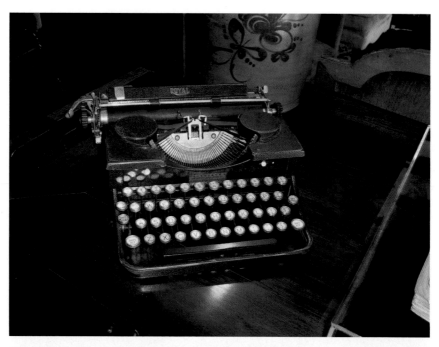

**Pearl Buck's Typewriter (Courtesy of Donna Carcaci Rhodes)**

**Lakota Sioux Ghost Dance Shirt (Courtesy of the South Dakota State Historical Society, Pierre, SD)**

**Babe Ruth Audio Disc: Quail Hunt at Forked River, New Jersey (Courtesy of National Archives and Records Administration)**

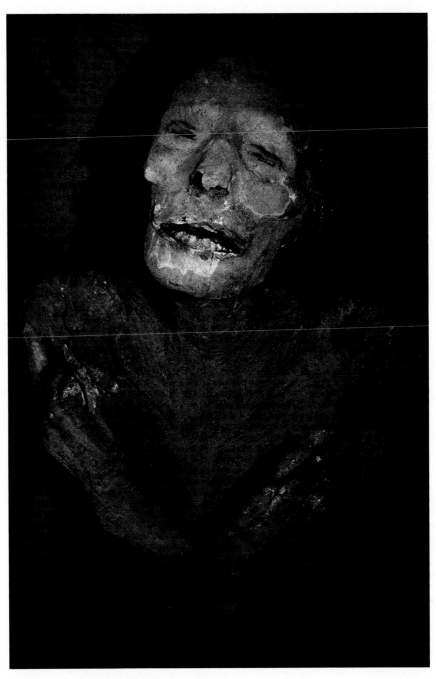

**Ramesses I? (© Robin Davis)**

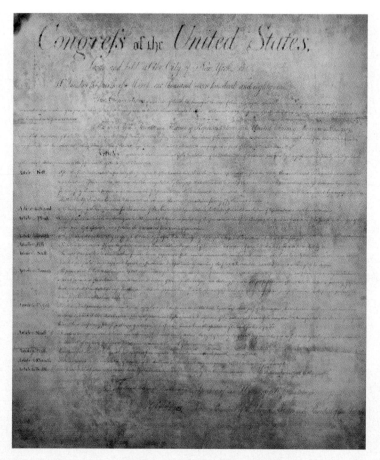

**Bill Of Rights (Courtesy of the State Archives of North Carolina)**

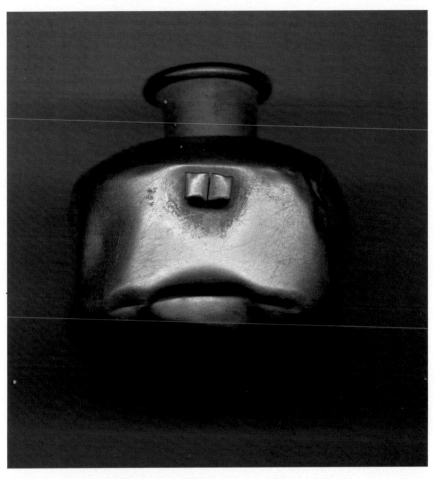

**Sumerian Vessel 3rd Millennium, BCE (Courtesy of Römisch-Germanisches Zentralmuseum, Michael Müller-Karpe)**

Sculpture VI and VII, Bilderrahm, 2007. Courtesy of Kamin-Dichmann Gallery and the artist, Mikhail Malikowskya.

*Chapter Five*

# The Only Pharaoh Outside of Egypt

What is so fascinating about ancient Egypt? Why do we crowd into museums, tune into television documentaries, compose waltzes, paint paintings, devour books, swoon over knockoffs of the jewels painted around the neck of the bust of Nefertiti, and cherish plastic miniatures of the Sphinx? What is it about these ancient people that spark such Egyptomania?

I've been asking this question a lot recently and have received many answers: The massive scale of the monuments. The otherworldly beauty of the antiquities. The mystery of the tombs. The exotic figures with their faces in profile. Cleopatra. The Pharaohs. The Pyramids. The Rosetta Stone. There is certainly a lot of ancient Egypt to love.

Whatever the reason for the public's passion for all things Egypt, it's a passion that has been around for a long, long time, since well before Herodotus the Greek wrote about it after his visit in 450 BCE. And, since the early 1800s, Westerners have endured backbreaking work and dangerous conditions to dig for treasures in Egypt's sands, hills, and cliffs. In 1887, Gaston Maspero, director of Egyptian Antiquities, described the passion that motivated him and other Egyptologists:

> The Valley of the Nile is, in short, one great museum, of which the contents are perhaps one-third or one-fourth part only above ground. . . . Exploration in such a land as this is a kind of chase. You think that you have discovered a scent. You follow it; you lose it; you find it again. You go through every phase of suspense, excitement, hope, disappointment, exultation. The explorer has need of all his wits, and he learns to use them with the keenness of a North American Indian.[1]

All of this goes far in explaining the allure of ancient Egypt to both layman and specialist. I believe that mummies are a big part of it, too. When

ancient Egyptians have been especially well preserved, their faces and bodies, though shriveled and black, are unmistakably human. We sense their spirit and can imagine them thousands of years ago walking the same earth that we traverse today. Much can be learned about a lost civilization from painted walls and inscribed pots, but a mummy can step out of the past and drag you back in.

I thought about this when I read about the repatriation of an Egyptian mummy from the Michael C. Carlos Museum in 2003. Part of Emory University, the Carlos collects and presents art and artifacts from antiquity to the present. The big news about this particular event was that there was significant evidence to suggest that this was a very special mummy, a royal mummy that may actually have been Ramesses I, the founder of the illustrious Nineteenth Dynasty, 1292–1190 BCE. None other than Dr. Zahi Hawass, director general of the Supreme Council of Antiquities of the Arab Republic of Egypt and the country's most celebrated Egyptologist, had declared the mummy a royal and helped orchestrate its return to Egypt. The fact that the royal mummy had lost his coffin and almost all of his bindings and was naked except for his wrapped genitalia and a bit of fine linen around his neck made this identification especially significant. If Hawass was convinced this naked mummy was the real deal, so was I.

Unfortunately, there was no way to ask Hawass about his verdict in person, because he had not left Egypt since he relinquished his post in the summer of 2011. It would be impossible to write about this royal mummy without interviewing the man who had helped bring him home, so I filed the idea away. That's where matters rested until early 2014, when an email appeared in my computer announcing that Dr. Hawass was going to lecture at the Penn Museum of Archaeology and Anthropology—where, as it happened, he had earned his Ph.D. in Egyptology. I quickly contacted Pam Kosty, the museum's public relations director, who in turn contacted Hawass. A couple of days later, I was on my feet clapping along with the rest of the audience as the regal gentleman took the stage.

A striking, square-built man with penetrating black eyes and a high-energy charisma, Hawass is one of those rare combinations of scholarship and showmanship. He is as close to a superstar as archaeologists get, with his own television documentary series and even a line of Indiana Jones-style clothing. In his day, Hawass chaired the committee that decided who could excavate in Egypt and under what conditions. He capitalized on the world's Egyptomania for his country's benefit, instituting admission fees at ancient sites and using the millions generated from the blockbuster exhibits he helped curate to preserve and protect ancient monuments. Hawass's website features a gallery of celebrity photos, all of which include him, as well as his impressive and extensive bibliography: scientific articles, books, encyclope-

dia entries, picture books, guide books, newspaper and magazine articles in Arabic and English. One wonders when he has time to sleep.

"I am proud I put the pharaohs in the hearts of people all over the world," he told me when we met after his lecture.

"So, how did you get into this line of work?" I asked.

"When I was a kid in Egypt, people didn't know about archaeologists," he said. "I originally wanted to be a diplomat, but I failed the exam. Archaeologists were government employees. The government sent me to excavate, and it became my passion. When I began, our antiquities were in the hands of foreigners. I trained Egyptian archaeologists to be the best."

We quickly got onto the topic of the repatriation of the royal mummy, and I could see that Hawass was very proud of this, too. He had gone to Atlanta to lecture at the Carlos Museum. There, he met the museum's director, Bonnie Speed, and a curator, Peter Lacovara, and learned that the museum had recently acquired a cache of Egyptian mummies, coffins, and other funeral material from a museum in Niagara Falls, Canada, that was called the Niagara Falls Museum and Daredevil Hall of Fame. One of the mummies might have been taken from a cache of royal mummies and funeral objects discovered in the mid-1800s near Luxor.

"It had been stolen by the Abd el-Rassul grave-robbing family, which operated in Luxor," he said. "It came from a cache that was filled with other mummies and funeral objects."

That struck me as odd. "Why did the Abed el-Rassul family want to steal a mummy?" I asked.

"Someone in Luxor may have said, 'I want a mummy,'" he responded.

*Aha,* I thought. *Perhaps some tourist wanted a scary Egyptian souvenir.*

"At the time there was no royal mummy outside the Cairo Museum," Hawass continued. "I said I want to see the mummy on display in the museum before giving the lecture. I took a look. The mummy's nose looked like the nose on Seti I and the nose on Ramesses II. The mummy's arms were crossed in the position reserved for royals. I took one sniff, and I knew it was a royal."

After our meeting, I reviewed my notes and realized that each of Hawass's statements sparked many more questions. He had mentioned a grave-robbing family in Egypt, the Abed el-Rassuls. How did Hawass know their name? Wasn't notoriety bad for the grave-robbing business? Hawass said this royal mummy was discovered in a tomb with a number of other mummies. But, weren't pharaohs buried one per tomb? Why did the mummy's nose mean that this might be a royal, maybe even Ramesses I? What was this about Hawass being able to sniff out kings? How exactly did that work?

So, after Hawass's brief introduction, I set off to discover Ramesses I's roots and search for the connection between the ancient pharaoh and the

naked mummy from Niagara Falls. Along the way, I found a host of very colorful characters. Egypt seems to attract colorful characters.

The first thing I learned was that the truth is a moving target in Egyptian archaeology. This has nothing to do with a lack of material. There are sizable Egyptian collections in the national museums in Cairo and Luxor, the British Museum, the Louvre, the Metropolitan Museum of Art, the Neuse Museum in Berlin, the Penn Museum of Archaeology and Anthropology, and many others around the world. There are countless antiquities owned by the heirs of explorers and travelers and the entities connected to them. There are reams of scientific papers and periodicals and thousands of books and reports in multiple languages by both professional Egyptologists and amateurs, some of whom imagine themselves as professional Egyptologists. Nevertheless, researching ancient Egypt can feel like staggering through a maze without a map.

There are several reasons for this. Egyptology seems to attract consummate storytellers, and the Egyptians themselves sometimes embellish their own stories for effect. More to the point, the science of Egyptology is always evolving. New information turns up all the time as Egyptologists discover new sites, revisit old ones, and re-examine artifacts long out of the ground and stored in museums. Yesterday's facts become today's hypotheses, which may or may not lead to new questions for the future. That is why Egyptologists are careful about using absolutes; they are more prone to say something is likely, as opposed to true. They are not willing to say a naked royal mummy is Ramesses I unless the evidence is irrefutable.

"In Egyptology, it's never the case that everybody agrees," Peter Lacovara told me when I went to see him in his home in Albany, New York, on a bright October day. He greeted me at the door of his stately Victorian house in a plaid shirt and blue jeans, and led me into the front parlor. Though he looked much too young to be a retiree, Lacovara had recently retired from his position as senior curator of Ancient Egyptian, Nubian, and Near Eastern Art at the Carlos Museum. He had just launched a new nonprofit, the Ancient Egyptian Archaeology Trust, and was preparing for an extended trip to Egypt to restore a palace that the Metropolitan Museum of Art excavated about a hundred years ago. "There's certainly a need to work in Egypt these days," he said. "All of these sites are threatened, so we've got to do what we can now."

I looked around at his parlor. It was clear from the floor-to-ceiling shelves stuffed with books and Egyptian trinkets that ancient Egypt had long been an abiding passion. "I've been acquiring the library for over thirty years," he said. "You need a lot of books, especially since good Egyptological libraries are few and far between."

"Why are so many people so fascinated with Egypt?" I asked, while admiring a lovely Egyptian Revival clock that reminded me of the objects

made in France soon after Napoleon returned from Egypt in the early nineteenth century.

He thought for a moment. "I think it's a lot of things—the age, the mystery, beautiful things. Egyptian antiquities are easy to relate to. The art from other ancient peoples in places like South and Central American and Asia is a bit removed from our aesthetic, so it's not immediately accessible. Egyptian art is nearer to the way we depict things. The people look like us."

I said, "I know you were instrumental in bringing a royal mummy to the Carlos Museum and returning it to Egypt. Did you think that it was Ramesses I?"

"Actually, we are not sure it is Ramesses I," he answered. "There is enough evidence to say for certain that this mummy is a royal from the New Kingdom, but not enough to prove beyond a reasonable doubt that it's Ramesses I. The evidence is key. You need to look at the evidence."

When I looked into it, I was surprised by how much evidence there actually was about Ramesses I, given that he was born around 1330 BCE. To understand his life and times, we must first understand where he fits into the three thousand years in which the pharaohs ruled Egypt. During this time, there were some 350 kings, most of whose names we know from ancient Egypt's "king lists." The three thousand years are divided into kingdoms— the Old Kingdom, the Middle Kingdom, and the New Kingdom—with numbered intermediate periods in between. These periods are divided into dynasties. An Egyptian prince named Manetho is credited with this classification system, which clusters the descendants of each king in a single dynasty. Ramesses I lived in the New Kingdom, Nineteenth Dynasty.

Ancient Egyptians sought immortality. Their literacy, as well as their luck, took them a long way towards this end. They left exquisite records: hieroglyphics written onto papyrus and also incised on the walls of tombs and temples and monumental statues and steles. These, along with colorful wall paintings, document virtually every aspect of their life, every hope for their afterlives, every custom and religious ceremony. The luck lay in their hot and arid climate, which retards the disintegration of organic material. Tombs are the perfect environments in which to preserve ancient bodies and possessions. Such preservation was critical because the dead needed an intact body and an eternity's worth of goods in order to enjoy the next chapters in their existence. Many of the wall paintings, statues, pottery, weapons, musical instruments, and other funerary items remain remarkably fresh even today.

Some Egyptologists believe that succession passed through the female line: the pharaoh's oldest daughter was the legal heir to the kingdom, though a pharaoh generally selected a son as the actual heir, and the son usually married his sister to signify his right to the throne. A pharaoh could have as many wives as he wished, but there was only one, generally his sister, who

counted as his queen. A dynasty ended when a pharaoh ran out of descendants.

That happened in 1319 BCE, when Horemheb, the last pharaoh of the Eighteenth Dynasty, had produced no heirs and, therefore, appointed his most trusted adviser, Paramessu, to succeed him. Horemheb was not of royal blood, and neither was Paramessu: both were military officers who had spent twenty years re-establishing order after the chaos left by the iconoclastic Pharaoh Akhenaten and his followers. When Horemheb became pharaoh, he acknowledged his debt to Paramessu by appointing him vizier, awarding him a string of impressive titles—Master of the Horse, Commander of the Fortress, Controller of the Nile Mouth, Charioteer of His Majesty, King's Envoy to every Foreign Land, Royal Scribe, General of the Lord of the Two Lands—and, eventually, leaving him the throne.[2] Some believe Horemheb selected Paramessu as his successor because Paramessu had a son and a small grandson, which promised a stable line of dynastic succession. A stone head from a statue of Paramessu is now at the Museum of Fine Arts in Boston, its blank face surrounded by a cap of stylized hair.

When Horemheb died, Paramessu was forty, rather old for the time. He took the name Menpehtyre Ramesses, which means "eternal is the strength of Re, Re has fashioned him." In hieroglyphs, the name is represented by a circle with a bull's eye, next to something akin to a pitchfork, next to a staff, next to a stalk with four leaves, next to a standing bird in profile. Menpehtyre Ramesses, or Ramesses I, shared the throne with his son and heir Seti I, who seemed to hold his father in especially high regard: the evidence can be seen in inscriptions and in the chapel that Seti I built in honor of his father at Abydos. The chapel is now in New York City at the Metropolitan Museum of Art.

The Nineteenth Dynasty spawned by Ramesses I was a Golden Age, an era of great luxury, high artistic achievement, and general well-being, especially for the royals and the wealthy. They slept on beds with linen sheets and feather pillows; in their homes, oil lamps diffused through alabaster illuminated the dark. The women rouged their cheeks, reddened their lips, darkened their eyelashes, and dyed their hair. The children played with rag dolls, hoops, and toy figures, went to school, and learned to read and write. Parents attended parties at which they were entertained by singers, orchestras, and dancers, played table games, and gambled with dice. Skilled physicians took care of them when they were sick, treating ailments with potions that mixed pharmacology and sympathetic magic.

Ramesses I died unexpectedly. The evidence is that his tomb was only partially completed at the time of his death. His body was mummified and placed in his unfinished tomb in the Valley of the Kings near Thebes, where other New Kingdom rulers were buried. If you were anybody in Egypt you were mummified, because an intact body was essential in order for your soul

or *ka-spirit* to live on. In predynastic times, Egyptians buried their dead in arid desert sands that dried out organic material like body parts, a form of natural mummification. When they began to place their dead in sealed tombs, the bodies were better protected from the elements but also more likely to decay. That's where mummification came in.

Mummification practices changed over time and were more or less elaborate depending on the embalmer's skill and the family's wealth. Ramesses I received the royal treatment. After he died, embalmers sliced across the body from the hipbone to the pubic area close to the thigh and extracted the liver, lungs, stomach, and intestines, which were placed in canopic jars, special vessels Egyptians used to hold body parts. Embalmers then inserted linens soaked in expensive resin deep into the incision to absorb moisture and retain Ramesses I's body's shape after it was wrapped. The heart, which Egyptians considered the source of all knowledge and center of the soul, was left in place. Ramesses I's brain was removed in a particularly pragmatic and gruesome manner. The embalmer took a chisel and inserted it into the left nostril until it broke the ethmoid bone that separates the nasal cavity from the brain. After that, the embalmer took a metal rod with a tiny ladle at the end, stuck it up the nostril into the brain, swirled the rod around until the brain broke into tiny pieces, and scooped the pieces out with the ladle. Then the rod was extracted, resin poured into the hole, and the skull filled half-full. Ramesses I's nails were then painted, possibly with henna. By the time the process was over, what had once been a balding, late middle-aged man had become a shiny black mummy with orange fingernails.[3]

As befitting a king, Ramesses I's genitalia were wrapped separately, and his toes were splayed; perhaps each was wrapped separately and encased in a golden toe stall. His arms were crossed over his chest, right over left, with the left hand clenched, probably to hold a royal scepter. Finally the embalmers sewed up the incision on the side of the body or sealed it with resin, then waterproofed the entire body with a resin layer.

When this was done, Ramesses I was ready to be wrapped in linen, a process that took fifteen days and many solemn priestly prayers, and placed in a painted wooden coffin with a royal portrait carved on its lid. Mourners, perhaps including some hired for the occasion, escorted the king to his tomb in the Valley of the Kings directly across from the tomb of his patron, Horemheb. Ramesses I's coffin was placed in his red granite sarcophagus, the crypt was filled with a wealth of funerary statues and goods, and the tomb was sealed—forever, it was hoped. Except for the priests responsible for funerary rituals, it was forbidden for anyone to enter the tomb and disturb the dead, especially a pharaoh. Archaeologist James F. Romano explained this as follows:[4]

If the mummy or tomb statue were damaged or destroyed, if the deceased's
name were somehow forgotten, if the appropriate offerings were not left, or if
the *ka-* priests neglected their responsibilities to the funerary cult, the *ka* would
cease to function as an animate force with ties to the living. Rather, it would
face an eternity of dark, formless oblivion. This was the ultimate fear of the
ancient Egyptians.[5]

For virtually all of Egypt's most illustrious pharaohs, this ultimate fear
became a reality. Despite their best efforts to hide tombs in secure locations
in the most inhospitable terrain, grave robbers have successfully looted
tombs since antiquity: the draw of their treasures has been just too much to
resist, especially in times of economic turmoil. By the time Western archae-
ologists arrived in the Valley of the Kings in the early 1800s, every tomb
they found had been opened. In a number of cases, even the pharaoh himself,
in the form of a mummy, was missing.[6]

This was Ramesses I's fate. Within four hundred years of his burial, his
eternal life fell victim to a wave of ancient tomb robbing. His tomb was
penetrated, the gold and other valuables removed, and his sarcophagus vio-
lently pried open.

But nobody knew that Ramesses I was missing from his tomb until 1817,
when an Italian circus strongman-turned-water engineer-turned-explorer
named Giovanni Baptista Belzoni chanced by the entrance to Ramesses I's
tomb while touring the Valley of the Kings. Belzoni and his wife had come to
Egypt to sell hydraulic irrigation machines to the Viceroy, but when that
scheme failed, Belzoni was hired by British Consul Henry Salt to move
colossal Egyptian monumental sculptures from their sandy resting places
down the Nile and back to England. You might wonder why Egyptians were
willing to let foreigners remove their precious cultural heritage, until you
realize that the Egyptians were not in charge. At the time, Muhammad 'Ali,
the Viceroy of Egypt under the Ottoman Turks, was keenly aware of the
economic and political potential of Egypt's antiquities, so he offered Western
nations permits to excavate ancient sites and allowed them to export obe-
lisks.[7]

Belzoni was among the first to rediscover many tombs in the Valley of
the Kings. On his second trip there in October 1817, he stumbled upon a
small one. As he later wrote, "The appearance of the entrance indicated it
would be a very large one, but it proved to be only the passage of one that
was never finished." This one belonged to Ramesses I.

If you would like to see Ramesses I's tomb, it can be found on a website
created by the Theban Mapping Project.[8] The address of the tomb is KV16.
When I found it on the website, I opened a cross-section of Ramesses I's
tomb and imagined what it would have been like to join Belzoni in his
discovery. I imagine standing next to him as he lights a torch and leads me

down a long flight of stairs, a downward-sloping corridor, and another flight of stairs, the temperature dropping slightly as we descend. At the base is a small chamber dominated by a large red granite sarcophagus with a damaged lid. I imagine Belzoni holding his torch close to the wall as together we admire the beautiful figures with faces painted in profile.

"The painted figures on the wall are so perfect that they are the best adapted of any I ever saw to give a correct and clear idea of the Egyptian taste,"[9] Belzoni later wrote.

"It's the Book of Gates, a guide to the underworld," I comment to him.

We look around. Much of the funerary equipment is missing, and so is the mummy.

Belzoni published an account of his discovery of what is now known to be the tomb of Ramesses I. It had the same long corridors and style of wall painting as of the tomb of Ramesses' famous son, Seti I, but it was much smaller because it was incomplete. Ramesses' sarcophagus was broken, and his casket and mummy had been missing since antiquity. Where did it go? Why would anyone steal a mummy?

The answer to these questions lies in an incident that occurred around 1860 at the cliffs of Dier el-Bahri, located near the Valley of the Kings. In that year, two brothers, Mohammed and Ahmed Abd el-Rassul, came across a shaft cut deep into the raw grey rock. They thought it might lead them to a tomb. Ahmed let himself be lowered down on a rope until he hit bottom. He found a sealed tomb entrance, broke through, entered a passage, and eventually came to a burial chamber that was filled with funerary statues, canopic jars, libation jars, a funeral tent, and coffins with strange inscriptions on them. When Mohammed joined him, the brothers could see that this was a remarkable find, valuable enough to support their family for years. They knew they needed to keep it secret. Late that night they returned to the tomb and deposited a dead donkey in the shaft, reasoning the noxious odor of its decay would keep the others away. By selling a small number of items at a time, they would maximize their value and avoid detection by the authorities. The Abd el-Rassul brothers arranged for a respected dealer, Mustapha Aga Ayat, to sell their antiquities.

"Zahi Hawass told me that the Abd el-Rassul family were grave robbers. Was this true?" I asked Lacovara.

"Yes," he answered, "there were lots of grave-robbing families and a couple of famous ones in Luxor. The Abd el-Rassul family was the most famous. They were the Donald Trumps of tomb robbery." He smiled.

"Was it a respectable occupation?" I asked.

Lacovara paused, thinking this over. "Well . . . not from our perspective. But they certainly became very wealthy from it and they seemed to do well. They continued on, they opened a big hotel with the proceeds, and they're

still around. They worked for the Antiquities Service. They are a very color-ful bunch."

Soon after the brothers' discovery, a small number of items bearing royal insignia began to appear discreetly on the antiquities market. They were soon traced back to Mustapha Aga Ayat. By 1881, the Egyptian government had learned that royal antiquities were being purchased; they sent the German archaeologist Emile Brugsch, a former assistant to Gaston Masparo, director of the Egyptian Antiquities Service who was then out of the country, to investigate. Posing as a tourist, Brugsch began buying antiquities in Luxor, becoming familiar with the locals, and eventually learned that the Abd el-Rassul family was the source of these special goods.[10] The government cracked down hard on the brothers, first attempting to bribe them into telling the source of the royal antiquities and, when that failed, brutally torturing them.

Eventually, another brother revealed the secret source in return for a hefty bribe. Mohammed Abd el-Rassul then agreed to take the officials to the secret tomb. He led Brugsch and Police Inspector Ahmed Effendi Kamal up a steep cliff at Dier el-Bahri to the hidden opening in the rock, dropped a coil of rope down the hole, and invited Brugsch to let himself down. At the bottom of the shaft, Brugsch found a breathtaking sight: a room filled with coffins and funerary items. By the light of his torch, Brugsch could read on the coffins the names of some of Egypt's most illustrious kings. Unable to read the inscriptions, the grave robbers had never known the true identities of the inhabitants.

In all, what is now called the Royal Cache held six thousand smaller objects and forty mummies belonging to New Kingdom royalty, members of the priestly families of the Third Intermediate Period, and other unidentified private individuals. Brugsch later described these as "mummies of royal personages of both sexes" and "mummy-cases of stupendous size and weight."[11] Included was Ramesses I's illustrious son, Seti I, and even more illustrious grandson, Ramesses II. They also found the damaged coffin with Ramesses I's name on it. There were some linen wraps inside, though the mummy itself was missing. But Ramesses I had originally been buried in his own small tomb, not the Royal Cache. How did he get to the Royal Cache in the first place?

As it turns out, Ramesess' mummy was moved out of his tomb during antiquity. Ramesses I lived in the Nineteenth Dynasty, and by the Twentieth Dynasty his tomb already had been breached. In the Twenty-First Dynasty, the high priests of Amun removed many of the royal mummies whose tombs in the Valley of the Kings had been violated. They reconsecrated the mum-mies and placed them into the Deir el-Bahri cache and another tomb. Accord-ing to dockets found in the Deir el-Bahri cache, Ramesses I's mummy and

the mummies of Seti I and Ramesses II were interred there during the Third Intermediate Period. [12]

I wondered why anyone would want to move the mummies.

"The high priests said they removed the mummies for their safekeeping," Lacovara said, "but it was actually to recycle all their gold and jewels for their own king. There was all that wealth just sitting in the tombs, so it was sort of official tomb robbery. We know the army must have done it, since no tomb robber would have been strong enough to move the top off of a heavy sarcophagus."

Ramesses I's casket showed that his mummy had been placed in the Royal Cache in ancient times. By the time the Egyptian officials arrived in 1881, it had been removed. The next time we see the mummy is in the Niagara Falls Museum and Daredevil Hall of Fame more than one hundred years later. How did he get there and why?

Peter Lacovara has a theory about this. He thinks that one of the first coffins the Abd el-Rassuls found when they entered the Royal Cache still held the mummy of Ramesses I. They pried open the coffin and unwrapped the mummy, looking for the gold and jewels typically found in the wrappings. When they realized there was none, the grave robbers surmised that none of the mummies held riches. Lacovara thinks that Ramesses I's unwrapping may have saved the other mummies from having their caskets destroyed and their bodies unwrapped. Remember, the grave robbers had no idea these were royal mummies, because they couldn't read the inscriptions.

In any case, sometime before 1861, the Abd el-Rassuls moved the unwrapped mummy out of the tomb, carried it to Luxor, and gave it to Mustapha Aga Ayat, the dealer, who sold it to a Canadian for the Niagara Falls Museum. At least that's what some Egyptologists think happened.

The Niagara Falls Museum was Canada's first museum, founded in 1827 by Thomas Barnett, an enterprising entrepreneur who decided to move his personal "cabinet of curiosities" into a retrofitted former brewery house and charge admission. By 1844, the museum, geared to Niagara Falls' growing tourism market, held more than five thousand items, including specimens of mammals, birds, fish, shells, reptiles, and Native American artifacts. Beginning in the mid-1850s, in order to capitalize on the public's passion for exotic Egypt, Thomas Barnett sent his son, Sidney Barnett, across the seas to purchase antiquities. On one of those trips, Sidney Barnett was accompanied by Dr. James Douglas, who purchased for Barnett four mummies and other items from Mustapha Aga Ayat. [13] Egyptologists hypothesize that Ramesses I was one of these mummies, part of the inventory that Mustapha Aga Ayat received from the Abd el-Rassul family.

"At the time, people were looking for mummies as souvenirs," Lacovara told me. As evidence, there is a period photograph of a fez-wearing Egyptian

dozing next to two erect mummies propped against a wall, one of them naked.[14]

"One of the few things we do know is that Mustapha Aga Ayat, who was working with the Abd el-Rassuls, was the same guy who sold mummies to James Douglas for the Niagara Falls Museum. We assume, although we don't have exact proof, that the mummy they got from Ayat was Ramesses I."

"And how do we know that the mummy had been removed from the Royal Cache by the time the Canadians came mummy-hunting?" I asked.

"The discovery of the tomb had to date to the 1860s," Lacovora replied, "and there is some evidence that supports this."

The first piece of evidence is a portion of the ancient papyrus of Nodjmet that the Prince of Wales acquired in Egypt during his tour in 1869 and donated to the British Museum.[15] The papyrus came from the Royal Cache, which means that the Abd el-Rassuls were already bringing royal items to market by that time. The second piece of evidence is a reference from 1881 by author Amelia Edwards, who visited Egypt in the 1870s. She wrote: *"for the last twenty-two years,* the hiding place at Dier el Bahari has been known and plundered by the Arabs."[16] Subtract twenty years from 1881 and you get 1861. Linked together, these bits of circumstantial evidence suggest that Ramesses I's mummy may have appeared on the market just when the Canadians were in Egypt shopping.

The mummy likely to be Ramesses I and the other antiquities were transported by boat to Canada and placed in the Niagara Falls Museum, where they entertained and frightened tourists for more than 120 years. The naked royal mummy remained on display as the museum moved and moved again, adding the words "Daredevil Hall of Fame" to its name in honor of those brave or crazy enough to ride over Niagara Falls and acquiring new items: Japanese and Chinese relics; an egg collection; a giant Sequoia tree seventy-seven feet in circumference; a shell and coral collection; Eskimo, Asian, and South Sea Island items; and the remains of a forty-foot skeleton of a humpback whale. Sometimes the mummy was displayed in a coffin and sometimes he was set out on a shelf, his private parts discreetly covered with a blanket. The mummies and coffins were mismatched and damaged as they were moved and reinstalled.

In 1878, the Barnetts sold their museum to the Davis family, who later purchased five more Egyptian mummies. Some years later, the owners moved the museum across the river to Niagara Falls, New York; later still, they moved it back to the Canadian side of the river, where it was installed in the Spirella Corset Factory, the only suitable vacant building capable of housing a collection that had grown to a remarkable seven hundred thousand items. In 1999, the Niagara Museum and Daredevil Hall of Fame finally closed its doors to the public.[17]

I had read that a Toronto-based dealer, William (Billy) Jamieson, had purchased the entire collection of the defunct museum. I was curious to know who would buy seven hundred thousand oddities, so I went online to see whether I could find his contact information and came across his obituary. It described him as one of the world's foremost dealers in quality tribal and ancient art, whose clientele featured rock stars and major museums, and whose home sported an electric chair and a collection of shrunken heads. [18] According to one account, Jamieson bought the museum's collection after drinking opium tea. Among the persons mentioned in the obituary was Gayle Gibson, who worked in the education department of the Royal Ontario Museum, so I gave her a call to learn more.

Gayle Gibson has suffered from acute Egyptomania ever since the time she visited the mummies in a museum as a Brownie scout. "After that," she told me, "I went by myself every Sunday on the bus to the museum. I would walk until my feet were bleeding, and I gradually got to know the mummies and became friends with them."

I asked her to tell me about Jamieson. "Billy Jamieson was fun beyond belief, just being near him was exciting," she said. He had originally contacted the owner of the Niagara Falls Museum and Daredevil Hall of Fame to ask about buying its New Guinea artifacts and learned that the family was interested in selling the entire collection. It turned out that because the museum was located in the middle of the tourist district, and because casinos were moving into the district, the land was very valuable. Jamieson also learned that the Egyptian items were worth a lot of money—in fact, they could be worth enough to cover the entire two million dollar cost of the museum. He hired Gibson to identify the antiquities and ready them for sale on the web.

"There was competition for the museum collection," Greene remembered, "and Billy needed to get the money to buy it. We had a lot of offers for the Egyptian antiquities. The National Museum of Scotland was very interested."

The community of Egyptologists is small enough so that people generally know when something important goes on the market. Peter Lacovara heard about the Niagara Falls Museum's collection from a Canadian colleague, and he paid close attention. He had recently been hired by the Carlos Museum as senior curator of Ancient Egyptian, Nubian, and Near Eastern Art and was looking to expand its small but popular Egyptian display.

"It's hard to get Egyptian material nowadays—because you want stuff that's legally out of the country, and export stopped in the early 1980s," he explained. "There's a limited supply of items that one can get. I'd always been interested in funerary material, and this was a large number of coffins and mummies." Although the Carlos had no acquisition budget, he decided to go to Niagara Falls to take a look.

Billy Jamieson made quite an impression on Lacovara when they first met. "He was tall, all dressed in black, and drove a fancy sports car. You could tell there was something odd about him. He was a shrunken head collector, interested in weird, macabre stuff." Jamieson took Lacovara to the museum. They entered and walked by an Egyptian coffin, up a flight of stairs, and past the barrels that carried daredevils over Niagara Falls, dinosaur skeletons, and other oddities. The place was creepy and dirty, more circus sideshow than museum.

The Egyptian objects were on shelves in a long glass case. The coffins were very beautiful and rare, though badly damaged from having been moved from place to place. Lacovara saw that most of the mummies were in their original coffins, too fragile to have been removed from their resting places. They had not been embalmed very carefully and would have fallen to bits if they had been disturbed. He noticed that one mummy was unwrapped; its arms were crossed over its chest. Could this be a royal mummy?

Lacovara was not the first professional Egyptologist to have asked himself this question. In the 1980s, Dr. Arne Eggebrecht, a distinguished authority, had accompanied a German television crew to the Niagara Falls Museum to produce a documentary on another mummy they had been led to believe might be Queen Nefertiti. The cameras were set up. The wrap was pulled back. All looked down on the mummy and saw . . . male genitalia, which quickly put an end to the intended project. But as Eggebrecht looked around, he spotted a naked mummy with crossed arms and immediately wondered whether it might actually be a New Kingdom royal. In fact, he was so convinced that when he returned home, he wrote down the names of each of the pharaohs whose mummy he thought this might be, went to his attorney, and had the paper notarized. One was Ramesses I. Around the same time the mysterious mummy was X-rayed; the film revealed packages in the chest cavity, which Eggebrecht thought were "organ packets." No New Kingdom royal mummy would have organ packets, so there was no way this could be Ramesses I. That's where the matter rested until Peter Lacovara showed up.

Jamieson was asking two million dollars for the 145 Egyptian items, including nine mummies, nine coffins, and random arms, legs, and feet. The money had to be delivered within two months.

"I thought two million dollars was high but not outrageous," Lacovara said. "The coffins were quite nice but needed a lot of conservation. They had been very badly neglected and cared for, but they had an interesting history. It's so hard to get that kind of material these days, especially in bulk."

Lacovara returned from Toronto and soon made his case to the museum's board of trustees. They were very enthusiastic—after all, Egypt is the most popular topic in most museums—but wanted to make sure the collection was up to snuff. Lacovara returned to Canada with the museum's conservator. They took a careful look at the coffins, mummies, and everything else, and

decided that the collection could be restored to its former glory and would make a sensational display. The board enthusiastically set out to raise the two million dollars. Soon local newspapers joined in the campaign, and contributions began to flow in from corporations, foundations, and even school children.

Lacovara had, of course, seen the unwrapped mummy with the crossed arms and heard about its possible attribution. So, when he told the board about the acquisition, he was careful to note that the staff was committed to researching this mysterious mummy. If it turned out to be a royal, he explained, it was important to return it to Egypt.

I asked Lacovara's former boss, Bonnie Speed, about this. Since I am a former museum director, I knew how hard it was to raise two million dollars in only two months. How could the museum sanction buying the mummy only to give it away?

"There was never any question," she said when I called. "As soon as we knew it might be a royal mummy, we knew we had to give it back. Think about it. If the Egyptians happened to have the coffin of George Washington, why would they want to keep it?" Soon after purchasing the mummies, the Carlos had promised in a letter to the Egyptian government to send the mummy back if it were determined to be a royal.

Within a few weeks, the Carlos staff was back in Canada, handling some emergency conservation and packing the Egyptian collection for its trip to Atlanta. Soon after it arrived, they made good on their pledge to learn what they could about the identity of the unwrapped royal mummy. Emory University Hospital agreed to help. Over the next two years, the mummy was subjected to X-ray and computed tomography scans resulting in hundreds of images and enabling the technicians to compile a three-dimensional reconstruction of the body. Tests verified that the mysterious mummy had received the royal embalming treatment. His right arm crossed over the left arm across the chest was further evidence, since this position was reserved for royal males of the New Kingdom. His jaw line and distinctive large hooked nose matched those of Seti I and Ramesses II. On the basis of his spinal degeneration, the doctors estimated that he was at least forty-five years old at the time of his death and likely died of chronic mastoiditis, an inflammatory condition generally caused by repeated ear infections. If Ramesses I were alive today, antibiotics would have cured his condition. As it was, he likely died in excruciating pain.

I had been mulling over a question for a couple of days. "Do you think it's disrespectful to take an ancient individual and put him through [computed tomography] scans and other tests?"

Lacovara looked at me quizzically. "No, you wouldn't think it's disrespectful when he was alive, so why would you think it's disrespectful when he's dead?" Then he went on.

"For ancient Egyptians, public displays were a bit part of their mortuary tradition. They wanted to be part of this life; they wanted to be seen after they were dead. The most important thing was to remember them and see them and look at them. So it's far from disrespectful, it's what they would have wanted."

Ancient Egyptians spent more for their tombs than for their homes. They bought their caskets well before they died and filled them with a houseful of items. All of their investments—and there were many—were made because they wanted to live forever.

There's an ancient Egyptian inscription that reads, "To speak the name of the dead is to make them live again." I thought about this lovely sentiment when I read about the four-month exhibit that the Carlos staged as a send-off for this royal mummy. Thousands of visitors came. Hundreds of thousands more heard his name spoken repeatedly during a NOVA documentary, titled, "The Mummy Who Would be King," which was broadcast on PBS. I recently watched the show and saw many who were touched by the naked royal mummy: the radiologist, the Canadian museum educator, Gayle Gibson, Billy Jamieson, Bonnie Speed, and Peter Lacovara. I watched as Salina Ikram, an Egyptologist from American University Cairo, noted the many parallels between this mummy and that of Seti I, gave it a sniff, and commented that this mummy lacked the odor associated with poorly preserved specimens. Then I watched Zahi Hawass perform his special sniff test and identify "this royal mummy." He had smelled many, many mummies, so he should know. As I said, if Hawass says it's the real deal, then so do I.

Hawass and the Carlos made arrangements for transporting the royal mummy back to Egypt. On the day of departure, it was rolled out of the museum in a large crate covered with the American and Egyptian flags and sent off by singing schoolchildren. When the mummy who may be Ramesses I arrived via Air France at the Cairo Airport some hours later, more than two hundred members of the media from all over the world greeted him. "I have never in my life seen anything like it," Hawass remembered. "It was as if a live king had arrived!"

Today, the royal mummy occupies a room of his own in a museum in Luxor. Nearby is a sign explaining that he is a gift from people of Atlanta to the people of Egypt. He's identified as a royal mummy. Ramesses I's name isn't mentioned.

But should it be? There is a great deal of evidence from 3300 BCE forward that links this mysterious mummy to Ramesses I. Unfortunately, all of it is circumstantial.

I know what would convince Peter Lacovara, the Egyptologist who identified him, and Zahi Hawass, the Egyptologist who brought him home. If this royal mummy has the same DNA as his alleged son, Seti I, and grandson, Ramesses II, his true identity as Ramesses I would be irrefutable. Unfortu-

nately, DNA testing of mummies is problematic, since the ancient embalming process can distort or destroy DNA. Moreover, ancient specimens can easily become contaminated as they pass from hand to hand.

Nevertheless, using cutting-edge technology, the mysterious royal mummy was recently DNA tested. Hawass believes it proves he is Ramesses I. Lacovara isn't quite convinced. As usual, Egyptologists don't agree.

But, you can go and see him for yourself. Ramesses I awaits your arrival in the museum in Luxor. His empty tomb stands in the desolate Valley of the Kings, and the site of the Royal Cache is close by in the barren rocky cliffs of Deir el-Bahri. You can visit his descendants and other royals from the Royal Cache in the Cairo Museum. In the meantime, we all can ponder a remarkable fact told to me by the great Zahi Hawass himself: "Only thirty percent of Egyptian monuments have been discovered. A full seventy percent have yet to be found, they are still underground."

That means Egyptologists will be excavating, sorting, testing, publishing their findings, and disagreeing with other Egyptologists for decades, maybe even centuries into the future. And that's good news for all who revel in Egyptomania.

## NOTES

1. Ibid., 12.

2. "Carlos Museum," www.carlos.emory.edu/.

3. Darrell D. Baker, *Encyclopedia of the Pharaohs: Predynastic to the Twentieth Dynasty 3300-1069 BC, Volume 1* (United Kingdom: Bannerstone Press, 2008), 306–07.

4. James F. Romano, *Death, Burial, and Afterlife in Ancient Egypt*, Carnegie Museums, (Pittsburgh, PA: Carnegie Museum of Natural History), 38.

5. Ibid.

6. F. Gladstone Bratton, *A History of Egyptian Archaeology* (London: Robert Hall, 1967), 136–38.

7. Stephanie Moser, *Museum Display, Representation, and Ancient Egypt* (Chicago: University of Chicago Press, 2006), 94.

8. "Tomb of Ramesses I, Theban Mapping Project," www.thebanmappingproject.com.

9. Giovanni Battista Belzoni, *Travels in Egypt and Nubia* (Italy: White Star Publishers, 2007), 206.

10. Dylan Bickerstaffe, "The Royal Cache Revisited," JACF, *The Institute for the Study of Interdisciplinary Sciences*, 10(2005), 9–25.

11. Ibid.

12. "Carlos Museum."

13. "Niagara Museum," http://www.niagaramuseum.com.

14. Felix Bonfils, *The Mummy Seller* (1883).

15. "The Royal Cache," 22.

16. Ibid.

17. "Niagra Museum."

18. Lindsay Bourgon, "Bill Jamieson Was a Treasure-Hunting Rarity," *The Globe and Mail*, July 29, 2009, http://www.theglobeandmail.com/arts/television/bill-jamieson-was-a-treasure-hunting-rarity/article4260507/.

# Chapter Six

# Selling History

Civil War soldiers loved Civil War trophies: they plucked them from battle-fields, secreted them out of prisons, removed them from plantation mansions and public buildings, placed them in their knapsacks and carried them home. Today, Civil War buffs—and there are many of them—love these relics. I have personally witnessed grown men and women of otherwise sound minds swoon over hunks of logs with bullets still lodged in them, corroded can-teens, pocket watches with smashed faces, fraying regimental flags, and crumpled Confederate currency. Most of these have modest monetary value. But, once in a while a Civil War relic comes along that's so rare, so remark-able, that it can seduce even an expert, blind his or her professional judg-ment, fill his or her dreams with dollar signs, and set off a cascade of events that can only end in trouble.

That's what happened with North Carolina's copy of the Bill of Rights. Although it had been penned on vellum parchment in 1789, it counts as a Civil War relic because an infantryman had taken it during the Union occu-pation of Raleigh, North Carolina. The document was penned and signed in New York, sent by George Washington to North Carolina's governor Samuel Johnson in 1789, and stolen in 1865. It then traveled to Troy, Ohio; to Indianapolis, Indiana, where it stayed for 134 years; then to Woodbury, Litchfield, and New Haven, Connecticut. It briefly stopped in Washington, DC, Manhattan, and Philadelphia before finally returning home in 2003.

"Everyone who comes here says they want to see it," Sarah Koonts said as she opened the heavy door to the climatically stable vault. We were standing in the basement of the North Carolina Department of Cultural Af-fairs in Raleigh. Koonts, the director of the Division of Archives and Records, led me into the silent, chilled room and turned on the light.

I had just arrived after a ten-hour drive from Philadelphia to Raleigh to see North Carolina's Bill of Rights, even though I could only view it for five minutes. In fact, it had taken all my Northern charm to convince Koonts, its keeper, to allow me any access to a document in such delicate condition, since it had suffered some damage during its many travels. I was happy to make the trip, though, to see it in person and visit the spot where it was stolen.

The storage crypt was banked with metal shelves that held carefully arranged documents and microfilm. Koonts pulled a heavy metal case off one of them until it tipped down, then gently slid it on to the table she had placed below the shelf. She carefully removed a piece of muslin that covered the front of the case. There it was: North Carolina's copy of the Bill of Rights, a fading twenty-seven-by-thirty-one-inch parchment, surrounded by a gold gilt frame. I noticed it had all of the twelve amendments proposed by Congress in 1789. Only ten had been ratified by three-quarters of the states and so became the first ten amendments to the Constitution. Much of the text and the signatures of Senate President John Adams and House Speaker Frederick Muhlenberg were faded but legible—though the ink of their titles had long since flaked off, which can happen to ink on documents, like this one, made of vellum, which is animal skin. North Carolina's copy of the Bill of Rights is identical to its thirteen counterparts—except for a small anomaly.

"Look closely here," Koonts said, pointing to the "Trial by Jury Amendment." "Ours says '*where the crime*,' while in all other thirteen, the words are '*wherein the crime*.' It was this copying error, along with the handwriting on its reverse side, which proved this particular copy of the Bill of Rights belonged to North Carolina."

I had first learned about North Carolina's copy of the Bill of Rights in 2003, when it was seized by the FBI, but didn't focus on it until a decade later when a friend reminded me about it. I vaguely remembered that the document had been offered to the National Constitution Center, a museum located close to Independence Hall, and that there had been quite a stir when the FBI captured it during a government sting at a local law firm. It sounded intriguing. I decided to take a closer look.

It didn't take long to research the journey of the document as it passed from hand to hand. But I could not figure out why it had taken North Carolina 140 years to get it back. After all, this wasn't a lost treasure: North Carolina knew where to look for it since the 1890s. Three times the state was offered the document and every time it turned the offer down. Why? Didn't they want it back? Couldn't North Carolina afford the asking price? Or was there something else at play, perhaps something connected to its theft during the Civil War?

On October 2, 1789, President George Washington signed a letter addressed to North Carolina Governor Samuel Johnson transmitting a copy of the proposed twelve amendments to the U.S. Constitution that Congress had passed the previous August. Washington's clerks had penned fourteen copies of the document on vellum, and Senate President John Adams and House Speaker Frederick Muhlenberg had signed them: one for each of the eleven states, one for Rhode Island, one for North Carolina—neither of which was a state at the time—and one for the federal government.

From our vantage point some 225 years later, it seems odd that the U.S. Constitution sparked so much controversy—but it did. While the Constitution assigned the federal government only limited powers, many feared it might be used to run roughshod over the rights of states and their citizens. Some states ratified the Constitution reluctantly, and Rhode Island decided not to take a vote at all. North Carolina alone refused to ratify the Constitution without a Bill of Rights. North Carolina insisted on amendments that would curtail the scope of federal control and delineate such fundamental civil rights as freedom of speech, press, and religion; the right to keep and bear arms; the right to assemble; the right to fair and unbiased trials; and the right to due process. President Washington hoped this Bill of Rights would be sufficient to quell the worries of the legislators in Rhode Island and North Carolina and convince them to ratify both the Constitution and these protective amendments.

North Carolina's copy of the Bill of Rights arrived in Raleigh in the fall of 1790 and made its way to Pleasant Henderson, engrossing clerk of the General Assembly.[1] He folded the large parchment into a packet small enough to fit into his filing box. Then he "docketed" it—officially accepted it—by writing on the backside, "1789 Proposed Amendments to the Constitution of the United States," before slipping it into the file. Washington's plan worked. North Carolina ratified the U.S. Constitution on November 21, 1789, and all twelve amendments on December 22 of that year.[2]

The document remained snug in its packet in the state Capitol building for seventy-six years—as North Carolinians became increasingly frustrated with the federal government, voted to join the Confederacy in May of 1861, and waved their fathers, husbands, brothers, and sons off to war. The people of Raleigh looked on as battles were won and lost; as their men wounded and killed Union fathers, husbands, brothers, and sons; and as they themselves were wounded and killed. They watched as Union soldiers captured North Carolina's coastline and General William Tecumseh Sherman's army swept through Georgia and the Carolinas, leaving death and destruction in its wake. They learned about "Sherman's bummers," who were officially authorized to take, from any available source, whatever they needed to supply the army. Raleigh's residents knew Sherman was on the way. They had reason to fear the worst.

On April 9, 1865, General Robert E. Lee surrendered the Army of Virginia to General Ulysses S. Grant at Appomattox Court House in Virginia. I was surprised to learn that Lee's surrender represented a major Northern victory, but did not end the war. Four days later, tens of thousands of Union soldiers and officers began to enter Raleigh. By that time, local officials had formally surrendered the city to avoid the devastation experienced by others in the South.

"What was it like to be living in Raleigh during the Union occupation?" I asked Chris Meekins on the steamy August day when I visited Raleigh. A large burly man, Meekins is a North Carolinian born and bred, an archivist, and authority on its history, especially its Civil War history. We were sharing a bench in front of North Carolina's Capitol, a grey granite antebellum beauty framed by Doric columns. In front of us was a statue titled "Presidents North Carolina Gave the Nation," depicting James Knox Polk (1845–1849), Andrew Jackson on his horse (1829–1837), and Andrew Johnson (1856–1869). A shabbily dressed man dozed at its base.

"It was pretty scary," Meekins said. "The locals had direct telegraphs, instant communications, so they knew that Wilmington, North Carolina, had been lost. As a resident, you heard rumors of Sherman's army coming up from South Carolina and the total war he was perpetuating on the population." General Sherman, Meekins said, wanted to break the will of the people, so he handpicked a core of hard, battle-ready men and directed them to destroy rail lines, free the slaves, and forage for food off the land.

"As Sherman's troops closed in, the Confederate cavalry was on the skedaddle moving west out of town," Meekins continued. "They were stealing everything they could get their hands on, rummaging and ransacking the city on the way out. The railway depot in South Raleigh was on fire, likely set by Confederate troops."

I tried to imagine the scene, to join with the people awaiting their fate: parents, grandparents, and children, Southern politicians, wounded soldiers in hospital wards, Confederate recruits from the training camp nearby, refugees from South Carolina, former prisoners of war, people fleeing with their slaves. Most supported the Confederacy, but there were others who were against it and a few who looked forward to welcoming the troops. Most were inside; the streets were empty.

Early on April 13, a giant brown cloud of dust was stirred up by boots marching into town along Fayette Street. As the Union troops appeared far in the distance, a lone Confederate cavalry lieutenant stood at the head of Fayette Street and fired his gun in a useless display of gallantry that placed the entire city at risk. He was caught, tried, and hanged, the only casualty of Raleigh's occupation.

Over the next days, tens of thousands of Union soldiers and officers streamed in as fearful residents looked on. The conquerors set up camps in the parks surrounding the Capitol, on the lawns of private homes, and on the grounds of the State Insane Asylum. Within a day or two, Union General John M. Schofield announced that the Emancipation Proclamation was in effect, ending slavery, so the city was also filled with jubilant blacks. Sherman ordered that the inhabitants and their property be treated with courtesy, and things calmed down. Soon, winsome Southern belles, eager for socializing after years of war, were accompanying young Union officers on their strolls through town.[3]

Raleigh's most commanding, and certainly most intriguing, building was the glass-domed Capitol in the center of town. Company D of the 94th Ohio Volunteers patrolled its grounds; they had been assigned provost duty at the request of the locals, who insisted on military police protection. At some point during the two-week-long occupation, one of the soldiers entered the building. The Bill of Rights, encased in a packet, was among the stacks of documents in a closet in the office of the attorney general. The soldier looked through the packets until he found a folded parchment with the words "1789 Proposed Amendments to the Constitution of the United States" written on its reverse side. He unfolded it to find North Carolina's copy of the Bill of Rights, then carefully folded it back up and walked out the door. A year later, he sold it to one Charles Shotwell. The identity of the thief remains a mystery to this very day.

Chris Meekins escorted me across the square to the Capitol where the unnamed soldier had committed the crime. Tiffianna Honsinger, collections curator and research historian for the North Carolina State Capitol, was waiting, her soft flowered dress and charming drawl revealing her Southern roots.

"During the Union occupation, the building looked exactly the same, but what was in it was completely different," she began as she led me up a flight of winding granite stairs. At the time, the Capitol housed the offices of the governor and secretary of state, chambers for the Senate and House, and the state library and geological museum. It also served as a depot for military supplies and a gathering place where people came to roll bandages and sew blankets for their soldiers. I wondered how all these functions could fit into a single building until I learned that Raleigh at the time was a small town of only ten square blocks, not the big, bustling city of today.

On the second floor, we entered the majestic Senate chamber with its white pillars and flowered parlor carpeting. I looked at the painting above the presiding officer's desk and found George Washington looking back at me. "George Washington was a revolutionary, he was from the South, and he fought the bad guys," Honsinger explained. "Washington became a symbol for the Confederacy." During the Civil War, Confederacy honor flags and captured Union flags hung from the balcony that surrounded the room. A

couple of years before our meeting, Honsinger had caused considerable controversy by installing replicas of these flags to celebrate the war's anniversary. The Confederate flag, with its stars and bars, was quickly removed.

Back on the first floor, we entered a bare room with a small closet. "This is the office of the attorney general," she said. "The Bill of Rights was stored here with stacks of other documents." I had seen a photograph of the closet in the attorney general's office stuffed with high stacks of packets containing government documents. I imagined the thief pulling and opening one after another until he found the Bill of Rights.

Newspaper accounts and soldiers' letters home described the conditions they found at the Capitol: the place was a mess. "The interior of the Capitol presented a scene of utmost confusion," wrote the regimental surgeon of the 117th Regiment of New York. "Bound legislative documents, and maps, laid strewn about the floor of the library. The museum rooms were in even a worse plight . . . glass of the cases had been broken, and many of the specimens of natural history had been confiscated . . . geological collections broken and scattered."[4] State officials caused some of this disarray, spilling papers onto the floor in their haste to remove incriminating documents before they fell into Union hands. The rest of the disorder was caused by Union troops who stopped by the Capitol to pick up a war souvenir or two.

As soldiers and locals attempted to coexist peacefully, the war swirled around them. On April 14, President Lincoln was assassinated and Union troops found themselves defending Raleigh from fellow soldiers infuriated by the murder. Eight days later, General Joseph E. Johnson surrendered some ninety thousand troops to General Sherman at Bennett Place, just up the road from the city. While the final Confederate surrender did not take place until November, the war was essentially over.

Looting government documents was a crime. At the beginning of the war, Lincoln had issued General Order 100, the first attempt to codify the laws of war, which forbade individuals to remove or destroy such items.[5] Near the end of the war, the War Department issued other General Orders that mandated returning the state of North Carolina's property back to the secretary of state.[6] Sherman had discouraged troops from looting Raleigh. But, even if the soldiers knew about these orders, they certainly didn't follow them. Many of North Carolina's documents, geological specimens, and other items left with the troops.

On April 30, 1865, the 94th Ohio Volunteers and most of the rest of Sherman's army began their march to DC, where they joined the Grand Review on May 24 before mustering out of service on June 5 and returning home.[7] Military occupation of North Carolina continued until 1870, two years after the state ratified a new constitution that gave blacks the right to vote and rejoined the Union. Raleigh suffered much more humiliation by

Northerners during these five years of Reconstruction than it did during its two weeks of occupation.

After the War, North Carolina's secretary of state desperately tried to reclaim its official documents. Many were returned, but not the Bill of Rights.

"Why was it so important to get this particular document back?" I asked Honsinger.

She thought for a moment, frowning. "We in North Carolina believe the Bill of Rights was written for us," she said. "We're the only state that voted against the Constitution until we got the Bill of Rights. Only after it arrived were we willing to ratify the Constitution and the amendments. The Union soldier stole something that has to do with our birth as American people. That's insulting, you know."

The North Carolina History Museum was across the street from the Capitol, so I went in it to cool off and look at the face of the Confederacy. I gazed at Civil War era guns, battle gear, flags, and a quilt made from scraps of fabric from the clothes a mother sewed for her soldier sons. Three died during the war and one shortly afterward, four of the state's thirty-five thousand Confederates casualties. I had seen similar relics many times. Why did these touch me so deeply?

I thought about mothers, guns, and the cost of war during the next couple of hours as I wandered around Raleigh in the sticky heat looking for the lovely antebellum town I had read about in history books. Not much remained since hulking government buildings and offices for lawyers and lobbyists had replaced homes and lawns. A couple of blocks from the Capitol, a charming red brick mansion with an historic plaque on its façade commanded the prime lot on a leafy street. Sitting in its front yard under the shiny, sheltering leaves of a magnolia tree, I finally realized why it had been so important to come to Raleigh. I needed to experience what it was like to look on helplessly as occupying troops stole your cultural treasures. I needed to learn about the legacy of defeat to understand the meaning, to North Carolina, of its Bill of Rights.

In 1897, an article in the *Indianapolis News* reported that North Carolina's Bill of Rights was hanging on the wall of an office in the Indianapolis Board of Trade occupied by Charles A. Shotwell, a grain and feed merchant. Shotwell told the reporter he had bought the document for five dollars from a Civil War veteran in Tippecanoe, Ohio, who had taken it from the State House in Raleigh during its occupation. A month later, the story was reprinted in the *Raleigh News and Observer*.

It had been thirty-two years since North Carolina had heard anything about its Bill of Rights, and the article caused considerable concern. North Carolina Secretary of State, Dr. Cyrus Thompson, who was responsible for

the state's archives, wrote to his counterpart in Indiana, William D. Owen, asking for his help. Owen then walked to Shotwell's office and personally examined the document. Shotwell was not willing to relinquish his copy of the Bill of Rights, certainly not for free. North Carolina was not in the mood to pay, so the matter ended there.

Another twenty-eight years passed before the Bill of Rights surfaced again. This time Charles Reid, on behalf of an unnamed client, wrote to a professor at the University of North Carolina to offer, for sale, North Carolina's original copy of the Bill of Rights, which "was taken from the state house at Raleigh by one of the Union soldiers who came from Ohio." The professor wrote back requesting its return and noting that the Bill of Rights was the property of North Carolina. Reid then wrote to a private collector in North Carolina offering to sell the document, but the collector had died, so Reid's letter ended up in the hands of R.B. House, secretary of the North Carolina Historical Commission. House's letter back to Reid again stated that Bill of Rights had been stolen from the Capitol in 1865 and belonged to North Carolina. When Reid repeated his offer to sell, House wrote back:

> "So long as it remains away from the official custody of North Carolina, it will serve as a memorial of individual theft. Since this fact must be clear to anyone acquainted with history and law, not to mention honor, it is interesting to note the present whereabouts of the document and to speculate on how long the joy of illegitimate possession can hold out against scruples arising from intelligent consideration of the facts involved.[8]

Everyone I interviewed repeated this statement. Each time I heard it, I thought: *What does this mean?*

Charles Shotwell died in 1972, passing the Bill of Rights to his son. When the son died, his widow hung it on the wall of her apartment in a continuing care retirement community, its black ink slowly fading brown from sun exposure. When the son's widow died in 1990, her two daughters inherited North Carolina's copy of the Bill of Rights and soon decided to sell it. They contacted their family lawyer, Charles Reeder, who contacted Leslie Hindman, owner of a Chicago-based auction house. Though intrigued, she decided not to participate because selling North Carolina's Bill of Rights at a public auction might draw the attention of North Carolina. In 1993 or 1994, she mentioned the document to a friend, Wayne Pratt.

Pratt was a high-profile antiques dealer in Westbury, Connecticut, with a spot as a guest appraiser on Public Broadcasting's popular program, *Antiques Roadshow*. He specialized in New England high-style furniture and folk art, but he was not above taking on something as potentially lucrative as an original copy of the Bill of Rights, even with a problematic past. Soon, dealer Wayne Pratt and attorney Charles Reeder were shaking hands in the Indi-

anapolis airport on their way to see North Carolina's copy of the Bill of Rights.

I began to wonder why a well-known antique dealer would risk arrest for trafficking in stolen goods. After all, Pratt knew the Bill of Rights had been stolen during the Civil War. But, was it actually stolen? Would Pratt violate any laws or professional ethics?

That's when I decided to consult someone reputed to be an especially ethical antique dealer: Ed Hild of Olde Hope Antiques. We met at the Phila-delphia Antiques Show, an annual event where men in prep school blue blazers and women in flowered scarves surveyed the well-heeled browsers while guarding their booths perfectly arranged with exquisite objects.

Olde Hope Antiques in New Hope, Pennsylvania, dealt in folk art and country furniture similar to what Wayne Pratt sold. Hild knew Pratt and remembered the unfortunate incident surrounding him and North Carolina's copy of the Bill of Rights, which had been the talk of the antiques trade when the FBI sting was reported in 2003.

"I wasn't surprised," Hild told me. "Wayne was driven. When he wanted the object, he had the passion to get it and was willing to fight for it. Some people believe they have a legal right to beat the system." Finding an original Bill of Rights was as good as it gets; it could be worth millions. In the late 1980s, a bargain hunter had found a very early and rare copy of the Declara-tion of Independence tucked into a picture frame he had purchased for four dollars at a flea market. In 1991, Sotheby's put the document up for auction, and it sold for $2.42 million, a new high watermark for historic documents.

I asked Hild what he would do if he ran across a copy of the Bill of Rights.

He didn't hesitate. "I'm a dealer in furniture and folk art, so I'm not an expert in documents. I would find the top person in the field to get advice," he said. "A document like this throws up a red flag. A dealer has a respon-sibility to prove ownership throughout history, so you can argue the law. You need to get it authenticated."

The Shotwell sisters originally asked two million dollars for North Caro-lina's Bill of Rights—perhaps they had heard about the valuable flea market Declaration of Independence—but Pratt was patient and persistent; and the longer he waited, the more the price dropped. In the spring of 1999, the Shotwell sisters sold North Carolina's copy of the Bill of Rights to Wayne Pratt and his friend and silent partner, Bill Matthews, for two hundred thou-sand dollars. The sale carried two conditions. First, Pratt had to agree to assume all risk for the cloudy title: if North Carolina sued, he would not ask for his money back. Second, he had to agree to sell North Carolina's copy of the Bill of Rights to a museum or library, or to someone who would donate it to such an institution.[9] This is not as onerous a condition as it might seem because a number of wealthy collectors purchase rare and valuable

Americana and donate it to museums and educational institutions for the tax deduction and considerable public recognition they receive.

Wayne Pratt knew little about historic documents or the collectors who purchased them. But he did know about selling and must have realized that finding a buyer wealthy enough to purchase the third most important document of the nation's founding—after the Declaration of Independence and the Constitution—was going to take some work. The first person he recruited was William Richardson, a well-connected Washington attorney who agreed to represent Pratt on the sale and advise on legal matters, including the potentially sticky issues related to selling a document that had been the property of a state government. Richardson signed on for three times his hourly rate, thirty percent of the profits, and reimbursement of all his legal expenses—a very hefty sum, but one only due upon the sale of the document.

In 1995, Richardson contacted North Carolina's secretary of the Department of Cultural Resources, offering to sell North Carolina its own Bill of Rights. At the time, Jeff Crow was the director of the Division of Archives and Records, and he agreed to tell me what happened.

"The Bill of Rights and its loss during the Civil War were always part of the lore of the State Archives, but no one thought it would ever be returned," he told me, noting it had surfaced in the 1880s and 1920s but was never recovered. "In the 1990s, a lawyer named William Richardson contacted us, said he had a client who had a document from North Carolina, and asked if we wanted to buy it back." Again, the state remained unwilling to pay for its own copy of the Bill of Rights, and Richardson soon disappeared.

"Why didn't you go after Richardson and get the document?" I asked.

"He refused to reveal the owner's name so there was no way the attorney general could get it back," said Crow. "Anyway, he had suggested it was worth a minimum of two million dollars. We didn't have two million dollars: we're a state agency."

When the sale to North Carolina failed to pan out, Wayne Pratt needed to find a wealthy, patriotic, private collector willing to donate the Bill of Rights to a nonprofit institution. That's when he turned to Peter Tillou. [10]

Tillou, who lives in tony Litchfield, Connecticut, was one of the nation's leading dealers in American folk art and antiques, known for the quality of his inventory and the wealth and prestige of his clients. Pratt knew these things. He approached Tillou with an offer to share in the profits from the sale of the Bill of Rights in exchange for an introduction to a buyer. Soon, Tillou was on his way to Pratt's home. Although Tillou didn't deal in documents, one look at the Bill of Rights convinced him to take on the assignment. At this point, Pratt got cagey since he needed to avoid revealing its connection to North Carolina and the Civil War. [11]

David Howard wrote about this incident in his book, *Lost Rights: The Misadventures of a Stolen American Relic*. According to Howard, Pratt ex-

plained to Tillou that a number of states were missing their original Bill of Rights for many years, and there was no way to know where this particular parchment came from, other than that it had been found behind a painting in upper New York State. The document could be worth as much as twenty million dollars, and if Tillou secured the buyer, he would receive twenty percent of the sale price. Pratt turned the document over to Tillou who carefully placed North Carolina's copy of the Bill of Rights under his bed for safekeeping, removing it occasionally to admire it. He knew his clients would need the document authenticated before spending millions on it, so he turned to William Reese of William Reese Rare Books and Collectables in New Haven, one of the most distinguished and reputable dealers in his field.

William Reese was happy to share his story of the Bill of Rights when I called. "When Peter Tillou came to me," Reese said, "he said he represented the owners of an original copy of the Bill of Rights and the owners didn't want their names known."

"Wasn't that suspicious?" I asked.

"No, it's not that unusual—to keep the customers quiet, since some buyers will try to cut you out of the deal by calling the owners directly," Reese explained. "Peter didn't know documents, but he knew I did—we'd been doing business for years—and he thought I would know the best buyer for it."

It was now 2002, and the price of history had gone up. The flea market copy of the Declaration of Independence that had sold in 1991 for $2.42 million had come back on the market, and had been purchased at Sotheby's for over $8 million. Reese reasoned that an original copy of the Bill of Rights was worth close to that—if it were real and had a clean title.

He explained. "The Bill of Rights was an unusual opportunity—a major document in American history. I often invest in cataloging—historical research—and in this case I was willing to make an unusual investment in time and effort. If it were legitimate, I thought it would go for five million to seven million dollars, so the investment was not large."

Reese soon learned that President Washington had prepared fourteen original copies of the Bill of Rights on vellum: eleven for each of the states that had ratified the Constitution, one for Rhode Island, one for North Carolina, and one for the federal government. Reese then began to search for all of these copies. The federal government and six states still had their original Bill of Rights in their archives or libraries, but five states were missing theirs: Georgia, Maryland, North Carolina, Pennsylvania, and New York. Reese then directed his staff to travel to these five states, find documents that had arrived in 1789—at the same time as the Bill of Rights—and bring back images of their front and reverse sides.

I knew why Reese wanted photos of the fronts—to see whether they matched the handwriting of one of Washington's clerks—but why the re-

verse sides? "Because of the docketing," he told me. "In the early years of the nation, when a federal government document arrived at a state capital, the receiving clerk would fold it four times into a long, thin piece of paper and write the name of the document and the date of arrival on its reverse side, near the top. He would then stick it in the file."

The same state clerk would docket and file everything that arrived around the same time. This meant if you found an original vellum copy of the Bill of Rights, you could turn it over, identify the handwriting on the reverse side, and know which state it came from.

Reese discovered that there were three mysterious copies of the Bill of Rights: one at the Library of Congress, one at New York Public Library, and the one that Tillou had left with Reese. Which of the five states did they belong to? Though the provenance was fuzzy, one thing was clear. If the copy in Reese's possession belonged to one of the five states that were missing their copies, he didn't want anything to do with it. Selling a document with a cloudy title could mean years of expensive litigation.

But was there another possibility? Was it possible that this Bill of Rights had never been owned by a state? Reese thought so. He had seen the situation before. During the first three sessions of Congress, when a bill became an act, official copies of it were prepared on vellum parchment and sent to all the states and the federal government. But often, at the same time, other copies were made, sometimes for those involved in the legislation or the Speaker of the House. If the mysterious Bill of Rights in Reese's shop was one of these unaffiliated copies, the title went from cloudy to clear, and the document would be worth millions.

"I'm not saying more copies were created here, but the possibility exists," said Reese.

Reese's sleuthing had taken some time. Meanwhile, he had repeatedly asked Peter Tillou for provenance and conditions reports, the standard documents related to any item worth more than fifty thousand dollars. Reese assumed that a professional conservator had worked on Tillou's Bill of Rights, and he wanted to talk to the conservator to find out what he or she had done. When no reports arrived, Reese asked Tillou for the name of the owner so that he could contact him directly.

"When I heard it was Wayne Pratt, I was very surprised," Reese said. "I had been led to believe the owner was an individual, not an experienced dealer. A dealer would know the importance of authentication." When Pratt refused to supply it, Reese knew something was wrong. "I felt I was being stonewalled—it was a very big deal," he told me.

Reese's team compiled a comprehensive dossier with photographs of the front and reverse sides of the mysterious Bill of Rights. The report also contained photos of the reverse side dockets of the federal documents that the five missing states had received in 1789. Along the way Reese had remained

in touch with the representative of a potential buyer: Seth Kaller, a dealer in upper-tier historical documents. Kaller represented Richard Gilder and Lewis Lehrman, investment bankers, who purchased important documents and donated them to historical institutions. In January of 2003, Bill Reese brought the mysterious Bill of Rights and the dossier he had prepared to Kaller, Gilder, and Lehrman. They decided to purchase the document and donate it to a museum. The museum they all agreed on had not yet opened its doors: the National Constitution Center, slated to be launched in Philadelphia on July 4, 2003.

Gilder knew that Pennsylvania Governor Edward Rendell was the moving force behind the Constitution Center. He immediately wrote Rendell asking whether the center might want to receive a copy of the Bill of Rights, free of charge, and Rendell passed the letter along to Joe Torsella, the new center's president.

Steven Harmelin was the general counsel of the National Constitution Center at the time and involved in the negotiations to acquire the Bill of Rights. Recently, we met in the lobby of his law firm, Dilworth Paxson, LLP, where floor-to-ceiling windows framed Philadelphia's skyline. Harmelin spoke with the deliberate cadence of the esteemed Philadelphia lawyer that he is as he remembered the incident.

"If you're in for iconic material for a National Constitution Center, you don't do much better than the Bill of Rights," he said.

Soon after learning that an original copy of the Bill of Rights might be available, Harmelin and Torsella invited the seller, who was represented by his attorney, William Richardson, and Seth Kaller, representing the buyers, to bring the document to the temporary offices of the National Constitution Center in downtown Philadelphia. The center's officials were very impressed by what they saw, but once the delegation and document left, many questions remained. Richardson had mentioned that the Bill of Rights had been found, quite by accident, in upper New York state. How did it get there? More to the point, was the document genuine? At this point, Torsella and Harmelin decided to consult an expert, and with Kaller's approval, they sent it to the nation's leading authority on early Congressional documents: Kenneth Bowling of the First Federal Congress Project, a research center located at George Washington University.[12]

Bowling had encountered this Bill of Rights twice before: first, in the 1990s, when Richardson had sent a photograph of it to First Federal Congress Project, and again in 2000, when Richardson and a couple of other people had visited the project's offices with a faded vellum bearing the words "Bill of Rights" at its top, pasted on a backing, and set in an old gold gilt frame. One look at the document was all Bowling needed to realize it was an original. He told Richardson that it probably belonged to one of the five states that were missing their copies, and it could have a lot of value—or

none at all. Under federal law, a state that could prove it once was theirs could lay claim to it. Staff suggested that Richardson hire a conservator to remove the document from its frame and backing. The eighteenth-century docketing now hidden from view on the reverse side would reveal the state to which it belonged.

Now it was 2002, and Bowling was looking at pictures of the front and back of the same Bill of Rights. He recognized the handwriting of George Washington's clerk who had penned the document. The docketing on the reverse side read, "1789 Proposed Amendments to the Constitution of the United States," and Bowling didn't recognize the handwriting. He called in Helen Veit, the project's handwriting expert, who not only immediately iden-tified North Carolina as the original owner of the document, but the name of the person who had docketed it: Pleasant Henderson, a clerk to the General Assembly. Henderson had also docketed two letters from George Washing-ton to North Carolina Governor Samuel Johnson, and copies of these were sitting in their files. Veit and Bowling pulled them out, compared the hand-writing on the reverse sides of all three documents, and authenticated North Carolina's long-lost copy of the Bill of Rights.

Bowling wrote to Kaller who then wrote to Bill Reese, who sent the results to Tillou, who called Pratt, who was not pleased. "There are no existing challenges to ownership of the item that I am aware of," Pratt wrote in a follow-up letter.[13]

Bowling also contacted Harmelin and Torsella, who were both shocked to learn that the Bill of Rights they hoped to own had belonged to North Caroli-na. But they were not prepared to lose the opportunity for the National Constitution Center to acquire such an iconic document. Perhaps North Caro-lina would want to share ownership? Before exploring this option, they needed to know whether Pratt knew it had been stolen.

On a cold day in February of 2003, Harmelin, Torsella, Pratt, Reese, Richardson, and Keller met at the Yale Club in Manhattan. After some pleas-antries, Harmelin announced that there was strong reason to believe the Bill of Rights had come from North Carolina.

The room fell silent. Then Richardson countered: "North Carolina had a chance to buy back the document and declined."

Harmelin countered. "Maybe North Carolina didn't want to pay for its own property."

Richardson was asking five million dollars for the Bill of Rights, but that was before its North Carolina provenance was revealed. Now, it was worth less, only two million dollars, the National Constitution Center argued, since North Carolina might dispute its ownership.

This was not good news for Pratt, for the $2 million valuation left him in a bind: he owed Richardson $450,000 in legal fees plus thirty percent of the profit, Tillou and Reese together another twenty percent, and Leslie Hind-

man, Pratt's auctioneer friend, a finder's fee of $200,000. Pratt and Matthews were due reimbursement for their costs. If the Bill of Rights sold for only two million dollars, that left very little in profit for years of work. Moreover, North Carolina would undoubtedly make a claim that would result in more legal fees. Within thirty minutes, Pratt and Richardson walked away from the table and the meeting ended.

A few days later, Steve Harmelin received a call from Joe Torsella: two FBI agents were standing in his office, and they wanted the Bill of Rights.

"We had called Governor Rendell—Joe worked for him, so he made the call—and asked the governor to find out from North Carolina whether or not they want the Bill of Rights back," Harmelin recalled. Rendell called North Carolina Governor Michael Easley, and Easley's aide contacted both the U.S. attorney for the Eastern District of North Carolina and North Carolina's attorney general, Roy Cooper. The U.S. attorney immediately contacted the FBI, and U.S. marshals secured a seizure warrant from the U.S. District Court for the Eastern District of North Carolina.[14]

Harmelin wanted to pass along Richardson's and Pratt's names to the FBI, but he soon learned that the agency had other plans. The FBI's specialist in art recovery, Robert Wittman, told Harmelin and Torsella there was good reason to believe that the Bill of Rights might disappear forever. As proof, he handed them a copy of the letter from William Richardson to North Carolina threatening to sell the Bill of Rights to a Middle Eastern buyer. Wittman said the only one way to assure that the document would not disappear was to set up a sting. To trick Richardson into bringing the Bill of Rights to Philadelphia, the National Constitution Center needed to proceed with the negotiations, set up a settlement, and help the FBI seize the Bill of Rights.

"I told Joe there are two ways of looking at this," Harmelin remembered. "As your lawyer, I must remind you this is high risk for a fledging institution like the National Constitution Center to take on. The other way of looking at this is that we're Americans. What else can we do?"

On March 18, 2013, the stage was set. At Harmelin's law firm, closing documents were set on a conference room table. Kaller was there to authenticate North Carolina's copy of the Bill of Rights, along with Harmelin to handle the closing and deliver a four-million-dollar cashier's check to Richardson once the document was in Harmelin's hands. Wittman was there, too, posing as a dot.com millionaire. Pratt was in Colorado awaiting news.

Richardson arrived alone and without the Bill of Rights to review the closing documents. When he was satisfied, he called a courier who entered the conference room carrying a large package. Everyone gathered around to see the iconic document: a large cream-colored vellum parchment with faded letters. Kaller pronounced it authentic.

"I walked out of the conference room and knocked on the door to the room next door, where five FBI agents were waiting," said Harmelin. "I

knocked once—and the agents ran quickly into the conference room and pushed everyone against the wall. The messenger and Richardson were neutralized."

The FBI squad supervisor handed Richardson the seizure warrant. Richardson asked, "Am I under arrest?"

"Oh no," Wittman said. "We're conducting a criminal investigation into an allegation of interstate transportation of stolen property. The document is now evidence."

It was left to the courier to call Pratt in Colorado with the bad news. Within a day, the story of the FBI sting was broadcast on CNN, and soon North Carolina's copy of the Bill of Rights was flying back to North Carolina on the director of the FBI's jet. The document carried a transmittal receipt that read, "Appraised value $30 million."[15]

As the plane flew south to Raleigh, the office of the North Carolina attorney general was planning its legal strategy for regaining possession of its own copy of the Bill of Rights. In order for that to happen, the claims of Wayne Pratt and his partner, David Matthews, had to be defeated.

Karen Blum is a special deputy assistant attorney general for North Carolina, a bulldog of a lawyer who happily admits to loving legal research and hating to lose a case. She was interning at the attorney general's office when she was asked to help prepare North Carolina's case. Later, she served as second chair in the many ensuing trials of the matter.

"This was the case of a lifetime, right out of law school," she told me, her eyes glittering. "My job was to put that Bill of Rights right back in the Capitol, where it belongs." Blum offered to send me some legal briefs, and when many long documents arrived via email, I forwarded them to Bruce Bellingham, my legal advisor for this book, along with a request: "According to Karen Blum and the archivists I met in North Carolina, repatriation of the Bill of Rights took years of litigation," I told him. "Can you please help me figure out why?"

A week later, I received a long email back from Bellingham with a concise summary of the many procedural steps it took for North Carolina to repatriate its own copy of the Bill of Rights: a trial in federal district court, proceedings in the U.S. Court of Appeals for the Fourth Circuit in Richmond, and another trial in federal district court where North Carolina was awarded possession. Even after that, the saga continued, since possession is not ownership. It took another trial, this time in state court in Wake County, North Carolina, for the state to legally reclaim ownership. The decision was based on the theory that the state can never lose title to its records without legislative intent.[16]

The FBI sting took place in 2003; the matter was finally resolved in 2008. The Civil War took less time.

Bruce Bellingham had spent considerable time studying the laws and had developed an opinion. He believed that the FBI overstepped its authority in seizing the Bill of Rights. "The way the government took possession and flew what was then still Pratt's property off to North Carolina, a preferred venue, was thuggish," he said. "This is a case where the FBI got away with abuse to achieve a good result that probably could have been achieved without the abuse."

Bellingham's opinion made sense. But then again . . . was this an instance in which the ends justified the means? Would North Carolina have been able to secure its Bill of Rights if the case had been tried in any place other than North Carolina? I thought of all of the people involved in the effort: the governors of Pennsylvania and North Carolina, the FBI, the U.S. attorney, North Carolina's attorney general, a district court, federal appeals court and state court judges, Steve Harmelin and Joe Torsella, Jeffrey Crow, Chris Meekins, and other archivists. All of these people fighting, as Karen Blum said, "to put that Bill of Rights right back in the Capitol, where it belongs."

Now that North Carolina's Bill of Rights is safe in its chilled crypt, where are the four other missing copies? According to the experts, New York's copy was likely destroyed in the 1911 fire that destroyed the top floors of the building in which the state library was housed. Georgia almost certainly lost its copy during the Civil War when General Sherman burned Atlanta. Maryland's copy disappeared during a 1930 renovation of the Maryland State House but may have later resurfaced; some think it is the copy now in the Library of Congress. Pennsylvania's copy has been missing since the late 1800s, when a thief carrying carpetbags filled with Pennsylvania government documents was seen selling them to manuscript dealers in New York City. Bill Reese thinks that Pennsylvania's copy of the Bill of Rights was among these documents and is now at the New York Public Library.

Steve Harmelin thinks so, too, and made it a personal quest to get it back. As the Commonwealth of Pennsylvania's agent, he initiated an extended and delicate negotiation with the New York Public Library that resulted in an agreement to share stewardship for this mysterious Bill of Rights for the next one hundred years. In late 2014, the likely contender for Pennsylvania's copy of the Bill of Rights returned home for an exhibit at the National Constitution Center, where Harmelin now serves on the Board.

Wayne Pratt died in 2007 after having permanently tarnished his reputation and invested an estimated five hundred thousand dollars in a deal gone south. His fellow dealers, Peter Tillou, Bill Reese, and Seth Kaller, received nothing but aggravation for their time and trouble. We should not judge them harshly: none of them knew the Bill of Rights was stolen government property. And we should remember that even the most seasoned, ethical, and reputable dealers are free to sell history—unique and historically significant doc-

uments and other objects—to wealthy collectors, knowing that the public may never see them again. If you believe in market principles, you are hard-put to argue that selling history is not a legitimate line of work.

Soon after North Carolina won possession of the Bill of Rights, the state sent the document on a statewide tour. Around twenty thousand people stood in line to see it, some with tears in their eyes. The state's archivists continue to hunt for items stolen during the Union occupation of 1865 and over time have gained a reputation for tenacity. Clearly, North Carolinians loved their Bill of Rights in a way that may be hard for some Northerners to understand.

Early on, I had wondered why North Carolinians had placed principle over pragmatism. Why didn't they just buy the Bill of Rights when it surfaced? There is always money to be found for something this important, so cost could not have been the issue. After visiting Raleigh, I finally understood why. North Carolinians refused to buy back their Bill of Rights not because they lacked the desire or the dollars, but rather because they loved it too much to turn it into a commodity.

Chris Meekins explained this to me. "It's Southern honor. Honor makes sense," he said. "For us, it didn't make emotional sense to buy it back. Because we can't get away from the material world, the Bill of Rights has a material value. You know this thing has been stolen; it has this purloined aspect to it. But beyond that, in and of itself, the Bill of Rights is an enormously important document. It's the veins, capillaries to the thought of our government's organization, the obligations and rights of citizenship."

Meekins stopped and thought for a moment. "It's now two hundred years later and only seventeen additional amendments have been added. For more than two hundred years, the experiment has gone on, and by and large the men who wrote the Bill of Rights got it right."

## NOTES

1. Kenrick Simpson, *Liberty and Freedom* (Raleigh, NC: North Carolina Office of Archives and History, 2009), 36.

2. Ibid., 46.

3. Burke Davis, *Sherman's March through the Carolinas* (Raleigh, NC: The University of North Carolina Press, 1996), 248.

4. James A. Mowris, *A History of the One Hundred and Seventeenth Regiment, New York Volunteers* (New York: Edmonstrom Publishing, 1996), 210.

5. Frances Lieber, *Instructions for the Government of Armies of the United States in the Field*, Article 36, General Orders No. 100 (Washington, DC: Government Printing Office, 1863).

6. E. D. Townsend, *General Orders No.88, War Department* (Washington, DC: Little, Brown and Co, 1865).

7. "Infantry 54th Ohio," Bowling Green State University, http://www2.bgsu.edu/colleges/library/cac//cwar/09ovi.html.

8. Simpson, *Liberty and Freedom*, 55.

9. Howard, *Lost Rights*, 73.

10. Ibid., 102.
11. Ibid., 139.
12. Ibid., 59.
13. Ibid., 154.
14. Wittman, 209.
15. Ibid., 199.
16. Simpson, *Liberty*, 43.

## Chapter Seven

# Sumerian Plunder

Imagine for a moment, a tiny golden vessel no more than an inch tall lying in a silent tomb near the child who played with it some 4,500 years ago. Suddenly, the silence is shattered by the sound of a collapsing stone wall, followed by the shuffling of men's feet. One of the men, a local farmer, carves a yellow arch with his flashlight. The beam falls on a cache of golden miniatures, the tiny vessel among them. He looks around furtively and, when he is sure none of the other grave robbers are watching, carefully scoops up the objects and hides them in his pocket. Back above ground, he examines the vessel closely. He sees that its rim, neck, and shoulder are intact; but the body of the vessel, instead of being a perfect sphere, is dented, as if it had been squeezed by tiny fingers.

Now, let's follow the farmer who actually found the vessel. He soon sold it and the other tiny treasures to a middleman working for organized crime who passed it along to another, then another. The cache of golden Sumerian treasures traveled through Beirut and Geneva to an antiquities dealer in Munich, Germany. The dealer put the golden miniature up for sale at a fraction of its value, planning on having an associate buy it—and later resell it for millions. Instead, a German authority on Sumerian antiquities spotted the scheme, rescued the vessel, and spent the following years engaged in a quest to return it to the Iraqi people.

Trafficking in looted art and antiquities is—along with illegal drugs and weapons—among the world's most lucrative crimes, generating billions of dollars a year. In fact, it is so lucrative that it has spawned a criminal network that reaches from the parched plains of the Middle East and the vine-wrapped ruins of Central Asia to the tony showrooms of Western antiquities dealers and, eventually, the pristine display cases of major museums and private collectors. While the illicit antiquities market may at first look like a victim-

less crime, it is anything but that. The proceeds of purloined cultural treasures frequently underwrite criminal activity, including terrorism. Experts tell us it is impossible to link a specific item, like the Sumerian vessel, to a specific terrorist attack. But sometimes there's a break in the chain from ancient tomb to auction house that allows a brief glance of how the system works.

I learned about the connection between stolen antiquities and terrorism by accident. I was visiting some friends in Mainz, Germany, a pleasant town of two hundred thousand on the Rhine River, when one of them, Professor Dr. Gunther Faust, excitedly announced that he had been able to secure a meeting for me with a curator at the Römisch-Germanisches Zentralmuseum. I had visited the museum briefly before; there was nothing in its gallery of Roman dignitaries, friezes, and pottery and ancient German tools and armaments that struck me as relevant to my research, but I didn't want to disappoint Faust. So, the next day we drove through the center of town and into a courtyard surrounded by elaborately festooned eighteenth- and nineteenth-century buildings. Behind them, in a more modest structure from the mid-twentieth century, we were greeted by Dr. Michael Müller-Karpe. My initial impression was of a slight man around fifty years old with a mustache, oversized glasses, and thinning hair, the type who spends his life peering through microscopes, instructing students, or reading from dusty texts. Müller-Karpe was all of this, but much more. I soon learned he was also a tenacious and fearless defender of cultural property.

The museum where he worked is also more than its name or the nature of its exhibition galleries implies. From its founding in 1852, the Römisch-Germanisches Zentralmuseum has conducted research into ancient times and served as a laboratory for preserving and reproducing delicate antiquities, many of which are broken or damaged when they are unearthed or later moved. Students from all over Europe come to Mainz for training in this exacting profession, and through the process of replication and reconstruction they deepen their knowledge of the techniques used by the original craftsmen. Müller-Karpe calls it "learning with your fingers."

"Let me show you an example," he offered, leading Faust and me down a corridor. We passed a room in which conservation students sat at brightly lit workstations reassembling crushed light bulbs, one tiny shard of glass at a time. "Students must restore crushed light bulbs," Müller-Karpe explained, "before they are allowed to move on to antiquities." We walked into another room and approached a glass display case. He opened it and removed a golden vessel no more than an inch high and about three inches around, with a spout too tiny to insert a single buttercup stem. The object was intact—but its sides were folded in, as if they had been squeezed by tiny fingers.

"This is a replica, but so exacting that only an expert could tell the difference," he said proudly. "The original comes from lower Mesopotamia

in southern Iraq at the time of the Sumerians. We know it was looted from an archaeological site there." He handed me a little booklet titled "Kriminalarchäologie," from the museum's 2011 exhibit on trafficking in stolen antiquities. He pointed out the pages that explained how the vessel was discovered, recovered, and returned to the Iraqi people.

The catalog was in German, so when I returned home to Philadelphia, I had it translated. The tiny Sumerian vessel appeared on three pages. One featured a map tracing its odyssey from Iraq to Munich by way of Beirut and Geneva. Another showed photographs of the terrorists who attacked the United States on September 11, 2001. I recognized Mohamed Atta, the leader of the attack, his defiant, black eyes glaring at the camera.

Why were the 9/11 terrorists in this German exhibition catalog? What was the connection between 9/11 and criminal archaeology? How did the Sumerian vessel fit in? And what exactly was Müller-Karpe's role? I decided to search for the answers, knowing it might take me into some dark places.

My first stop was the Athenaeum of Philadelphia, a historic private lending library and architectural archive with a particularly rich collection of books on obscure topics, including the Sumerians.

The Sumerians, I learned, were one in a succession of cultures that lived in the flat valley between the Tigris and Euphrates Rivers in lower Mesopotamia, now southern Iraq. The area had been continuously occupied since 7000 BCE and the Sumerians appeared around 4500 BCE, though their heyday was 3500 to 1000 BCE. For many of those years, they shared the river valley with a Semitic people who eventually became the Arabs and the Hebrews, and many Sumerian myths became theirs as well. Over time, the Sumerians transformed their arid land into what the great Sumerologist Samuel Noah Kramer called "a veritable Garden of Eden" and "developed what was probably the first high civilization in the history of man."[1]

Sumerian farmers harnessed the rivers for irrigation and used the water to cultivate beans, chickpeas, cucumber, garlic, leeks, coriander, mint, juniper berries, wheat, and barley. They raised chickens, brewed beer, and consumed it while celebrating with drinking songs.[2] The Sumerians built grand city-states—Ur, Eridu, Uruk, Lagash, Nippur, and Kish—that boasted elaborate temples known as ziggurats, elegant homes for the wealthy, and shops selling local crafts and imported goods. Sumerians were buried with their possessions, in case they needed to use them in the afterlife. This meant that royal graves were filled with jewelry made from shells, lapis lazuli, carnelian, and gold, as well as musical instruments, pottery, and other elegant accoutrements.

Compared with their contemporaries, the Sumerians were especially well situated. Some of them even attained the greatest luxury of all: leisure time to ponder their world. I soon fell in love with the Sumerians because of their wild creativity. They originated myriad concepts and invented a multitude of

items that one wouldn't have known had to be conceived until the Sumerians conceived them.[3] The Sumerians invented the first schools and pharmaco-poeia and the first experiment in shade tree gardening. They were the first to conceive of moral ideas and to write the first proverbs and sayings. They were the first to imagine "Paradise, "Moses," "Job," and "Noah's Ark," all of which later turned up in the Hebrew Bible. Once on a roll—the Sumerians invented the wheel—they went on to invent the first love song, historian, legal precedent, and, to keep track of it all, the first library catalog.

But our ancient Sumerians did not stop there: they also invented the potter's kiln, textile loom, plough, seed drill, farm cart, wind vane, and sailing boat. They invented the harp, lyre, and lute; in technology, they invented fired bricks, the vault, and the true arch. They invented the sling-shot, very useful for little folks like David to employ against giants like Goliath. The items that the Sumerians invented by 1750 BCE constitute much of the basic technology that supported human life until the beginning of the Industrial Revolution in the 1700s.

We know quite a bit about the Sumerians in part because they also invent-ed the oldest known system of writing: a script called cuneiform. They em-ployed reeds to write cuneiform on clay tablets, bricks, and walls. They scratched cuneiform on cylinders of carnelian, lapis lazuli, and shell, and then rolled these cylinders on clay to leave a continuous impression in relief. They prepared cuneiform lists of their rulers called King Lists, which archae-ologists later used to establish their chronology. The Sumerians produced millions of cuneiform-covered objects, and about one hundred thousand are known today; they address a multitude of subjects and allow us to admire the Sumerians' achievements.

Archaeologists believe the Sumerian culture ended when the rivers be-came too corrupted by saltwater to use for irrigation. For centuries, the area was largely unoccupied. By the mid-nineteenth century, the rich farmland between the Tigris and Euphrates had reverted to desert and the great Sumer-ian cities had all but disappeared. But here and there on the landscape were huge mounds of earth many meters high that began to capture the imagina-tion of the few Europeans who journeyed by. The locals called the largest mound Tell al Muquayyr, translated as "mound of pitch." The Sumerians had named it Ur.

To pronounce Ur properly, you must purse the lips as if preparing for a kiss. It and its neighboring mounds are actually stacks of cities, one on top of the other. For millennia, the people of Lower Mesopotamia lived in mud brick houses that tended to collapse after about fifty years. When that hap-pened, the occupants moved their possessions out, flattened the walls, and constructed new homes on the ruins of the old. Over the centuries, the mounds grew higher and higher, usefully protecting the cities from the annu-al floods of the Tigris and Euphrates. Archaeologists love these mounds of

stacked cities because, as Müller-Karpe says, "When you excavate them layer by layer, the deeper you go, the earlier you find—like a history book where the current page is more recent than the one before."

In 1922, Leonard Woolley, an ambitious young archaeologist, arrived at Ur to lead an expedition jointly sponsored by his employer, the British Museum, and the University Museum of the University of Pennsylvania, which financed the venture. With permission from the Iraqi government, the excavation began, and it continued for the next twelve years.[4] By the end of the fourth season, the crew, which numbered as high as four hundred, had excavated the ziggurat and major public buildings. They then turned their attention to Ur's massive cemetery. The archaeologists came to realize that there were actually two cemeteries, one above the other, belonging to different periods. They then discovered a series of graves unlike the others, constructed of walls of stone instead of mud, and filled with precious objects. Woolley called these the Royal Tombs.

In 1928, he excitedly cabled back from Iraq to his sponsors at the University of Pennsylvania—in Latin—translated, "I found the intact tomb, stone built, and vaulted over with bricks, of Queen Shubad, adorned with a dress in which gems, flower crowns, and animal figures are woven. Tomb magnificent with jewels and golden cups. Woolley."[5] Most astonishing of all was evidence of large-scale human sacrifice, with the bodies of likely members of the Queen Shubad's court, garbed in their finest, laid out in neat rows. The apparent lack of struggle and the tiny bowls found near the skeletons led Woolley to speculate that the courtiers had filled the bowls with poison and willingly lain down to die. Woolley had found one of the few such tombs that was still intact—for even in the 1920s, grave robbers had arrived there first.

By the time they left in 1934, Woolley's team had unearthed eighteen hundred burials, including sixteen royal ones. Woolley was rightly proud of the rich trove he had found of cuneiform cylinders, jewelry, pottery, armaments, musical instruments, and human remains, but he always believed his greatest find was an unusual layer of pure sediment that lay between Ur's two cemeteries. He pondered, where did it come from? Then he had an epiphany. The odd layer of sediment could only have come from a flood, a deluge of such monumental scale that it obliterated everything in its path. It could only have come, in other words, from Noah's flood. As Woolley later wrote, "We have proven that there really was a flood, and it is no straining of probabilities to maintain that this is the Flood of the Sumerian King-lists and therefore of the Sumerian legend and therefore of the story in the Old Testament." Many shared his opinion.

Woolley's excavations were big news in the 1920s and attracted a steady stream of visitors who were willing to brave the discomforts of third world travel for a first-hand view of the treasures of Ur. One of the visitors was the famed mystery writer Agatha Christie. In 1929, fresh from a divorce and

traveling alone, she boarded the Simplon-Orient Express in Calais, bound for Baghdad in search of adventure. When she learned about the fabulous excavations at Ur, she set off to see them.

"I fell in love with Ur," she wrote in her autobiography, "with its beauty in the evenings, the ziggurat standing up, faintly shadowed, and that wide sea of sand with its lovely pale colors of apricot, rose, blue and mauve, changing every minute. . . . The lure of the past came up to grab me."[6] Christie was also captivated by the archaeological team: the kindly scholar Leonard Woolley, his beautiful, mercurial wife Katharine, the erudite Jesuit priest, the architect, the foreman, and local tribesmen. "Leonard Woolley," Christie wrote, "saw with the eye of imagination: the place was as real to him as it had been in 1500 BCE or a few thousand years earlier . . . it was his reconstruction of the past, and he believed in it, and anyone who listened to him believed in it also."[7]

Ur was so romantic that Agatha Christie returned the following season at the invitation of the Woolleys—and promptly fell in love with one of the archaeologists, Max Mallowan. Despite the differences in their age—she was forty, he twenty-six—they married within the year. Later, Christie brought the excavations at Ur to life in her book *Murder in Mesopotamia*, which features two murders, the disappearance of priceless archaeological treasures, and their replacement by replicas so exacting that only an expert could tell the difference.

I spent a couple of years, on and off, reading about the Sumerians. During that time, I kept returning to Michael Müller-Karpe's catalog from the "Kriminalarchäologie" exhibit, especially the pictures of Mohamed Atta and other 9/11 terrorists. What was the link between them and looted antiquities? The Athenaeum owned a copy of the official Federal 9/11 Commission Report;[8] I checked it out and was soon reliving that frightening time.

The idea for the 9/11 attacks originated with Khalid Sheik Mohammed, a terrorist entrepreneur who had played a role in the 1993 bombing of the World Trade Center. His study of the buildings led him to a bold scheme: to hijack commercial airlines and employ them as massive bombs in an attack on key symbols of America's power and wealth. The plan required assembling a team of suicidal zealots, training some as airline pilots and others as hijackers, getting all of them into the United States, and providing the financing they needed to carry out the attack. In 1987, he proposed this idea to the leader of al Qaeda, Osama bin Laden, who had the money and manpower to execute such a complicated assault. Bin Laden bought into the program.

Al Qaeda had established terrorist training camps near Kabul, Afghanistan, and one of them became the training ground for the 9/11 terrorists.[9] In late 1999, four Western-educated Muslims—committed to dying for Allah, violently anti-American, and, most important, fluent in English and familiar with life in the West—arrived in the camp from Hamburg, Germany, eager to

learn the techniques of terrorism. They were the perfect candidates for training as pilots for the attack. Mohamed Atta soon emerged as their leader.

In early summer of 2000, Mohamed Atta and two others from the Hamburg group arrived in the United States, and within six months they had graduated from flight school and were simulating flights on large jets.[10] In spring 2001, other suicide mission zealots joined them in the United States. These, the "muscle hijackers," had been trained in firearms, heavy weapons, explosives, discipline and military life, and other essentials of airline hijacking.[11] Their responsibility was to storm airline cockpits and control the passengers. By this time, every man had committed himself to a suicide mission, though few knew the full details of what lay ahead.

On the morning of September 11, Atta and four other hijackers met at Logan Airport in Boston and boarded American Airlines Flight 11 with nonstop service to Los Angeles, joining its seventy-one other passengers and nine flight attendants. Almost immediately, Logan Airport knew there was a serious problem: the hijackers had attempted to communicate with the passengers but, not knowing how to work the public address channel, had mistakenly sent their message to air traffic control. At 8:46 a.m., the plane crashed into the North Tower of the World Trade Center, cutting through the ninety-third to ninety-ninth floors. All on board, along with an unknown number of people in the tower, were killed instantly.[12]

At 9:03 a.m., the hijacked United Airlines Flight 175 crashed into the South Tower of the World Trade Center, killing everyone on board and many others. At 9:37 a.m., hijacked American Airlines Flight 77 crashed into the western side of the Pentagon. At 10:03 a.m., hijacked United Airlines Flight 93 crashed into a field in Stonycreek Township, Pennsylvania. Its target had been the U.S. Capitol some 130 miles away, but several passengers and flight attendants had made telephone calls, learned about the other attacks, and attempted to take control of the aircraft. They were too late; everyone on board died.

By 10:28 a.m., the North and South Towers of the World Trade Center had collapsed, killing hundreds of civilians and scores of first responders. In all 2,996 people perished, including nineteen hijackers, the largest loss of life in history on U.S. soil as a result of outside assault.

Like other Americans, I lived through that day. I remember the terrifying speed with which events unfolded: the repeating televised images of airplanes crashing into tall towers, the broadcasters stunned and confused, initial disbelief that moved to chilling fear to deep despair.

I hope I never live through another like it.

How was the attack financed? Remembering the photograph of Mohamed Atta in the "Kriminalarchäologie" catalog, I combed the 9/11 Commission Report for any mention of trafficking in stolen antiquities. There was none. As of the 2004 publication date of the report, the U.S. government had

not been able to determine where al Qaeda secured the funding for the attack. "Al Qaeda has many avenues of funding," the report says. "If a particular funding source had dried up, al Qaeda could have easily tapped a different course or diverted funds from another project."[13]

I was, however, taken aback to learn how little it had cost to murder 2,996 people and terrorize the world: between four hundred thousand and five hundred thousand dollars, one-third the price of a used helicopter.

Two years after my first visit to Germany, I returned to re-interview Michael Müller-Karpe and see the replica of the miniature Sumerian vessel.[14] This time, my questions were far more specific. What was it about this tiny antiquity that made it so important? Did Müller-Karpe believe there was a link between it and the 9/11 terrorists? What was his role in the story?

As before, we met at Römisch-Germanisches Zentralmuseum and sat a moment to chat. I learned that Müller-Karpe came from a family of archaeologists. His field is Mesopotamian archaeology, most specifically ancient metal objects. In 1974, he began working in Iraq and continued there until the Persian Gulf War began in 1991, and the Iraq National Museum was closed. "Hopefully I will go back soon," he sighed.

We went down a flight of stairs into a dark room with a glass-fronted, locked case displaying replicas of famous originals, including a golden flask and the gold foil that had decorated the boots of a southern German who lived around 550 CE. There was the tiny, dented Sumerian vessel again. We peered through the glass to study it more closely.

"Originally it was perfect," Müller-Karpe told me. "It was damaged somehow after it was made, perhaps from the collapse of the stone or brick walls of the tomb in which it was found. But the rest is presented in its original shape—which is very rare. After 4,500 years, usually objects are not all together. The fact that this vessel is complete means it was preserved in its original place, the tomb chamber."

Müller-Karpe told me the vessel was likely robbed from an intact royal grave, because only the very rich could afford an item of such high-quality gold. He knew it to be Sumerian from the two distinctive golden handle attachments on either side of the vessel. Made from thin sheets of gold rolled into tubes, these handle attachments are another Sumerian invention, found only on objects from the early third millennium to the beginning of the second millennium.

"We know the owner was a Sumerian royal," I said. "But who would want such a tiny vessel? What would it be used for?"

"The reason the object is so distinctive is that it's so tiny," he told me. "Sometimes in the graves of children, you will find miniature weapons, miniature vessels, so it could have come from a child's grave." A golden dagger and several tiny goblets of the same date and high-quality craftsman-

ship appeared on the market around the same time this little vessel arrived in Munich. Discovering one untouched royal grave is very rare, let alone two; so all of these objects likely came from the same place.

Müller-Karpe thought they might have come from Ur, because it is Iraq's best-known archaeological site and the place where the Royal Tombs were first discovered. If the vessel actually came from a previously untouched royal tomb, it would be especially rare, because there have been no legal excavations there since Woolley left in 1934. Iraq's dictator, Saddam Hussein, may have been a monster, but he was committed to preserving Iraq's heritage, and under his reign grave robbing was a capital offense. Since his overthrow in 2003, grave robbing has become much easier; Iraq's ancient antiquities have flooded the market.

The tiny vessel was lovely. "If I wanted to purchase this replica, what would it cost?" I asked, imagining it glittering in my own display cabinet, perhaps magnified by the same kind of magnifying glass used by the restoration students upstairs.

"We are not selling," Müller-Karpe replied. "To replace it someone would have to go to the Iraq National Museum in Bagdad to make the mold. We only made this one. You see, the replica itself is somehow dangerous. Do you know the detective story by Agatha Christie, *Murder in Mesopotamia?*" he asked. "It is set in the excavations at Ur. The French archaeologist turns out to be an antiquities dealer who takes gold objects from the excavation and leaves replicas in their place. The idea that a replica can replace the original means replicas are quite valuable. They must be kept. They must not disappear."

I asked Müller-Karpe whether it was possible to trace the vessel's route from Ur to its sale in Munich. For example, who was the looter?

"The looter who came across the royal grave?" he replied. "I can imagine he was a poor farmer who worried about feeding his family. He couldn't sell his date crop because the chaos of war destroyed the economy. The reason I think he was in a desperate situation is that most Iraqis know the importance of antiquities. They are aware of their heritage and very are proud of it." When Müller-Karpe worked at the Iraq National Museum, he was especially impressed by how many people visited and how knowledgeable they were about their heritage.

"I don't know what I would do if my family was starving," he continued. "You will have bad feelings, your conscience, you might not sleep at night."

The hypothetical Iraqi farmer knew he would find something in the mound, though he had no idea what it would be. Typically, grave robbers dig a shaft as deep as ten meters down into the ground, and then dig horizontally into the layers that hold the ancient settlement. The tunnels can easily collapse if not dug correctly, smothering the robbers. But luck was with our farmer; he discovered a cache of valuable objects and was able to sneak them

out without the other looters knowing, and perhaps killing him for the treasures. No one knows how many are murdered in the course of criminal archaeology.

Our farmer would have sold the vessel and other miniatures for a pittance of their value to a middleman working for organized crime. Eventually they would sell for millions. Müller-Karpe told me about a miniature lion figurine that sold at auction in New York for fifty-seven million dollars. The catalog listed it as "excavated in the vicinity of Baghdad."

German customs investigators were able to trace the tiny Sumerian golden vessel to Beirut because they found the middleman who brought it there. The middleman transported it to the Geneva Freeport, a secured warehouse complex that has become a major storage center for stolen art and artifacts because owners pay no import tax or duties on goods stored there. From the Freeport, the vessel traveled to Munich in the German district of Bavaria. Munich had become an international hub of criminal archaeology because Bavaria did not require the source country to document legal export.

The golden miniature next appeared in late 2004 in the catalog of the Munich auction house of Gerhard Hirsch Nachfolger. It was listed as Mediterranean, possibly from Troy, and dated to the Roman Iron Age (first century CE).[15] The estimated auction price was 1,200 euros.

"No one would buy it in good faith," said Müller-Karpe, shaking his head. "People knew it was stolen. All archaeology students in their first year learn that double tube handle attachments are typical for Sumerian Mesopotamia of the third millennium. The owner of Gerhard Hirsch Nachfolger was trained as an archaeologist, so I would be surprised if she really thought this vessel was Roman."

"The auction estimate for the vessel was 1,200 euros," I said. "What do you think is the actual value?"

Müller-Karpe thought for a moment. "The true value of an archaeological object," he said, "is the information it carries, and that is far beyond any monetary value. But on the illegal art market, I would not be surprised if such a unique item would fetch thirty million euros."

I did a quick calculation: That would be about forty-five million dollars. If the 9/11 attacks cost five hundred thousand dollars, this little vessel could pay for ninety similar terrorists attacks. No wonder people were so interested in it.

Unscrupulous dealers are expert in transforming the looted into the legitimate. A dealer imports an antiquity and assigns it a false, later date and vague attribution, like, "from the vicinity of . . ." or "southern Mediterranean," which deflates its value. The dealer then pays import taxes on the deflated value, thus attaining legal documentation that supports the false attribution, and lists it in an auction catalog. Then, a co-conspirator buys the

antiquity, puts it away, and a number of years later brings it back onto the market and sells it for millions.

In 2006, a year after first appearing in the Gerhard Hirsch Nachfolger auction catalogue, the tiny golden vessel appeared again, this time with an auction estimate of two thousand euros, and was purchased by a German lawyer.

Müller-Karpe had been monitoring these transactions. Realizing that this might be the oldest intact Sumerian vessel ever to come on the market, he decided to try to rescue it. But first he had to verify its origins. Unfortunately, the photograph in the auction catalog had carefully positioned the vessel so that the distinctive Sumerian handle attachments were hidden from view. So, Müller-Karpe contacted a Munich policeman he knew and asked him to confiscate the vessel and send him a photograph of it showing the vessel's other side. The policeman, beaten down by years of fruitless fights against the clever attorneys of corrupt auction houses, wouldn't do it.

In Germany, property crimes fall under the jurisdiction of the district court—except for trafficking in Iraqi antiquities, which is a federal crime. When the Munich police officer refused to confiscate the Sumerian vessel, Müller-Karpe called an officer in the federal customs office, who went to Munich and confiscated the vessel. A few days later, Müller-Karpe received an envelope from customs. Inside was the tiny golden antiquity worth thirty million euros, sent by ordinary mail.

Now that the vessel was at the Römisch-Germanisches Zentralmuseum, its safety had to be ensured. Müller-Karpe notified the Iraqi ambassador to Germany and then invited a team of experts to examine the object thoroughly and report the findings to customs. Two years, later a letter arrived directing the museum to turn over the golden antiquity to the customs authorities. Müller-Karpe wrote back, suggesting that because of the vessel's small size, value, and rarity, it was safest to keep it in the museum's vault until the legal dispute over its ownership was resolved.

He didn't hear from customs until a letter arrived the following year informing the museum that an armored car would soon arrive to pick up the Sumerian vessel. Müller-Kamp called the officer who had initially confiscated the vessel and learned that, upon request by the auction house, the Bavarian district courts had decided to secure the object for court inspection. If the court ruled that the vessel was from any place other than Iraq, customs should not have confiscated it in the first place; it would be returned to the auction house.

"What does this mean, 'inspection by the court'?" Müller-Karpe frowned. "I suggested to the officer that if the court wanted to inspect the vessel, it could inspect it here. The Iraqi Embassy was very concerned that an antiquity this tiny and this valuable could easily disappear. The officer then asked if I was 100 percent certain the vessel was Sumerian. Of course, I was certain,

but only to the degree of certainty archaeology allows. There's no 100 percent in archaeology." As Müller-Karpe tried to convince the officer to allow the vessel to remain at the Zentralmuseum, the conversation heated up. Before he knew it, the customs official had threatened to take the vessel by force, by blasting open the safe with a welding torch if necessary.

When you are fighting the good fight, sometimes you get lucky. About thirty minutes after hanging up the telephone with customs, Müller-Karpe received a phone call from a reporter for *Der Spiegel*. Müller-Karpe told him about the officer's threat. That evening, *Der Spiegel*'s website carried the story, and the next morning it was picked up by major international papers. Soon, people throughout Europe knew that come Monday, customs personnel would appear at the Römisch-Germanisches Zentralmuseum in Mainz, Germany, to break open its safe and confiscate a miniature Sumerian antiquity. To avoid negative publicity, customs postponed the visit for three more days—then postponed it twice more.

Eventually, a large truck pulled up to the Mainz museum, picked up the little gold object, and drove to the world-famous museum of archaeology, the Pergamon Museum in Berlin. After a day of careful examination, its archaeologists verified Müller-Karpe's attribution.

The Sumerian vessel next appeared in Munich's financial court as the subject of a suit brought by the Gerhard Hirsch Nachfolger gallery claiming it was not of Iraqi origin. In October 2009, on the basis of a second expert opinion prepared by the Pergamon, the financial court ruled the vessel was of Iraqi origin. But, despite the court decision, the Sumerian miniature remained in the hands of German customs.[16]

As all this was unfolding, it became clear that the controversies surrounding the golden vessel presented the perfect opportunity to bring the story of illicit antiquities to a wider audience. "The public knows that the drug trade or weapons trade is evil and dangerous," Müller-Karpe told me, "but doesn't know that the trade in illegal antiquities is just as dangerous." The result of Müller-Karpe's effort to publicize this danger was an exhibit about stolen antiquities—and the "Kriminalarchäologie" catalog that accompanied it. To reach the largest possible audience, the exhibit was designed not for a museum but rather for high-traffic areas: the Mainz train station and the Munich airport. It opened in 2011 and was eventually viewed by more than six million people.

Shortly before the opening, Müller-Karpe received a note from customs reporting that the case of the Sumerian vessel was going back to court for the third time. Apparently, customs had only temporarily seized the object instead of formally confiscating it, and Gerhard Hirsch Nachfolger had taken advantage of this procedural error to reinstitute its suit. This time the gallery came armed with its own archaeologist, who disputed the vessel's Sumerian origin.

The case of the Sumerian gold vessel was one of the top stories in the exhibition. It informed a wider public about the ongoing legal dispute and the embarrassing inability of the authorities to return this precious treasure to the country from which it was plundered. Within a few days of the exhibition's opening, Müller-Karpe learned from the German Finance Ministry that the case of the Sumerian vessel was closed. On July 6, 2011, Germany's secretary of state officially returned the vessel to the Iraqi ambassador to Berlin. For several months, it was stored in the vault of the Iraqi Embassy in Berlin until the director of the Iraq National Museum arrived to personally escort it back home.

That was quite a story, but there was still something missing, so I asked Müller-Karpe the question that had been troubling me: "the "Kriminalarchäologie" exhibition catalogue included photos of Mohamed Atta and the other 9/11 terrorists. I read the official 9/11 Commission Report, [17] and it made no reference to criminal archaeology. Do you think illicit antiquities were used to finance the attacks?"

The Commission "knew nothing about antiquities," said Müller-Karpe, shaking his head. "Here is what I know."

In 2006, four years after publication of the 9/11 Report, Müller-Karpe gave a lecture to the German Oriental Society in Leipzig on the illegal excavations in Iraq. Afterwards, a former student, a woman who was an archaeology professor at Hamburg University, approached him and told him a remarkable story. In 1999, an architecture student came to her for advice. The student had just come back from "training" at some undisclosed location in Afghanistan, where he had seen caves filled with antiquities. Now, he wanted to know how to sell the antiquities in Germany, saying that he wanted the money to purchase flying lessons.

"The professor became very upset by the student's question," Müller-Karpe recounted, "and she made some kind of remark, like, 'Why do you ask me? You should ask your Allah' or something like that. The student became very angry and said if she were not a woman he would kill her. Later the professor learned that this student was head of the team of terrorists—Mohamed Atta."

Müller-Karpe tried to convince the professor to report this incident to the authorities, but she was too frightened, so he secured her permission to tell the federal police himself. Later, he learned that the police had interviewed the professor but had discounted her report as unreliable.

"Well, I don't know the woman that well," he said, "but I would not have thought she was nuts. Actually I believed her, and I don't see any reason not to believe her."

"Why do you think the police considered her unreliable?" I asked.

Müller-Karpe stopped and took a breath. "I have been involved in criminal archaeology for many years. I believe there are strong ties between the antiquities industry and the authorities, strong ties."

Did Mohamed Atta attempt to finance the 9/11 attacks by selling looted antiquities? If he did, then the antiquities would not have come from Iraq, but rather from Afghanistan, acquired when Atta was in the country for terrorist training.

Müller-Karpe is not the only one who believes this is true. A story published in July 2005 in *Der Spiegel* reported that Atta tried to sell looted antiquities;[18] the story was later cited on the FBI website in a Law Enforcement Bulletin about art theft.[19] *The Art News*, a weekly British magazine covering the art and antiques trade, reported on repeated statements by the secretary general of Italy's Ministry of Culture that the German Secret Service had testimony about Mohamed Atta's attempted sale of looted Afghani artifacts.[20]

We will never know whether Atta was as successful an antiquities dealer he was as a mass murderer. Ironically, what we do know concretely about the connection between illegal antiquities sales and violence involves not the causal link between looting and violence, but the link between violence and looting.

In the days after the March 2003 overthrow of Saddam, the National Museum of Iraq in Baghdad suffered heavy looting, despite the efforts of its staff to protect it. Among other things, five thousand cylinder seals were stolen: a cylinder the size of a human thumb can fetch upwards of five hundred thousand dollars.[21] As of 2013, 3,500 objects have been recovered, and experts estimate another 8,000 are missing. Many more antiquities were looted from unprotected archaeological sites.

Thus, although there is no evidence that the Sumerian vessel helped to finance the 9/11 attacks, we do know that the attacks, and the consequent overthrow of Saddam, sparked the discovery of the vessel in the mound at Ur, led to its illegal removal, and sent it off on its long, circuitous journey.

War can destroy more than individual lives. It can destroy a nation's patrimony. "Sometimes I'm asked by journalists what is the volume of the damage," Müller-Karpe told me. "Some colleagues give figures of two or three billion dollars' damage. This is nonsense. What is damaged is the historic memory of mankind. That loss can never be measured—not even in billions. These archaeological sites are archives in the ground. Even if you confiscate the material, identify its source, and give it back to the state the objects came from, this cannot compensate for the destruction."

Richard M. Leventhal agrees. He is executive director of the Penn Cultural Heritage Center at the Penn Museum of Archaeology and Anthropology, the institution that financed Leonard Woolley's excavations at Ur in the 1920s and 1930s. Leventhal's center is dedicated to the often-frustrating

quest of stopping wanton looting of archaeological sites. Most of these are in third world countries—what archaeologists refer to as "source countries. Museums in wealthy countries—called "market countries"—are especially at fault. UNESCO's Convention was adopted in 1970.[22] But museums in wealthy countries continue to buy.

"Museums must stop wanting to collect," Müller-Karpe told me. "They are still purchasing cultural objects without thinking of the morality. Why would they want to purchase objects that might be illegal or immoral? I think it's about showmanship."

In fact, as Leventhal pointed out, things are getting worse, not better. In 2008, the Association of Art Museum Directors agreed to direct its member institutions not to acquire objects excavated before 1970 without proper provenance. In 2013, the association re-evaluated these guidelines and added in some exceptions that allow museums to purchase "orphan objects" under some very few conditions. The association makes a good point: many antiquities without proper documentation were excavated decades before 1970 and acquired by private individuals.

My search began with a chance encounter with a tiny, ancient vessel small enough to hide in a child's hand, which led me to stolen antiquities and terrorism. I found myself wondering whether I was becoming one of those crazy conspiracy theorists, the kind of person who sees danger lurking behind every door, every rock.

But then I thought about post-9/11 America and the vast political consequences—the invasion of Iraq, the increased surveillance, the long security lines at every airport in the world, the massive barricades and stern guards surrounding Independence Hall, a block from my home—and I realized that the golden Sumerian vessel raised precisely these troubling concerns.

Looking for a broader perspective on these issues, I traveled across town to the Penn Museum, which displays the antiquities it received from Woolley's expedition in Ur. Within the museum, the quickest way to reach Ur is to take an elevator to the third floor and walk through Rome, Canaan, and Israel, all of them the subjects of study by Penn archaeologists and anthropologists. At the entrance to the exhibit entitled *Iraq's Ancient Past* is a wall-sized photograph of Woolley and his large crew of Iraqis standing on top of Ur's partially excavated ziggurat. Apparently, a number of celebrated British were involved in the story. Woolley's expedition was given the green light by the British Colonial Office, headed by a young Winston Churchill, on the advice of his assistant secretary, T. E. Lawrence, the famed "Lawrence of Arabia," who was himself an archaeologist. An Englishwoman, Gertrude Bell, was so revered by the Iraqis that she became their honorary director of antiquities. She helped to set in place the 1924 Iraqi Antiquities Law, then lorded over the division of the finds from the excavations at Ur and helped to establish the National Museum of Iraq—where Michael Müller-Karpe later

worked—to hold the Iraqi share of the objects. While the Penn Museum exhibition text does not mention Woolley's theory of the Great Flood, it does concede that Ur was likely the "land of the Chaldeans" noted in the Bible as the birthplace of Abraham.

The Penn exhibit is a Sumerologist's dream, with cuneiforms, pottery, jewels, and precious metal. I admired a set of game boards and a miniature golden bull wearing a false beard—the Sumerians loved false beards. Nearby were two lovely oval golden bowls, each, I noted, with the signature scrolled handle attachments on their sides.

The centerpiece of the exhibit is devoted to Queen Shubad, now called Pu-abi, whose twenty-first century avatar, a regal red velvet mannequin, is set in a glass box surrounded with items excavated from her tomb. Pu-abi sports an elaborate, puffy hairdo encircled by a wreath of golden leaves, and crowned by a golden Spanish comb topped by a spray of glistening stemmed flowers. Twin gold rings loop through the hair on either side of her head, and hammered golden earrings the size of bracelets hang from the place where her ears would have been. Draping her bodice is a sort of poncho comprised of strands of beads—blue lapis lazuli, red carnelian, and gold—that fall to a wide beaded belt. She is gorgeous and glittering.

Although the Ur dig was finished in 1934, research on it continues. Recently, three scholars decided to test Leonard Woolley's theory—that the bodies found in Queen Pu-abi's tomb died peacefully from poison—by taking a male skull and female skull from the royal cemetery at Ur to the University of Pennsylvania Hospital and sending them through a computed tomography scan. Both skulls showed circular holes in the backs of their heads, likely made by a heavy mallet with a point at the end. In other words, there was nothing peaceful about these burials. But that's the way archaeology is: new knowledge emerging from old objects examined in new ways.

Sitting with the ancient Sumerians, I thought again about the price society pays for criminal archaeology.

Everyone agrees that trafficking in stolen antiquities is harmful. But how do you stop it? Not at the source—since there are tens of thousands of archaeological sites, and few nations that can afford to pay guards as much to remain honest as organized crime can pay them to turn a blind eye. Not at the national borders—since borders are long and, with forged documents and a bit of cash, easily crossed. Not in Beirut or Geneva, huge international ports and free trade zones where tiny treasures made of alabaster or clay or gold are easily smuggled in and out. Not in Munich, with its relatively lenient import laws and aggressive lawyers.

Trafficking has to be stopped at the end—with the buyer. If there's no market for pilfered antiquities, then there will be no more pilfered antiquities on the market. As Michael Müller-Karpe says, "Everyone who buys antiqui-

ties of unknown origin should know he is committing current and future looting. He is committing a crime."

But even if all looting ceased and no new finds came on the market, the problem would not be resolved, for we still must deal with the antiquities that are currently on the market, these so-called orphan objects. What should happen to these? What is the value to society of leaving them floating out there? If we condone their purchase, are we encouraging looting, fueling illicit business, funding organized crime, and destroying the past? Should we agree with the archaeologists, who are against any acquisition of unprovenanced antiquities, or concur with those art museum directors who argue that orphan antiquities need the special care and attention only available from public institutions? These art museum directors and archaeologists continue to talk, but the debates seem irresolvable. The two sides can't even agree on what orphan objects really are. Archaeologists define them as objects that are missing contextual information about their "find spots." Art museum directors say they are antiquities that have yet to find homes in public museums.

Regardless of which camp you join, orphan objects also raise an ethical issue. Many of these antiquities come from countries that are, like Iraq, at their moments of greatest weakness. Should institutions in the United States, one of the wealthiest of nations, be allowed to take advantage of their straits?

Questions like these are as ancient as the Sumerians, as old as the Bible, and as current as the evening news.

## NOTES

1. Samuel Noah Kramer, *The Sumerians: Their History, Culture, and Character* (Chicago: University of Chicago Press, 1963), 3.
2. Ibid., 84.
3. Samuel Noah Kramer, *From the Tablets of Sumer: Twenty-Five Firsts in Man's Recorded History* (Colorado: The Falcon's Wing Press, 1956).
4. Sir Leonard Woolley, *Excavations at Ur: A Record of Twelve Years' Work* (New York: Thomas Y. Crowell Company, 1954), 12.
5. Ibid., 96.
6. Agatha Christie, *An Autobiography* (New York: Dodd, Mead & Company, 1977), 364.
7. Ibid., 97.
8. *The 9/11 Commission Report: Final Report of the National Commission on Terrorist Attacks Upon the United States, Authorized Edition* (New York: W.W. Norton & Company, 2004).
9. Ibid., 157.
10. Ibid., 227.
11. Ibid., 234.
12. Ibid., 4–7.
13. Ibid., 172.
14. Interview with Michael Müller-Karpe, September 3, 2013.
15. Lucian Harris, "German Court Orders Return of Ancient Vessel to Iraq but the Gold Vase is Still Believed to be Held in Germany Pending an Appeal," *The Art Newspaper*, November 18, 2009.
16. Ibid.

17. "The 9/11 Commission Report."

18. "Kunst als Terrorfinanzierung," *Der Speigel*, July 18, 2005, www.speigel.de/spiegel/print/d-41106138 html.

19. Noah Charney, Paul Denton, and John Kleberg, "Protecting Cultural Heritage from Art Theft: International Challenge, Local Opportunity," *FBI Law Enforcement Bulletin*, March 2012, http://leb.fbi.gov/2012/march/protecting-cultural-heritage-from-art-theft-international-challenge-local-opportunity.

20. Cristina Ruiz, "9/11 hijacker Attempted to Sell Afghan Loot," *The Art Newspaper*, April 17, 2013.

21. Laura De La Torre, "Terrorists Raise Cash by Selling Antiquities," *BGSN: Government Security News* 4, no. 3, February 20, 2006.

22. United Nations Educational, Scientific and Cultural Organization, *Convention on the Means of Prohibiting and Preventing the Illicit Import, Export and Transfer of Ownership of Cultural Property* (Geneva: United Nations Educational, Scientific and Cultural Organization, 1970).

*Chapter Eight*

# Heroes

A glittering portrait of an Austrian socialite. A garment removed from a murdered Indian. The original typescript of a wildly popular and influential book. An audio disc of a vintage radio show. A black Egyptian mummy with crossed arms and orange fingernails. An original copy of the Bill of Rights. An ancient golden vessel about the size of the tip of your thumb. These items are very different from one another. What could they have in common?

Though fashioned by different hands from different types of materials at vastly different times, all of these are cultural objects. Cultural objects tell us who we are and what we value. They ground us in the past, wrap us into a community, and connect us to the spiritual world. They reassure and comfort, charm and celebrate. Cultural objects are the mirrors of humankind.

UNESCO calls these objects "cultural property," defined as "property which, on religious or secular grounds, is specifically designated by each State as being of importance for archaeological, prehistory, history, literature, art or science."[1] UNESCO goes on to list categories of cultural property: property related to history, products of archaeological excavations, antiquities more than one hundred years old, objects of ethnological interest, property of artistic interest, rare manuscripts, and archives, including sound archives.[2] These include all of the objects profiled in this book.

The passion for cultural objects is deep and abiding. Humans create museums, archives, and libraries to care for those objects and assure their survival. But in the twenty-first century, these institutions face issues that their founders never contemplated. One of the most compelling is this: Who owns and who should own a culture's treasured objects? When I was a graduate student in the early 1970s, this issue of ownership never came up. Things in museums belonged in museums. Now, it's front and center, not only among museum professionals but also in the larger world.

Take, for example, the Parthenon marbles that Lord Elgin took from Athens in the early 1800s, quite legally, and sold to the British Museum. Many people, including those who have never been to either the British Museum or the Parthenon have strong opinions about whether the museum should return the marbles to the Greeks. The arguments against their repatriation make a lot of sense. For one thing, Elgin secured permission from the rulers of Greece to remove the marbles; for another, more people visit London than Athens, so more people can now enjoy them. Moreover, the British Museum has protected the marbles from air pollution, looters, and all similar threats; and finally, if the British Museum were to return the Elgin marbles, it would be overwhelmed with claims from every other culture whose treasures it holds. This last "slippery slope" argument darkly predicts such repatriations as, collectively, a death knell to "encyclopedic" museums of world culture like the British Museum.

The argument for returning the Elgin marbles to Greece is much simpler. It is embodied in the breathtakingly beautiful museum at the foot of the Acropolis in Athens. On the third level of this museum stands a full-scale display of all four sides of the Parthenon frieze. Museum visitors can walk around it and see the actual Parthenon sculptures that remain in Athens, placed in their appropriate places next to plaster casts of the Parthenon sculptures held by the British Museum. This is a powerful message of loss, as poignant as the sad smile of a beautiful woman missing half her teeth. The Greeks know the Elgin marbles are safe in the British Museum. But their longing for them is so profound that they created an entire museum to memorialize their grief. And to show that the Greeks are equipped and ready to reclaim these Greek treasures.

The case for returning the Elgin marbles, then, comes down to ethics. It's the right thing to do.

Each of the cultural objects profiled in *Stolen, Smuggled, Sold* is similarly emotionally resonant. The Ghost Dance Shirt was so important to the Lakota Sioux that they spent years trying to retrieve it from the Kelvingrove Museum in Edinburgh, Scotland. Their cause was so potent that it commanded the attention of a good portion of the population of Edinburgh, who saw the cause of the defeated Sioux as akin to their own. The power of this rough muslin garment hung with frayed bald eagle feathers reaches beyond the decades and the glass case in which it now stands.

North Carolina's copy of the Bill of Rights is beloved by North Carolinians, a feeling intensified by its theft at the moment when the state's capital, Raleigh, was most helpless. North Carolinians held the Bill of Rights in such reverence that they refused to sign the Constitution without it, and they refused three times to buy their original copy of it back when it was offered for sale. They refused to commoditize this sacred parchment. They, after all, owned it.

*Portrait of Adele Bloch-Bauer 1* embodies the loss of the Jewish people who lived in Europe before World War II. The painting was wrenched from its family when they were forced to flee their Vienna palace, and their descendants spent decades knowing that the painting was in a museum owned by those who were culpable in the destruction of the Jewish people. For decades, as the painting hung on the walls of the Austrian National Museum, Adele's beauty so seduced her visitors that all of Vienna mourned its loss when the painting finally returned to its rightful owners.

The royal mummy that might be Ramesses I went from dusty oddity to celebrated figure when archaeologists spotted it at the Niagara Falls Museum and Daredevil Hall of Fame. Practically overnight, the mummy came to command VIP treatment at a leading Atlanta medical center and starred in its own exhibit and television show. After Ramesses I finally made his flight back to Egypt, he received a mighty welcome—a truly king-sized celebration.

Not all cultural objects are as cherished as these. Some possess a sinister, even seductive, power. Obsession led Leslie Waffin, the former director of the National Archives Audio Section, to smuggle the audio disc of Babe Ruth at a Quail Hunt, plus 4,800 other recordings, out of the Archives. He stole them not for the money but to own the thing itself. Fear may have led Pearl Buck's long-time secretary to hide original typescript of Buck's masterpiece, *The Good Earth*, from its owner. The secretary may have believed that a false friend had seduced Pearl into selling her most cherished work to underwrite his lavish lifestyle.

Finally, there is that five-thousand-year-old Sumerian miniature vessel from a culture so creative that we continue to live with its inventions. This object raises a raft of complicated issues. If the world were truly just, we might never have known about it. The Sumerian vessel might still be resting in its grave if al Qaeda operatives had not attacked America on September 11, 2001, and if the American government had not invaded Iraq partly in response, bringing about the downfall of Saddam Hussein and, consequently, leaving archaeological sites vulnerable to grave robbers. That's quite a cascade of causation captured in a single tiny object. In archaeology, every aspect of an object can be just as it was yet never be the same. When an antiquity is removed from its find site, much of its meaning is lost forever.

These cultural treasures spark passion; they take on a moral life. They reflect a universe of people's legitimate claims and desires. They also stand for the millions of objects that have yet to be returned to their original owners, or will never be. Despite their social value, cultural objects are surprisingly vulnerable. There is no international clearinghouse of cultural objects. There is no way to count how many cultural objects that are missing provenance records are actually held by their legal owners. There is no way to tell how many may be tainted. Of those that are suspicious, there is no way

to know how many are stored in collecting institutions, hidden in criminals' safe houses, awaiting auction, decorating corporate offices, or enlivening the homes of collectors. This lack of information is what makes them vulnerable.

Experts are quick to say that there is no way to estimate either the number of illicit cultural objects or their financial value—but, of course, some do. Estimates for the global annual trade in illicit antiquities range from three billion to eight billion dollars.[3] Every time a war breaks out, the market is flooded with cultural property dug out of unprotected archaeological sites and national museums.

Holocaust artwork has been much in the news lately. What do we know about how much is returning to the descendants of its Jewish owners? There's good news and bad. The good news is that there is an international agreement that governs the restitution of Holocaust artworks: the 1998 Washington Principles on Nazi-Confiscated Art, renewed in 2009. The bad news is the international agreements have had only modest effect. The statistics prove this out. In 1998, it was estimated that 650,000 artworks had been stolen from Jews in Nazi-occupied Europe, and 200,000 remained at large.[4] Since that date, only 1,000 to 1,500 have made their way back to their Jewish families. This is according to Wesley Fisher, who is director of research of the Conference on Jewish Material Claims Against Germany and World Jewish Restitution Organization.

In the United States, the restitution statistics are equally discouraging. Since 2003, museums in this country have been encouraged to list all artwork with gaps in their provenance during the years 1933 to 1945 on the Nazi-Era Provenance Internet Portal.[5] In 2014, the Portal listed 28,930 artworks. Leslie Fisher estimates that fewer than fifty of these have been returned to Jewish families. As he told me, "The legal system is stacked against claimants."

The scale of the problem of cultural treasures that have been stolen, smuggled, and sold staggers the imagination. One cannot help but ask: Why isn't anyone doing anything about the problem?

Actually, law enforcement officials and others have been working for decades to end trafficking in looted and stolen antiquities, to return Jewish property to descendants, and to protect museums, archives, and libraries from crime by insiders and outsiders. UNESCO, the most important international agency in this field, has worked collaboratively with the International Council of Museums, and both have been supported by national law enforcement agencies. A number of countries have their own cultural police squads. For example, Italy's Comando Carabinieri per la Tutela del Patrimonio Culturale, better known as the Carabinieri Art Squad, is responsible for combating art and antiquities crimes. Moreover, the Italian Ministry of Finance has an office that investigates art thefts and illegal excavations. The FBI has a dedicated Art Crime Team of fourteen special agents, supported by three trial

attorneys responsible for art and cultural property crime, which consists of theft, fraud, looting, and trafficking across state and international lines. The Internet has become an enormously powerful tool for expediting research and information sharing. Interpol's website is one of many that list looted antiquities and stolen artwork. A number of nongovernmental agencies and university centers focus on aspects of the problem. There are newspaper reporters and bloggers who offer insight and some who simply share their paranoia.

Moreover, the nations of the world are papered in applicable laws. Hundreds of national laws govern cultural property: a UNESCO website[6] lists 1,087 acts and laws, 136 agreements, 38 codes, 27 conventions, and 162 regulations in many different languages addressing such themes as good faith acquisitions, illegal trafficking, importation, statutes of limitations, and reparations. There are 50 such laws in the United States and 148 in the United Kingdom, both of them major markets for such property, and source countries are protected with legal instruments as well: for example, Cambodia 18 laws, Nigeria 7, and Bolivia, which has a surprising 114. In the United States, art crimes and cultural heritage are prosecuted under statutes that cover mail fraud,[7] wire fraud,[8] smuggling,[9] and entry of false statements.[10] We have specific statutes governing stolen property[11] and theft of major artwork.[12]

Despite all these law enforcers, do-gooders, and legal instruments, the fact remains that only the tiniest of fraction of the gigantic number of suspicious cultural objects makes its way back to the original owners. The seven objects profiled in this book are the very lucky, very few.

Is it possible to stop the flow of illegal antiquities? Could there be an international tribunal to resolve competing claims between source nations and market nations? Let's consider each of these questions.

It is as impossible to end the illicit market for cultural property as it is to end to the illicit markets for drugs, weapons, or human beings. As we saw with the Sumerian golden vessel, war spawns looting and looting spawns black markets; in turn, black markets give rise to dealers, who lead to buyers. We cannot hope to end war, defeat the hydra-like criminal networks that traffic in cultural property, or redeem every notorious dealer. It is virtually certain that there is no international will to finance a large enough international army of antiquities agents as clever and dedicated as the Italian Carabinieri or our own FBI Art Team. We cannot stop looting of archaeological sites or stealing from unprotected museums. All we might be able to do is to stop ourselves: the buyers. As Michael Müller-Karpe, who rescued the Sumerian vessel, said, "We must stop the antiquities trade at the buyer's end."

Institutional buyers—collecting institutions—should no longer be buying suspicious objects, at least according to their professional associations. The Codes of Ethics of the Archaeological Institute of America, American Alliance for Museums, International Council on Museums, and the Association of Art Museum Directors explicitly discourage member museums from par-

ticipating in the trade in undocumented objects. Still, while all museums try to avoid acquiring suspicious objects, some are more proactive than others in searching out those already in their collections. Archaeology and anthropology museums, whose work depends on strong relationships with source countries, have been at the forefront of the repatriation movement, while art museums have been slower in adopting a proactive stance.

In fairness to the art museums, one must remember that the interest in repatriation is relatively recent; indeed, it represents a sea change for collecting institutions, as I learned from Victoria Reed, the Monica S. Sadler curator of provenance at the Museum of Fine Arts, Boston. She said of past practice, "I think the most consistent mistake was not asking questions. Or if we did ask questions, accepting the word of the dealer or donor at face value without probing further. For many years, that was just the way the art world operated. Nobody asked questions." And we must remember that the mission of collecting institutions is to collect, not to give things back. Their future is optimized if their donors are happy, and it is a rare donor who is happy to learn that the treasure he or she has so generously offered is not acceptable because of a fuzzy title.

Now that collecting institutions have become much more vigilant when approached by dealers and donors offering questionable acquisitions, the next target is in sight. It is the individual buyers, the collectors who, wittingly or unwittingly, purchase artwork without looking carefully at its paperwork. The purchasing practices of collectors are important to museums, since collectors are the source of most new acquisitions.

In a market economy like ours, art collectors have considerable freedom in purchasing artworks and antiquities. But, perhaps there is one tool that can be used to advantage: shame. The fear of negative publicity has already worked with institutions. The Italians directed a negative publicity campaign against the Metropolitan Museum and the Getty Museum, a campaign that resulted in repatriation of some very significant artifacts. The Peruvian government lobbied President Obama and staged large public demonstrations; eventually Yale University sent back the four hundred thousand objects from Machu Picchu that it had been holding since 1911. To encourage better purchasing practices among individual art and artifact collectors, one can imagine a public service campaign that would paint the acquisition of undocumented antiquities as being as déclassé as buying ivory or endangered species. Sometimes shame works.

The second question is this: is it possible to establish an international tribunal to adjudicate disputes over cultural treasures? If such an international tribunal had existed in 2003, for example, Marie Altman would not have had to spend years trying to secure *Portrait of Adele Bloch-Bauer I* or her other possessions.

Establishing a legally binding international tribunal for cultural objects seems as pie in the sky as ending their trafficking. For one thing, there would have to be some actual laws to enforce. Today, international cultural heritage law is not law at all but is rather based on UNESCO conventions. Conventions have no teeth. The United Nations Office on Drugs and Crime does not consider illicit cultural property important enough to be included as a subject of its Convention Against Transnational Organized Crime. [13]

One can only imagine the political challenges of establishing a specialized international tribunal that adjudicates disputes over cultural property; in fact, one need look no further than the International Criminal Court, which adjudicates cases in The Hague. [14] The International Criminal Court has jurisdiction to prosecute individuals for the international crimes of genocide, crimes against humanity, and war crimes. There are 122 member nations—but Great Britain, Russia, Germany, and the United States are noticeably missing. Wealthy market countries might see similar disincentives to bringing cultural property disputes to an international tribunal. Moreover, in order for an international tribunal to work, there would have to be not just laws—which are missing now—but subsidies to source nations that currently can ill afford the costly legal talent it would take to level the playing field.

Some international cultural property disputes are resolved through the Art and Cultural Heritage Mediation Program, which is sponsored by the International Council of Museums and the Arbitration and Mediation Centre of the World Intellectual Property Organization. This approach, while far from a binding international tribunal, might suggest a direction for the future.

Focusing on the end buyer in the fight against stolen and smuggled cultural property and establishing an international tribunal are long-term solutions. There are, however, actions that can be taken more quickly. We can ensure that collections professionals are equipped to address the challenges of the twenty-first century. We can educate, especially in the three critical areas discussed in this book: ethics, security, and provenance.

The Smithsonian Institution hosts a database of certificate, bachelors, masters, and doctoral degree museum training programs in the United States, by state and by discipline. [15] Some of these appear to offer training in museum ethics. Law schools now offer courses in art law. In contrast, there seem to be very few college courses on how to guard against security breaches of the type that led to the theft of 4,800 audio discs at the National Archives. Collections professionals who did not receive training in ethics or security as students can now opt for continuing education at professional conferences and seminars.

There seem to be fewer courses in provenance research, which I find surprising. Museums and other collecting institutions are vulnerable to fakes and frauds as well as stolen goods, unless someone is equipped to stand at the gate, examine the object and its paperwork, and ask the tough questions. As

Victoria Reed told me, "We need to ask more from dealers and donors, to ask for shipping documents if they are available, to look for publication history, and to create whatever paper trail we can before we make an acquisition rather than after the fact." There is a week-long, intensive provenance research training program sponsored by the European Shoah Legacy Institute, which was created by the Czech Ministry of Foreign Affairs.[16] Not surprisingly, it focuses on Holocaust material. There is also training available in implementation of the Native American Graves Protection and Repatriation Act that calls for repatriation of certain types of Native American materials to tribal people.

Reed questions whether Holocaust or any other type of provenance research can be taught in a university, since each case she encounters as a provenance curator is unique. Perhaps that is the point. One can imagine a practicum in which teams of students are presented with collections objects and charged with conducting provenance research: uncovering obscure information sources, chemically analyzing materials, replicating the artistic process, and asking tough questions of dealers and donors. Architecture students learn through design studios. Law students learn through mock trials. Tomorrow's curators and registrars can learn through provenance research practicums.

But, even without these advancements, things are changing for the better. For example, the Trafficking Culture project at the University of Glasgow's Scottish Centre for Crime and Justice Research[17] is conducting groundbreaking research on such topics as the laundering of looted antiquities into legitimate artworks, the dynamics of the illicit art market in Latin America, and regulatory effects on the illicit market in West African cultural objects. One study of items looted from Cambodia beginning in the 1970s, around the time of that country's civil war, shows how the market actually works. In 2013, two researchers traveled to Phnom Penh and visited six major Cambodian archaeological sites—one with no intact statues—before crossing into Thailand and ending in Bangkok.[18] Working with local contacts, the two conducted oral histories of diggers, middlemen, and dealers in both real and fake antiquities. Their findings suggest that a small number of middlemen tightly controlled much of the market, playing different types of roles at different times. Trafficking Culture's pioneering research is bringing new methods and findings to a field that has been woefully lacking in empirical studies. The center is funded by the European Research Council, and one can only hope it will continue long into the future.

In addition to university-based institutes like Glasgow's Centre, there are also some innovative models of institutional collaboration. Yale University's partnership with a university in Peru is a case in point. Within the last few years, Yale University returned the four hundred thousand artifacts that Hiram Bingham had rediscovered at the ancient site of Machu Picchu in the

Andean jungle and turned over to Yale. The return was accompanied by a promise of long-term collaboration. Today, the Universidad Nacional de San Antonio Abad del Cusco-Yale International Center for the Study of Machu Picchu and Inca Culture operates at Casa Concha, an historic Inca palace. It houses artifacts storage and a laboratory and research area to facilitate collaborative investigations of the Machu Picchu collections by both researchers from the two institutions and visiting scholars.

A second example comes from the University of Washington's Burke Museum of Natural History and Culture. In 1967 and 1968, a university graduate student, J. David Cole, acquired a very significant collection of artifacts while undertaking an archaeology project in the Eastern Highlands of Papua New Guinea. A portion of the artifacts were supposed to be returned to Papua New Guinea, but political upheaval and other factors delayed the return. To resolve the status of the collection, the Burke invited the PNG National Museum Archaeology Curator to evaluate it and negotiate an arrangement to share ownership and catalog information. This invitation is envisioned as the beginning of a long-term, two-way cultural exchange that will provide museum and archaeology training for researchers.

Back in the museum world, more institutions are stepping forward in ways never seen before. For example, the Museum of Fine Arts, Boston, recently repatriated stolen artifacts to Nigeria. The Norton Simon Museum, Metropolitan Museum of Art, and Sotheby's returned to Cambodia statues that had all been looted from the same temple.

Another example is that the small Kunstmuseum in Bern, Switzerland, recently accepted a vast trove of artwork bequeathed by Cornelius Gurlitt, the son of Hitler's main art dealer,[19] that includes masterpieces by Claude Monet, Pierre Auguste-Renoir, and Henri Matisse. Gurlitt's remarkable trove of artwork came to light in 2012 when German investigators broke down the door of his Munich apartment and confiscated more than 1,300 paintings as part of a tax probe. Additional paintings were found in his home in Salzburg, Austria. The Kunstmuseum has promised to restitute as much as possible as quickly as possible to the paintings' Jewish owners.

There is little financial benefit for the board of the Kunstmuseum in acquiring such a controversial trove of Holocaust artwork, only to give some or all of it away again. Repatriation can be very expensive in terms of staff time, opportunity costs, and, often, shipping fees. In the same way, there is no financial reward for a woman well into her eighties who decides to spend years trying to get a ceremonial Ghost Dance Shirt back from a Scottish Museum or for a German archaeologist who stands firm against dealers and government agents in order to assure the safety of an object he plans to return to Iraq. Dealers and middlemen get rich from stealing antiquities and artworks. No one gets rich from giving them back.

That is why I celebrate those who save the stuff. I honor those North Carolinians who refused to turn their beloved Bill of Rights into a commodity and instead seized it the moment they could get it back for free. I stand in awe of the tenacity of Hubertus Czernin, the Austrian newspaper reporter who uncovered the Austrian National Museum's treachery, and of Maria Altman and Randol Schoenberg, who yanked the *Portrait of Adele Bloch-Bauer* from the museum's clutches and set a landmark precedent for others to follow. Who would have imagined in 2003 that ten years later, Austria would be recognized as one of the nations doing to the most to return Jewish artworks to the heirs of Jewish victims of Nazi persecution? But that is just what Austria is doing.[20] They are heroes.

Some heroes do not see themselves as such: people like David Goldin, the collector who caught the archivist stealing the audio recordings he was supposed to protect, and David Ferriero, who turned tradition on its tail when he publicly acknowledged the failings of the National Archives' security systems and has since placed a priority on setting things right. But I do. I also believe that we in the United States carry a special responsibility—for when illicit treasures appear on the market, in many instances their ultimate destination is us.

You, the reader, and I, the author, have met each of seven objects at its home base and joined it in its circular journey back again. We have traveled the world, surfed the Internet, met the experts, and encountered the cops and robbers. We have observed the circumstances of the objects' removal and learned the laws and practices that condition their transfer, sale, and return. We have considered policies and practices that might lead to fewer missing and more returned.

Our world is too full of too many cultural objects that have been stolen, smuggled, or illegally sold. We need to think about how to reduce the crime and educate the collectors. We need fair and affordable legal instruments with which to resolve international cultural property disputes. We need generations of collections professionals eager and able to address security threats and suspicious objects within and outside their collections. We need staff and board members equipped with the empathy and analytical power to face tough ethical issues and arrive at decisions that are fair and right.

At the same time, we need to remember that every object should not necessarily return to its place of origin. Even the great Egyptologist Zahi Hawass would not expect the encyclopedic Metropolitan Museum of Art to empty an entire wing of its vast, rich, visually evocative, and educationally compelling collection of Egyptian treasures. But we don't have to choose between two competing viewpoints: the art museums, which want to leave the museum door ajar a bit, and the archaeologists, who want to shut it tight. We don't have to believe in a slippery slope theory. We can follow the lead

of Victoria Reed and her former colleague, Peter Lacovara, formerly of the Carlos Museum. They believe in a middle ground, where such matters are decided by both evidence and ethics. Cultural objects, we have come to see, reflect a universe of people's legitimate claims and desires. Although there is a raft of national laws, international protocols, and professional practices governing the objects that are stolen, smuggled, and illicitly sold, the same basic question remains: who should own the world's cultural treasures?

There is no single answer to this question. I struggle with the conflicting rights and ethical issues it raises. But sometimes I imagine all the cultural treasures now sitting in all the museums and rare book libraries and archives in the world. I picture them breaking free from their dark storage crypts and the glass prisons of their display cases. I see them slowly ascending to the heavens. I imagine following along as they glide over land and ocean until they reach their homelands and gently descend to the place where they belong.

## NOTES

1. "Convention on the Means of Prohibiting and Preventing the Illicit Import, Export and Transfer of Cultural Property," United Nations Educational, Scientific and Cultural Organization (Paris: 12 October to 14 November 1970), Article I, http://portal.unesco.org/en/ev.php-URL_ID=13039&URL_DO=DO_TOPIC&URL_SECTION=201.html.
2. Ibid.
3. Jeremy Haken, *Transactional Crime in The Developing World* (Washington, DC: Global Financial Integrity, 2011), 47–49, http://www.gfintegrity.org/report/briefing-paper-transnational-crime/.
4. Bureau of European and Eurasian Affairs, *Washington Conference Principles on Nazi-Confiscated Art* (Washington, DC: 1998),http://www.state.gov/p/eur/rt/hlcst/122038.htm.
5. Nazi Era Provenance Internet Portal, "The Nazi Era Provenance Internet Portal Project" (Washington, DC: American Alliance of Museums),www.nepip.org.
6. United Nations Educational, Scientific and Cultural Organization Database of National Cultural Laws, http://www.unesco.org/culture/natlaws/.
7. *Frauds and Swindles*, 18 U.S. Code §1341, http://www.law.cornell.edu/uscode/text/18/1341.
8. *Fraud By Wire, Radio, or Television*, 18 U.S. Code §1343, http://www.law.cornell.edu/uscode/text/18/1343.
9. *Smuggling Goods into the United States*, 18 U.S. Code §545, http://www.law.cornell.edu/uscode/text/18/545.
10. *Entry of Goods By Means of False Statements*, 18 U.S. Code §542, http://www.law.cornell.edu/uscode/text/18/542.
11. *Transportation of Stolen Goods, Securities, Moneys, Fraudulent State Tax Stamps, or Articles Used in Counterfeiting*,18 U.S. Code §2314, http://www.law.cornell.edu/uscode/text/18/2314.
12. *Theft of Major Artwork*, 18 U.S. Code §668, http://www.law.cornell.edu/uscode/text/18/668.
13. United Nations, *United Nations Convention against Transnational Organized Crime and the Protocols* (New York: United Nations Office on Drugs and Crime, 2004), http://www.unodc.org/unodc/treaties/CTOC.
14. "International Criminal Court," http://www.icc-cpi.int.

15. "Smithsonian: Museum Studies," http://museumstudies.si.edu.

16. http://provenanceresearch.org.

17. "Trafficking Culture," http://www.gla.ac.uk/schools/socialpolitical/research/sociology/groups/traffickingculture/.

18. Simon Mackenzie and Tess Davis, "Temple Looting in Cambodia," *British Journal of Criminology* (June 13, 2014).

19. Andrea Thomas, "Swiss Museum Accepts Art from Late Dealer Cornelius Gurlitt," *The Wall Street Journal* (November 20, 2014).

20. Wesley A. Fischer and Ruth Weinberger, "Holocaust-Era Looted Art: A Current Worldwide Overview," *Conference on Jewish Material Claims Against Germany and World Jewish Restitution Organization* (September 2014).

# Sources

Association of Art Museum Directors. "Art Museums and the Identification and Restitution of Works Stolen By the Nazis," Position Paper. New York: May 2007. https://aamd.org/sites/default/files/document/Nazilooted%20art_clean_06_2007.

Association for Recorded Sound Discussion List. Sunday, 16 October 2011 17:26:50, Leslie Waffen, Listerve.LOC.GOV.

Baker, Darrell D. *Encyclopedia of the Pharaohs: Predynastic to the Twentieth Dynasty 3300-1069 BC*, Volume 1. London: Bannerstone Press, 2008.

Belzoni, Giovanni Battista. *Travels in Egypt and Nubia*. Vercelli, Italy: White Star Publishers, 2007.

Bickerstaffe, Dylan. "The Royal Cache Revisited," JACF, *The Institute for the Study of Interdisciplinary Sciences*, 10(2005), 9–25.

Bonfils, Felix. *The Mummy Seller* (1883).

Bourgon, Lyndsie. "Bill Jamieson Was A Treasure-Hunting Rarity," *The Globe and Mail*, July 29, 2009.

Bratton, F. Gladstone. *A History of Egyptian Archaeology*. London: Robert Hall, 1967.

Brosz, Daniel. "Lakota Ghost Dance Clothing: History, Meaning and Manufacture." The University of Nebraska-Lincoln: 2002. Unpublished.

Brosz, Daniel. "Mending the Hoop: The Repatriation of the Sacred Ghost Dance Shirt." The University of Nebraska-Lincoln: 2002. Unpublished.

Buck, Pearl S. *My Several Worlds: A Personal Record*. New York: The John Day Company, 1954.

Bureau of European and Eurasian Affairs. *Washington Conference Principles on Nazi-Confiscated Art*. Washington, DC: 1998. http://www.state.gov/p/eur/rt/hlcst/122038.htm.

"Carlos Museum." www.carlos.emory.edu/.

Charney, Noah, Paul Denton, and John Kleberg. "Protecting Cultural Heritage from Art Theft: International Challenge, Local Opportunity," *FBI Law Enforcement Bulletin*. March 2012. http://leb.fbi.gov/2012/march/protecting-cultural-heritage-from-art-theft-international-challenge-local-opportunity.

Christie, Agatha. *An Autobiography*. New York: Dodd, Mead & Company, 1977.

Conn, Peter. *Pearl S. Buck, a Cultural Biography*. Cambridge: Cambridge University Press, 1996.

Davis, Burke. *Sherman's March through the Carolinas*. Raleigh, NC: The University of North Carolina Press, 1996.

De La Torre, Laura. "Terrorists Raise Cash by Selling Antiquities," *BGSN: Government Security News* 4, no. 3(February 20, 2006).

"E. Randol Schoenberg." http://www.bslaw.net/schoenberg.html.

133

Edwards, Amelia B. *Pharaohs, Fellahs and Explorers*. New York: Harper & Brothers, 1891.

Fallen, Anne-Catherine, and Kevin Osborn. *Records of Our National Life: American History and The National Archives*. London: D. Giles Limited, 2009.

Fischer, Wesley A., and Ruth Weinberger. "Holocaust-Era Looted Art: A Current Worldwide Overview," *Conference on Jewish Material Claims Against Germany and World Jewish Restitution Organization*. September 2014.

Garner, Dwight. "The Meteoric Rise, and Decline, of a Talented Young Writer," *New York Times*, June 8, 2010.

Greenfield, Jeanette. *The Return of Cultural Treasures*, 3rd ed. New York: Cambridge University Press, 2007.

Haken, Jeremy. *Transactional Crime in the Developing World*. Washington, DC: Global Financial Integrity, 2011.

Harris, Lucien. "German Court Orders Return of Ancient Vessel To Iraq But the Gold Vase Is Still Believed To Be Held in Germany Pending an Appeal," *The Art Newspaper*, November 18, 2009.

Howard, David. *Lost Rights: The Misadventures of a Stolen American Relic*. New York: Houghton Mifflin Harcourt, 2009.

"Infantry 54th Ohio," Bowling Green State University. http://www2.bgsu.edu/colleges/library/cac//cwar/09ovi.html.

International Criminal Court. http://www.icc-cpi.int.

Interview with Daniel Brosz (curator, South Dakota Cultural Heritage Center) in discussion with the author, July 24, 2012.

Interview with David Ferriero (archivist of the United States, National Archives and Records Administration), in discussion with the author, August 19, 2013.

Interview with David Goldin (David Goldin's home), in discussion with the author, July 5, 2013.

Interview with Marcella LeBeau (Cheyenne River reservation), in discussion with the author, July 25, 2012.

Interview with Michael Müller-Karpe (Curator, Römisch-Germanisches Zentralmuseum), in discussion with the author, September 3, 2013.

Interview with James Nason and Megon Noble (Burke Museum of Natural History and Culture at the University of Washington in Seattle), in discussion with the author, August 3, 2012.

Izadi, Elahe. "Leslie Waffen: Ex-National Archives Director's Home Raided," *TBD*, October 28, 2010, accessed February 2014.http://www.tbd.com/articles/2010/10/leslie-waffen-ex-national-archives-directors-home-raided-profile--26689.html.

Kramer, Samuel Noah. *From the Tablets of Sumer: Twenty-Five Firsts in Man's Recorded History*. Indian Hills, CO: The Falcon's Wing Press, 1956.

Kramer, Samuel Noah. *The Sumerians: Their History, Culture, and Character*. Chicago: University of Chicago Press, 1963.

Kränsel, Nina. *Gustav Klimt*. Munich: Prestel, 2007.

"Kunst als Terrorfinanzierung," *Der Spiegel*, July 18, 2005. www.spiegel.de/spiegel/print/d-41106138.html.

Lester, Patrick. "Missing Pearl S. Buck Writings Turn up Four Decades Later," *The Morning Call*, June 28, 2008. http://articles.mcall.com/2007-06-28/news/3723754_1_manuscript-bucks-county-buck-s-son.

Lieber, Francis. *Instructions for the Government of Armies of the United States in the Field*, Article 36, General Orders No. 100. Washington, DC: Government Printing Office, 1863.

Lillie, Sophie, and Georg Gaugusch. *Portrait of Adele Bloch-Bauer*. New York: Neue Gallerie, 2007.

Mackenzie, Simon, and Tess Davis. "Temple Looting in Cambodia," *British Journal of Criminology*, June 13, 2014.

Maddra, Sam. "Glasgow's Ghost Shirt," booklet published by Glasgow Museums, 1999.

Maykuth, Andrew. "FBI says Secretary took Buck Typescript," *Philadelphia Inquirer*, June 28, 2007.

Merryman, John Henry. "The Public Interest in Cultural Property," 77 Cal.L.Rev.339, 1989. http://scholarship.law.berkley.edu/californialaw/vol77/iss2/3.

Mooney, James. *The Ghost-Dance Religion and Wounded Knee*. New York: Dover Publications, Inc. 1973, unabridged replication of the accompanying paper, "The Ghost-Dance Religion and the Sioux Outbreak of 1890," of the *Fourteenth Annual Report (Part 2) of the Bureau of Ethnology to the Smithsonian Institution, 1892-93, by J.W. Powell, Director*, originally published by the Government Printing Office, Washington, DC, 1896.

Morris, Eric W. "Leslie Waffen, Ex-Archives Worker Sentenced for Stealing Recordings," *Washington Post*, May 3, 2012.

Moser, Stephanie. *Museum Display, Representation, and Ancient Egypt*. Chicago: University of Chicago Press, 2006.

Mowris, James A. *A History of the One Hundred and Seventeenth Regiment, New York Volunteers*. New York: Edmonstrom Publishing, 1996.

"Ms. Maria Altman Talking About The Gold Portrait by Gustav Klimt." February 8, 2011. Youtube. https://www.youtube.com/watch?v=DsSnR0IygJ8.

National Archives and Records Administration. *Theft of Historical Audio Recordings Investigation Number 11-00021*, 2013.

Nazi Era Provenance Internet Portal. "The Nazi Era Provenance Internet Portal Project." Washington, DC: American Alliance of Museums. www.nepip.org.

"Niagara Museum."http://www.niagaramuseum.com.

O'Neill, Mark. "Glasgow City Council's Arts and Culture Committee Report." November 13, 1998.

"Provenance Search." http://provenanceresearch.org.

Romano, James F. *Death, Burial, and Afterlife in Ancient Egypt*. Pittsburgh: The Carnegie Museums of Natural History, 1990.

Ruiz, Cristina. "9/11 Hijacker Attempted to Sell Afghan Loot," *The Art Newspaper*, April 17, 2013.

Samuelson, Todd, Laura Sare, and Catherine Coker. "Unusual Suspects: The Case of Insider Theft in Research Libraries and Special Collections," *College & Research Libraries*, 73, no. 6 (2012), 556–68.

Simpson, Kenrick N. *Liberty and Freedom: North Carolina's Tour of the Bill of Rights*. Raleigh, NC: North Carolina Office of Archives and History, Department of Cultural Resources. 2007.

Smithsonian: Museum Studies. http://museumstudies.si.edu.

South Dakota Department of Tourism and State Development. "Curation Agreement," January 2005.

Spurling, Hilary. *Pearl Buck in China: Journey to The Good Earth*. New York: Simon & Shuster, 2010.

*The 9/11 Commission Report: Final Report of the National Commission on Terrorist Attacks Upon the United States*, Authorized Edition. New York: WW. Norton & Company: 2004.

Thomas, Andrea. "Swiss Museum Accepts Art from Late Dealer Cornelius Gurlitt," *The Wall Street Journal*, November 20, 2014.

"Tomb of Rameses I, Theban Mapping Project."www.thebanmappingproject.com.

Townsend, E. D. *General Orders No. 88, War Department*. Washington, DC: Little, Brown and Co, 1865.

United Nations. *United Nations Convention against Transnational Organized Crime and the Protocols*. New York: United Nations Office on Drugs and Crime, 2004. http://www.unodc.org/unodc/treaties/CTOC.

United Nations Educational, Scientific and Cultural Organization. *Convention on the Means of Prohibiting and Preventing the Illicit Import, Export and Transfer of Ownership of Cultural Property*. 1970.

United Nations Educational, Scientific and Cultural Organization Database of National Cultural Laws. http://www.unesco.org/culture/natlaws/.

18 U.S. Code §542, *Entry of Goods By Means of False Statements*. http://www.law.cornell.edu/uscode/text/18/542.

18 U.S. Code §545. *Smuggling Goods into the United States*. http://www.law.cornell.edu/uscode/text/18/545.

18 U.S. Code §668. *Theft of Major Artwork*. http://www.law.cornell.edu/uscode/text/18/668.

18 U.S. Code §1341. *Frauds and Swindles.* http://www.law.cornell.edu/uscode/text/18/1341.
18 U.S. Code §1343. *Fraud By Wire, Radio, or Television.* http://www.law.cornell.edu/uscode/text/18/1343.
18 U.S. Code §2314. *Transportation of Stolen Goods, Securities, Moneys, Fraudulent State Tax Stamps, or Articles Used in Counterfeiting.* http://www.law.cornell.edu/uscode/text/18/2314.
Vogel, Carol. "Lauder Pays $135 Million, a Record, for a Klimt Portrait," *New York Times,* June 19, 2006.
Weiner, Rebecca. "The Virtual Jewish History Tour," *Jewish Virtual Library.* http://www.jewishvirtuallibrary.org/jsource/vjw/Vienna.html.
Wittman, Robert K., and John Shiffman. *Priceless: How I Went Undercover to Rescue the World's Stolen Treasures.* New York: The Crown Publishing Group, 2010.
Woolley, Sir Leonard. *Excavations at Ur: A Record of Twelve Year's Work.* New York: Thomas Y. Crowell & Company, 1954.

# Additional Reading

## CHAPTER 1: THE LADY IN THE JEWELED DOG COLLAR

Lillie, Sophie, and Georg Gaugusch. *Portrait of Adele Bloch-Bauer.* New York: Neue Gallerie, 2007.

Nichols, Lynn Holman. *Rape of Europa: The Fate of Europe's Treasures in the Third Reich and the Second World War.* New York: Knopf Publishing Group, 1995.

O'Connor, Ann-Marie. *The Lady in Gold: The Extraordinary Tale of Gustav Klimt's Masterpiece Portrait of Adele Bloch-Bauer.* Knopf Doubleday Publishing Group, 2012.

Weiner, Rebecca. "The Virtual Jewish History Tour," *Jewish Virtual Library.* http://www.jewishvirtuallibrary.org/jsource/vjw/Vienna.html.

Whitford, Frank. *Klimt.* London: Thames & Hudson, 1990.

## CHAPTER 2: THE CASE OF THE MISSING MASTERPIECE

Buck, Pearl S. *The Good Earth.* New York: The John Day Company, 1931.

Conn, Peter. *Pearl S. Buck, a Cultural Biography.* Cambridge: Cambridge University Press, 1996.

## CHAPTER 3: GHOST DANCING AT WOUNDED KNEE

Mooney, James. *The Ghost-Dance Religion and Wounded Knee.* New York: Dover Publications, Inc. 1973, unabridged replication of the accompanying paper, "The Ghost-Dance Religion and the Sioux Outbreak of 1890," of the *Fourteenth Annual Report (Part 2) of the Bureau of Ethnology to the Smith-*

*sonian Institution, 1892-93, by J.W. Powell, Director*, originally published by the Government Printing Office, Washington, DC, 1896.

## CHAPTER 4: BABE RUTH ON A QUAIL HUNT

Anne-Catherine Fallen and Kevin Osborn, eds. *Records of Our National Life: American History and the National Archives*. London, UK: The Foundation for the National Archives, 2009.

## CHAPTER 5: THE ONLY PHARAOH OUTSIDE OF EGYPT

Baker, Darrell D. *Encyclopedia of the Pharaohs: Predynastic to the Twentieth Dynasty 3300-1069 BC*, Volume 1. London: Bannerstone Press, 2008.
Belzoni, Giovanni Battista. *Travels in Egypt and Nubia*. Vercelli, Italy: White Star Publishers, 2007.
Dunand, Francoise, and Roger Lichtenberg. *Mummies and Death in Egypt*. Translated from the French by David Lorton. Ithaca, NY: Cornell University Press, 2006.
Edwards, Amelia B. *Pharaohs, Fellahs and Explorers*. New York: Harper & Brothers, 1891.
Tomb of Rameses I, Theban Mapping Project. Information can be found at: www.thebanmappingproject.com.

## CHAPTER 6: SELLING HISTORY

Barrett, John. *Sherman's March through the Carolinas*. Chapel Hill, NC: University of North Carolina Press, 1956.
Howard, David. *Lost Rights: The Misadventures of a Stolen American Relic*. New York: Houghton Mifflin Harcourt, 2009.
Simpson, Kenrick N. *Liberty and Freedom: North Carolina's Tour of the Bill of Rights*. Raleigh, NC: North Carolina Office of Archives and History, Department of Cultural Resources, 2007.

## CHAPTER 7: SUMERIAN PLUNDER

Christie, Agatha. *An Autobiography*. New York: Dodd, Mead & Company, 1977.
Kramer, Samuel Noah. *From the Tablets of Sumer: Twenty-five Firsts in Man's Recorded History*. Indian Hills, CO: The Falcon's Wing Press, 1956.

*The 9/11 Commission Report: Final Report of the National Commission on Terrorist Attacks Upon the United States*, Authorized Edition. New York: WW. Norton & Company: 2004.

Römisch-Germanisches Zentralmuseum (Ed). Kriminalarchäologie, 2011.

Woolley, Sir Leonard. *Excavations at Ur: A Record of Twelve Year's Work*. New York: Thomas Y. Crowell Company, 1954.

## CHAPTER 8: HEROES

Cuno, James. *Who Owns Antiquity? Museums and the Battle over our Ancient Heritage*. Princeton: Princeton University Press, 2008.

Greenfield, Jeanette. *The Return of Cultural Treasures*, 3rd ed. New York: Cambridge University Press, 2007.

United Nations Educational, Scientific and Cultural Organization. *Convention on the Means of Prohibiting and Preventing the Illicit Import, Export and Transfer of Ownership of Cultural Property*. 1970.

Washington Conference Principles on Nazi-Confiscated Art. http://www.state.gov/p/eur/rt/hlcst/122038.htm.

# Index

Abd el-Rassul, Ahmed and Mohammed, 67, 73–76
acquisition practices: historical vs. modern, leniency in, xiv; international law on, xiv
Adams, John, 84, 85
Afghanistan: antiquities trafficking in, 115, 116; terrorist training camps in, 108, 115
agriculture: Chinese, 22; Sumerian, 105
Agua Caliente Tribe, 47
Akhenaten (pharaoh), 70
Al Qaeda, 108–110. *See also* 9/11 terrorist attacks
Altman, Maria Bloch-Bauer: childhood in Vienna, 3; death of, 16; family art collection reclaimed by, 11–14, 16, 130; flight from Nazis, 9
American Civil War. *See* Civil War
American Indian Movement, 36, 47
Ancient Egyptian Archaeology Trust, 68
Anschluss, 7–8
antiquities trafficking: approaches to stopping, 116–117, 118–119, 125–130; estimates of value of, 103, 116, 124; laundering in, 112–113; organized crime in, 103; terrorism funded by, 104, 105, 108–110, 114–116
anti-Semitism, in Vienna, 4, 7–8
arbitration, 127

archaeology: Egyptian, 67, 68, 72; in Ur, 106–108, 111, 117–118. *See also* antiquities trafficking; Ramesses I mummy; Sumerian vessel
Army, U.S., Seventh Cavalry, in Wounded Knee massacre, 35, 39–40
Art and Cultural Heritage Mediation Program, 127
art museums: Holocaust art held by, xi–xii, 2–3, 11, 124; repatriation efforts by, 16, 125–126; responsibility for stopping illicit trade, 125–126; theft of artwork from, xiii. *See also specific museums*
*Art News* (magazine), 11, 116
Art Restitution Act of 1998 (Austria), 11
*Asia* (magazine), 28
Association for Recorded Sound Discussion List, 60–61
Association of Art Museum Directors, xii, 2, 117
Athenaeum of Philadelphia, 105
Atlanta. *See* Michael C. Carlos Museum
*Atlantic* (magazine), 23
Atta, Mohamed: connection with antiquities trafficking, 105, 108, 109, 115–116; role in 9/11 attacks, 109
Atwater Kent Museum (Philadelphia), 51
audio discs: value of originals vs. copies of, 56. *See also* National Archives audio discs

141